Max Jacob and the Poetics of Cubism

Gerald Kamber

Max Jacob

and the

Poetics

of

Cubism

The Johns Hopkins Press / Baltimore and London

Je l'ai vu moi l'esprit, Ferdinand, céder peu à peu de son équilibre et puis se dis-
soudre dans la grande enterprise des ambitions apocalyptiques! Cela commenca
vers 1900.

[I saw it I did, Ferdinand, I saw the mind lose its balance more and more until it
dissolved in the great rush of apocalyptic ambitions. That began around 1900.]

<div align="right">L.-F. Céline, Voyage au bout de la nuit</div>

Copyright © 1971 by The Johns Hopkins Press
All rights reserved
Manufactured in the United States of America

The Johns Hopkins Press, Baltimore, Maryland 21218
The Johns Hopkins Press Ltd., London

Library of Congress Catalog Card Number 70–105364
ISBN 0–8018–1160–0

Contents

Preface

SINCE THE PRESENT book was conceived and composed over a period of years, it would be impractical if not impossible to acknowledge in print my debt to that small army of professors, fellow graduate students, colleagues, friends, and students who in one way or another helped me to crystallize an idea or two or supplied me with just the right bibliographical reference. It would be equally ingracious of me, however, not to name those who most specifically contributed either to the initial conception or the final realization of the book. The topic was originally suggested by Professor Georges Poulet (now of the University of Nice). It is also fitting that I evoke here the memory of the Professor of Romance Philology at The Johns Hopkins University, Leo Spitzer (1887–1960), from whose seminars (1952–55) I gleaned certain concepts and techniques of literary analysis used here. I should like to express my deep appreciation to Professors René Girard (now of the State University of New York at Buffalo) and Nathan Edelman (now of Columbia University) who guided me through the early, difficult versions, and to the late Professor Christopher Gray (of Johns Hopkins) for having read the section on cubism.

In addition, I was immensely fortunate to enjoy the encouragement, both professional and personal, of Professors Richard A. Macksey (of

Johns Hopkins), Clarence E. Turner (of Rutgers University), Anthony L. Bascelli (of Ithaca College), and Lawrence Joseph (of Smith College), all of whom contributed in no small measure, by their valuable suggestions and critical reading, to the successful completion of the manuscript. I wish to thank Mr. Jacques Lindon (of New York City) for obtaining a print of Juan Gris' *Violon et Damier* for me and Mrs. Leon Simon (of Rye, New York) for her gracious permission to reproduce it here. I also acknowledge my debt to the gentlemen of the Faculty Research Committee of Bowdoin College and to the Ford Foundation for financial aid in defraying the secretarial expenses of the definitive typescript.

I owe very special gratitude to my parents, Mr. and Mrs. Robert Kamber (of Asbury Park, New Jersey) for the steadfastness of their devotion during the long years of my education, and to my wife, Hannah Griffiss Kamber, without whose understanding and help this book might never have been completed.

In the manner of the Sorcerer's Apprentice, I suspect I have deformed material, so prodigally bestowed upon me by friends and mentors, to the point where it is scarcely recognizable to them now; or I have put their ideas and methods to uses for which they never intended them, so that recognition of the sources is apt to arouse only indignation on the part of their generous authors. These are sophisticated as well as generous men, however, well aware of the horrendous difficulties awaiting the critic who would undertake to analyse Jacob's writings, and I count on one more instance of their indulgence. Given the excellence of their contributions it should be clear that the shortcomings of this book are attributable to me alone.

Finally a word is in order on my intentions in writing such a book and on the public I would hope it to reach. The book has a triple purpose or rather a greater purpose enclosing two lesser ones. The greater: it is addressed primarily to specialists in contemporary French literature who have long lived with a serious gap in Jacob criticism. I trust I neither delude myself nor mislead the reader when I state that solutions never before attempted on this scale are herein proposed for the knottiest problems confronting the interpreter of Jacob. These solutions embrace a broad spectrum of exegetical possibilities including the relationship of both the esthetic and the technical means existing between two media as diverse as painting and poetry in order to show how both may operate

on similar or even identical premises within a common art style, cubism; the discovery and identification of extensive Baudelairean elements (as well as echoes of Gautier, Verlaine, Corbière, and Rimbaud) fragmented and redisposed within the fabric of Jacob's supposedly hermetic poetry and never before identified; and the most complete and varied *explication de textes* to which Jacob's writings have ever been subjected, rendered possible specifically by the forgoing information. Finally, the last chapter suggests lines of force emanating from Jacob and extending to his younger contemporaries, especially the surrealists and post-surrealists, thereby illuminating one hitherto obscure facet of recent French literature and casting some light on several others as well.

As for the two lesser purposes: the first, deliberately didactic, is to demonstrate to the novice of literary criticism precisely how one may first explore, then synthesize and apply data, historical, ideological, esthetic, linguistic—in short, critical data in the fullest sense of the word —to specific works of literature. The second is to trace, as the title indicates, and for the very first time, the specific, irreducible links between cubist painting and cubist poetry. Any artist, art historian, art lover, esthetician, or student of the history of ideas, having an interest in the period/style of cubism and a collateral interest in contemporary French letters, should find the book provocative and perhaps even useful.

And finally a word is in order about the many French citations and the English translations which are supplied in nearly all instances (only those few being omitted where the sense is perfectly clear to the English-language reader). After surveying the rare existing translations of Jacob and the numerous ones of Baudelaire, as well as those of some of the other authors cited herein, I found that while certain translations are quite successful poetically they seldom if ever deliver up to the reader the basic structure of the French utterance. I therefore deemed it expedient to furnish literal translations in all cases for all authors with no concern for the poetic effect in English.

As will become clear to the reader, regardless of how much French he knows, most of these translations are profoundly problematic whether because of highly idiomatic French, of semantic suggestion due uniquely to sound patterns, of a mixture of two or more levels of discourse used in contrast to each other, or of the liberal intrusion of nonsenses syllables. It is hardly possible to capture the subtle suggestiveness of this poetry in

a literal translation. In the case of puns, it has been squarely impossible and I have simply indicated the primary meaning since the further meanings are always analyzed and explained in the exegesis. In short, despite their imperfections, the translations supply the minimum sense necessary to render intelligible the analysis of the text, and this is all that I had hoped to do.

Introduction

MAX JACOB was born on July 12, 1876, at Quimper, Brittany, to Alsatian-Jewish parents of modest means, his father being a tailor and part-time antique dealer. Although Jacob proved at first to be a mediocre student, he displayed a lightning-like intelligence from an early age. He was also beset by numerous manias. Inordinately sensitive, he accused his schoolmates of persecuting him and complained that his brothers beat him and that his authoritarian mother mistreated him at home.

One biographer confirms this, speaking of Jacob as being "dur comme un rocher et insensible à tout, même aux coups qu'on ne lui épargnait guère" [hard as a rock and indifferent to everything, even to the blows which they hardly spared him]; and described him as "très battu, très battu par ses frères et par sa mère qui était nerveuse et impatiente" [very, very often beaten by his brothers and by his mother who was nervous and impatient]. He adds:

> Sa tristesse, Max la tient de naissance. Souvent, il fut battu. Il reçut à 24 ans sa dernière gifle [sic] de sa mère (parce qu'il avait fait une faute d'orthographe).[1]

[1] Robert Guiette, "Vie de Max Jacob," N[ouvelle] R[evue] F[rançaise], CCL, CCLI (1934), p. 8.

[Max already had his sadness from birth. Often he was beaten. At the age of twenty-four he received his last slap from his mother for having made a spelling error.]

Jacob kept a kind of journal in which he inscribed his *Maximes d'adolescence*. Here is a typical statement, ostensibly motivated by his personal suffering and perfectly consonant with his love of paradox and ironic contradiction, as reported by a school chum:

La douleur et la volupté se touchent souvent au point de se confrondre. N'approfondissez pas ceci, c'est une de ces pensées qui, avec des apparences de profondeur, ne veulent, en vérité, rien dire du tout.[2]

[Pain and voluptuousness are often so close as to become one. Don't pursue this; it's one of those thoughts that, with an appearance of depth, do not really mean anything at all.]

After a serious illness, Jacob's schoolwork improved and his secondary studies were so brilliantly accomplished that, at their conclusion, his parents tried to persuade him to accept a scholarship at the École normale supérieure. Whether because of a virtual obsession with exotic lands—contracted perhaps from reading Galland's *Mille et une nuits,* Poe, and Hoffmann—or simply because an older brother was already in the government service in Africa, Max Jacob entered the École coloniale in 1894.

A call to the army soon interrupted his studies there and the tiny, timid, unenthusiastic recruit was returned to his native Brittany for basic training. His resignation to his own total ineptitude and his jubilation (as well as that of his superiors) at the failure of the experiment are humorously related in the following passage:

l'inefficacité de mes efforts pour collaborer aux exercices de la caserne lassa la patience de ceux qui les dirigeaient et quand la bienveillante vigilance des autorités militaires interrompit mes travaux après six semaines pour m'en épargner les fatigues, je dissimulais mieux ma

[2] From a letter of René Villard, childhood friend of Jacob and presently professor at the Lycée of St. Brieux, quoted by Hubert Fabureau, *Max Jacob, Son Oeuvre* (Paris, 1936), p. 12.

honte d'avoir été dérobé de ma charge que mes chefs la joie de s'être acquitté de la leur.[3]

[The inefficiency of my efforts to collaborate in the exercises of the barracks exhausted the patience of those who were directing them and when the benevolent vigilance of the military authorities interrupted my tasks at the end of six weeks in order to spare me further trouble, I better dissimulated my embarrassment at having been relieved of my responsibilities than my chiefs their joy at having acquitted themselves of theirs.]

This is actually the opening sentence of "Surpris et charmé," a detective story reminiscent of Poe, which is supposed to show the circumstances leading up to Jacob's protracted sojourn in Paris.

The last sentence of the same tale is equally illuminating: "Alors commença cette vie de privations et de souffrances qui est aujourd'hui la mienne" (p. 48). [Then began that life of privation and suffering which today is mine.] He relates that he supported himself by giving piano lessons, supported himself to the extent of "quatre sous de pain par jour,"[4] slept in a hammock offered him by another Breton as poor as he, and attended courses at the Académie Jullian where the other students, hardly a prosperous lot, thought *he* had come to sell pencils.

Finally in 1898, a friend got him the job of writing art criticism on the *Gaulois,* and he prospered, relatively speaking. This was the epoch of the monocle, the gray top hat and spats, and the swallow-tail coat. "Il gagna sa vie et il vécut dans les honneurs que les peintres rendent à ceux qui s'occupent d'eux. . . . Il fit la connaissance des peintres d'avant-garde." [He earned his living and he lived on the prestige that painters accord to those who look after them. He met the avant-garde painters.][5] But by now Jacob knew that he would consecrate himself to literature. In order to perfect his style, he quit the obscure art journal and plunged once more into voracious reading until as he says, "Je retombais dans une misère profonde" [I fell once again into profound poverty],[6] a

[3] *Le Roi de Béotie, Nouvelles* (Paris, 1922), p. 36. Since there is a selected bibliography of the works of Jacob, all citations from Jacob will hereinafter carry the title of the work immediately following in parentheses and will not be footnoted.

[4] Guiette, "Vie de Max Jacob," p. 250.

[5] Ibid., p. 11.

[6] Ibid., p. 11.

poverty which forced him back to Quimper. There he tried various jobs, working as carpenter's helper and then as clerk in a law office, with the most indifferent success.

Finally in 1901, he returned to Paris, this time to work as clerk and sweeper at the Entrepôt Voltaire and ever afterwards, "la foule de petits employés, les chefs de rayon, le patron" [the mob of clerks, department supervisors, the boss] swarm over the pages of his books. Having attended Picasso's first exposition that same year, Jacob says: "J'avais été si émerveillé par sa production, comme critique d'art professionnel, que j'avais laissé un mot d'admiration chez Ambroise Vollard." [I was so dazzled by his production that I, as a professional art critic, had left an admiring note at Ambroise Vollard's.] They became fast friends and "naturellement Picasso vint habiter dans ma chambre, boulevard Voltaire, au cinquième. Elle était très vaste. Picasso dessinait toute la nuit. Et quand je me levais pour aller au magasin, il se couchait pour se reposer." [. . . naturally Picasso came to live in my room, boulevard Voltaire, on the fifth floor. It was a vast room. Picasso painted all night. And when I was getting up to go to work at the department store, he was going to bed to get some rest.][7]

Picasso returned to Spain and then came back to Paris in 1904. Suddenly we find them both at number thirteen of the rue Ravignan in the incredible Bateau Lavoir a few doors down from André Salmon and Juan Gris (at number seven). Jacob describes the building:

> Etranges structures des terrains montmartrois! Etranges conceptions des architectures! Cette demeure qui n'avait pas d'étages visibles de l'extérieur, avait des caves et des greniers et n'avait que cela, et tels que les caves, semblaient des greniers et les greniers des caves. (*Le Roi de Béotie*, p. 37)

> [Strange structures of Montmartre building plots! Strange architectural conceptions. That edifice that had no stories visible from the outside had cellars and attics and only cellars and attics and they were such that the cellars appeared to be attics and the attics cellars.]

The Bateau seemed to symbolize their disordered lives and provide the ideal setting for that welter of intellectual and artistic activity, mostly of a revolutionary nature, that they were living through in the years 1902–6.

[7] Ibid., pp. 12–13.

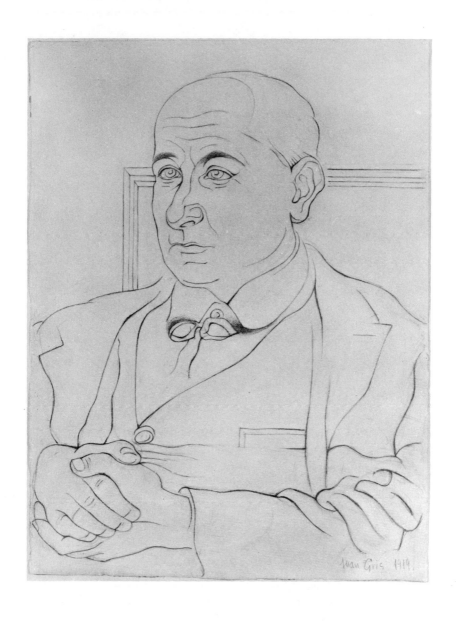

Juan Gris, *Max Jacob*, 1919. Pencil 14⅜″ x 10½″. Collection The Museum of Modern Art, New York. Gift of James Thrall Soby.

In 1905, Picasso "me dit qu'il avait passé la soirée avec un homme étonnant, Guillaume Apollinaire, et qu'il me le ferait connaître le soir même. Je connus Guillaume Apollinaire." [Picasso told me that he had spent the evening with an astonishing man, Guillaume Apollinaire, and that he would introduce him to me that very night. I got to know Guillaume Apollinaire.][8] The three became virtually inseparable and Jacob gives us this picture of their friendship:

> Nous ne nous quittions guère: nous allions attendre Guillaume Apollinaire à la sortie de la banque qui l'employait, rue Lepelletier. Nous déjeunions et dînions ensemble. Nos opinions littéraires se résumaient dans ces mots: "A bas Laforgue! Vive Rimbaud!" Le "vive Rimbaud" a fait fortune comme on sait.[9]

> [We hardly left one another: we used to wait for Guillaume Apollinaire at the entrance to the bank which employed him, rue Lepelletier. We ate together at noon and again at dinner. Our literary opinions could have been summed up in these words: "Down with Laforgue! Hurrah for Rimbaud!" The "Hurrah for Rimbaud" had some success as everybody knows.]

Most of these young people lived, at least at the outset of their careers, under conditions of terrible poverty, nourished principally by their extravagant fantasies. Max Jacob was the comedian of the group. With his superb talent for mimicry and an unerring eye for detail, he would parade impressions of the people of the streets before his convulsed comrades, would pronounce hilariously solemn "commencement exercise" speeches, or act out all the roles in a scene from Horace.

> Le soir, nous nous jouions des pièces de théâtre sous la lampe à pétrole, ne pouvant aller voir jouer celles des autres. Nous faisions alternativement tous les rôles, y compris celui du régisseur, du directeur, des électriciens, des machinistes en les mêlant à la pièce.[10]

> [Evenings we would do plays under the kerosene lamp, not being able to go see those done by others. We took turns playing all the roles including those of the stage manager, the director, the electricians, and the stage hands, mixing them into the play.]

[8] Ibid., p. 251.
[9] Ibid., p. 251.
[10] Ibid., p. 251.

By 1903, Jacob had already written his first book, *Le Roi Kaboul et le marmiton Gauwain,* a children's tale and a model of pure and delightful whimsy of which he never hestitated to avail himself whenever he needed fairytale ambiance in his later works. He speaks of the care he took in its composition:

> Cela dura bien six semaines. Je n'ai jamais poli mon style et regratté les *que,* les *qui* et les virgules, comme je le fis pour ce conte je voulais parfait.[11]

> [That lasted all of six weeks. I have never polished my style and gone over the "whiches" and the "thats" and the commas as I did for that fable which I wanted to be perfect.]

He also continued to dabble in painting, daubing bizarre gouaches from the dregs of coffee cups left in his poor room, from soot from his tiny stove, from cigarette ashes, rice powder, and/or ink, for want of better supplies. In the next couple of years, collectors began to seek out these paintings and he again prospered in a modest way.

It is not unlikely that Max Jacob was predisposed toward religion from an early age, for he speaks of it a good deal. An atheist, he would throw himself on his knees when passing Notre Dame and implore: "Mon Dieu, si par hasard vous existez, faites que je ne sois pas trop malheureux." [God, if by chance you exist, see to it that I am not too unhappy.] On October 7, 1909, "ce fut Dieu qui vint." Every commentator has noted the Pascalian quality of Jacob's anguished vision:

> Je suis revenu de la Bibliothèque Nationale; j'ai déposé ma serviette; j'ai cherché mes pantoufles et quand j'ai relevé la tête, il y avait quelqu'un sur le mur! il y avait quelqu'un! il y avait quelqu'un sur la tapisserie rouge. Ma chair est tombée par terre, j'ai été déshabillé par la foudre! Oh! impérissable seconde! oh vérité! vérité! larmes de la vérité! joie de la vérité! inoubliable vérité. Le Corps Céleste est sur le mur de la pauvre chambre! Pourquoi, Seigneur? Oh! pardonnez-moi! Il est dans un paysage, un paysage que j'ai dessiné jadis, mais Lui! quelle beauté! élégance et douceur! Ses épaules, sa démarche! Il a une robe de soie jaune et des parements bleus. Il se retourne et je vois cette face paisible et rayonnante. (*La Déf. de Tartufe,* pp. 31–32)

11 Ibid., p. 249.

[I returned from the Bibliothèque Nationale. I set down my brief-case. I glanced down for my slippers and when I raised my head again there was somebody on the wall! There was someone on the red wall-paper! My flesh fell to the floor. I was stripped by lightning! Oh imperishable second. Oh verity, verity. Tears of verity, joy of verity, unforgettable verity. The celestial body is on the wall of my poor room. Why Lord? Oh forgive me! He is in a landscape, a landscape that I drew long ago, but Him! What beauty, elegance and sweetness. His shoulders, his bearing. He is wearing a robe of yellow silk with blue cuffs. He turns and I see that peaceful shining face.]

This revelation had almost no immediate effect on the dissolute life Jacob led, and consequently many doubted his sincerity. Guiette asserts that as late as 1921, "Max menait une vie épouvantable" [Max led a dreadful life],[12] and André Billy confirms this judgment:

La dérision, la parodie ont toujours constitué un élément essentiel de l'inspiration de Max. D'où la difficulté que certains eurent à prendre sa conversion au sérieux. Une parodie de conversion, disait-on, et d'un bon rapport. Calomnie à laquelle se prêtaient l'attitude de Max et ses écrits. Sa pratique de l'éther, postérieure, il l'a dit, à sa vision de 1909, empêchait que sa foi fût reconnue comme absolument sincère, et enfin ses moeurs n'étaient pas bonnes, c'est le moins qu'on puisse dire.[13]

[Derision and parody have always constituted an essential ele-ment of Max's inspiration. Whence the difficulty that certain persons had in taking his conversion seriously. "The parody of a conversion," they were saying and with good reason. It was a calumny to which Max's attitude and his writings lent themselves. His use of ether as an intoxicant, posterior, he claimed, to his vision of 1909 kept his faith from being recognized as absolutely sincere. And finally his morals were not good; that's the least that one can say.]

[12] Ibid., p. 258. It is curious to note that this was not the only vision that Jacob had; André Billy in his *Max Jacob* (Paris, 1946), reports: "Une autre vision qu'il eut au Sacré Coeur de Montmartre se racontait quelques années après parmi ses amis. La Vierge lui apparut et lui dit: 'Ce que tu es moche, mon pauvre Max!' 'Pas si moche que ça, bonne Sainte Vierge!' répondat-il, et quitta l'église dérangeant toute l'assistance et mécontentant fort le Suisse." (p. 26) [Another vision that he had at the Sacre Coeur of Montmartre was told around a few years later among his friends. The Virgin appeared to him and said: "How 'crummy' you are my poor Max." "Not as 'crummy' as that, my good Holy Virgin!" he answered and he left the church upsetting the communicants and annoying the Swiss Guard.]

[13] Billy, p. 26.

Other friends have discussed the conversion and the entire question of Jacob's faith in cynical terms indeed. Francis Carco attributes it simply to the neighborhood:

> Cette partie de Montmartre est la moins agréable. Une sournoise humidité y englue les pavés et les murs, s'insinue, se répand partout. . . . Dans une semblable rue où ne roulaient pas trois voitures par jour et où les ménagères, pareilles à des béguines, longeaient les murs en s'effaçant, on pouvait assez bien admettre qu'une atmosphère spéciale favorisait les conversions . . . lorsqu'un peu plus tard j'appris que Leprin subissait à son tour la même crise, je n'en fus guère surpris car je connaissais le quartier.[14]

> [That part of Montmartre is the least agreeable. A pervasive humidity slimes over the cobblestones and the walls, insinuates itself, spreads itself everywhere. In such a street where not three cars a day roll through and where the housewives, like nuns, slink along the walls, one could easily enough admit that a special atmosphere favored conversions. When, a little later, I learned that Leprin was undergoing in his turn the same crisis, I was hardly surprised since I knew the neighborhood.]

Well-known writers with recognized Catholic affiliations, however, accorded Jacob a certain ideological solidarity and he had rather a *correspondance suivie* with such men as Claudel, Daniel-Rops, Maritain, and Jouhandeau. But his irrepressible flippancy about serious matters tended to prevent even his most sympathetic partisans from having much confidence in the newly acquired faith. He confided, for example, in a letter to Marcel Jouhandeau:

> Si j'ai péché la veille terriblement, le lendemain bien avant l'aube, tu me verrais sur les genoux ramper tout le long du Calvaire, je suffoque, je sanglote, je pleure, je me frappe au visage, à la poitrine, aux membres, aux mains; je saigne, je me signe avec mes larmes. A la fin, Dieu est dupe.[15]

> [If I had sinned terribly the night before, next morning, well before dawn, you would see me crawling on my knees through the

[14] *Montmartre à vingt ans* (Paris, 1938), pp. 169–70.
[15] First published in the Max Jacob issue of *Le Mail* and reproduced in *Simoun* (Oran, n.d.), p. 61.

Stations of the Cross. I choke, I sob, I weep, I strike my face, my breast, my arms and legs, my hands. I bleed, I make the Sign of the Cross with my tears. At the end, God is taken in.]

The *Dieu est dupe* too, in fact, *a fait fortune,* as we know.

We have seen Jacob torn between the desire to participate in the tribal rites and, on the other hand, the need to exorcise those very rites by literary creation, a need dictated by his extreme lucidity. At one and the same time, he hates and is fascinated by it all. As a result, he is drawn in many directions by conflicting attractions and finds himself at the very epicenter of the intellectual and spiritual tensions of his period.

Jacob fully understood that, in a mercenary world where the only hard "reality" is money, "reality" has ceased to exist. Or, as this thought might better be formulated, in a world where reality has become unreal, the only true reality is un- or even anti-reality. Alfred Jarry has spoken of "univers que l'on peut voir et que peut-être l'on doit voir à la place du traditionnel" [a universe that we may see and that perhaps we must see in place of the usual one], and this notion serves as a kind of ground for the whole cubist movement.[16] By the same token, the only true religion ceases to be an affluent, socially exclusive Catholicism but becomes rather a return to an originally humble Christianity.

For the young cubist revolutionaries equated the romantic esthetic with the bourgeois social ethic and, in turn, with Catholic religious orthodoxy. Since they had set out to outrage and deprecate the first two, it followed that they extended their animosity to the third, regarding all three as facets of the same unacceptable philosophy. But Jacob, in some ways the most idealistic and yet the most revolutionary of them all, wishing to carry his animosity beyond mere revolt, tried to find a higher expression.

The Catholic church had already rejected Jacob as a social undesirable; indeed he had an extremely difficult time persuading any priest to baptize him. To the degree that certain representatives of Catholicism appeared materially oriented, they could hardly have been expected to encourage ecstatic visionaries of a most disreputable appearance to enter the Church. For this reason, Jacob tended to hark back to an earlier and more modest version of the Christian religion, materially poor, socially

[16] *Gestes et opinions du Dr. Faustroll, pataphysicien* (Paris, 1911), p. 3.

revolutionary, politically persecuted (analogous in some ways to his un-conventional literary models), as it emerged from an ancient Hebrew messianic tradition.

In other words, Jacob in no way relinquished the Jewish theological heritage in favor of some newer faith, but merely retraced a path back to that Messiah whom his people had given to the world and then refused to accept. His conversion was in a sense a vindication of his Jewishness in a world which he found anti-Semitic and thereby *falsely* Christian, a way of crying out in pain and revolt against those latter-day pretending Christians who were manifestly perverting Christ's word as well as Christ's spirit and making of prejudice a weapon to advance their selfish interests.

Catholicism then effected a synthesis for Jacob: only in the conversion could he finally resolve the torturing contradictions. Guiette would seem to bear out some of these hypotheses when he explains the conversion in this manner:

> Dieu l'avait touché d'une sorte d'ivresse. Ce n'était pas de l'ascé-tisme. La grâce peut nous prendre par notre faiblesse. Dieu l'avait appelé du fond de son tourment intérieur. Il était entré dans l'âme de *l'homme ancien* [emphasis added]. Une grande lueur éclairait la douleur du poète.[17]

> [God had touched him with a sort of intoxication. It was not asceticism. God's grace can come to us in our weakness too. God had called him from the bottom of his inner torment. He had entered into the soul of the *ancient man.* A great light illuminated the pain of the poet.]

The *homme ancien* in this context is the Jew, finally coming to accept the prophet of his own people.

Even the apparent conflicts and contradictions between religion and debauchery (or better, weakness), poverty and opulence, lucidity and slavishness, can be resolved in Jacob's conversion. Guiette concludes:

> Sa conversion était la fin d'un dur apprentissage. Elle conférait un tel poids à la douleur de son existence, que celle-ci s'en trouvait

[17] Guiette, p. 255.

justifiée. L'équilibre était né, auquel la moindre parcelle de cette vie était nécessaire.[18]

[His conversion was the culmination of a hard apprenticeship. It conferred such a weight on the pain of his existence that that existence thereby found itself justified. An equilibrium was born to which the least particle of that life was necessary.]

Very much as he was attempting to eliminate romantic sensibilities from what was to be cubist art, Jacob was attempting to eliminate conventional bourgeois standards from what was to be Kierkegaardian Christianity, breaking the mold of nineteenth-century thinking in both of these realms.

At the same time, another and more negative factor in Jacob's conversion, an overwhelming fear of the devil, would seem to be indicated by the abundant references to Satan throughout his work, as well as by a quotation like the following:

Il faut croire à l'enfer parce qu'il a été vu et décrit par les voyants et les saints. Il y a une herbe qui fait voir les démons; j'ai bu une tisane de cette herbe et j'ai vu les démons; je dois croire ce que j'ai vu. Je les ai décrits et ma description coïncide avec d'autres descriptions. (*Méd. rel.*, p. 74)

[We must believe in Hell because it has been seen and described by seers and saints. There is an herb that makes us see demons. I drank an infusion of that herb and I saw demons. I must believe what I saw. I have described them and my description tallies with other descriptions.]

More of this will be treated in the Satanic passages from the *Matorel* where Jacob manifests a really abject terror.

On the esthetic plane, and especially in painting, the destructive-creative dynamism of cubist experimentation, its wholesale rejection of the *mystique* and clichés of romantic art, its insistence upon throwing all questions back into the balance, has been called by Joan Miró "l'assassinat de la peinture" [the assassination of painting]. And Jean Cocteau, developing this idea, has injected into it a note of religion: "L'art est religieux; une vraie crucifixion résulte des colères de Picasso

[18] Ibid., p. 258.

contre la peinture." [Art is religious; a real crucifixion results from the anger of Picasso against painting.][19]

If art is religious to the cubist, for whom art was by definition a revolutionary activity, religion to these same cubists had assumed the proportions of that act of violence that broke all ties with conventional reality. Jacob's conversion forced the wealthy and socially exclusive Church to accept the little Jewish derelict that he was and, at the same time, enabled him to identify himself with a common martyrdom inflicted at the hands of this same Church.

Many and varied hypotheses have been advanced to explain the conversion. For example, there is Jacob's near legendary timidity and physical weakness. He himself, describing the end of his army service, had said:

> Je suis réformé. Pas de bras, pas de tour de poitrine et faiblesse générale. On me déclare incapable d'être soldat. . . .[20]

> [I received a discharge. No arms, no chest expansion and general weakness. I am declared incapable of being a soldier.]

And indeed, in a world that admired handsome, strapping, devil-may-care fellows, Jacob was short, puny, unprepossessing, and an abject coward. During an epoch notorious for its ostentatious free love, and while his cronies from the Butte were blithely collecting mistresses, Jacob was an avowed pederast.

While the Dreyfus affair was uncovering a hornet's nest of anti-Semitism in a self-consciously liberal France, Jacob was a Jew. The reasons for Jacob's feelings of personal and social inferiority are endless. But the most obvious source of his weakness is that he had no confidence in his art. As Leroy Breuning explains it:

> A Max Jacob il manquait la volonté, la confiance, le génie; il lui fallait donc un point d'appui. La foi était un besoin d'amitié à la Verlaine. La vision du Christ coïncide avec le départ de Picasso du Bateau Lavoir. Il serait certainement audacieux de prétendre que le Christ a remplacé Picasso; ce qui est certain, du moins, c'est que

[19] *Carte blanche* (Paris, 1919), p. 102.
[20] Quoted by Guiette, p. 9.

pendant les premières années du siècle et surtout avant la conversion, Picasso est devenu—comme Claudel le disait de Victor Hugo—l'ombre à la place de Dieu et que Jacob lui a voué un véritable culte.[21]

[Max Jacob lacked will power, confidence, genius. He needed a fulcrum. He needed faith as he needed friendship à la Verlaine. His vision of Christ coincides with the departure of Picasso from the Bateau Lavoir. It would certainly be audacious to claim that Christ replaced Picasso in Jacob's life. What is certain at least is that during the first years of the century and above all before the conversion, Picasso had become—as Claudel said of Victor Hugo—the shadow in the place of God and Jacob absolutely worshipped him.]

And the Abbé Garnier says virtually the same thing:

Max Jacob, par humilité, par manque de confiance, par l'obsession de son infériorité cherchait toujours une *force extérieure*, un style, un ami, et enfin une religion. Picasso ne dépendait que de lui seul pour se dépasser, pour surmonter sa condition humaine. Max se sentait le regret de ne pas se sentir à la hauteur des autres étoiles de la pléiade de la rue Ravignan, de Picasso surtout, de l'Apollinaire des "Collines."[22]

[Max Jacob, through lack of confidence, through the obsession with his own inferiority, was always seeking an exterior force: a style, a friend, and finally a religion. Picasso only depended on himself alone to transcend himself, to surmount his human condition. Max regretted not feeling himself on a level with the other stars of the Pléiade of the rue Ravignan, of Picasso above all and of the Apollinaire of the "Collines."]

There is no doubt of Jacob's pitiful dependence on the opinions of others, and a related tendency to name-dropping as may be seen from Jacob's own "Petit historique du *Cornet à dés*":

"O quel titre! disait miss Hastings (dame écrivain anglaise et femme de Modigliani), en Angleterre, vous savez, on vous le volerait avant la parution du livre!" . . . *On venait le matin, 7, rue Raviguan.* [sic] *lire le poème de la nuit . . . les voisins, Picasso, Salmon, Mac*

[21] "Max Jacob et Picasso," *Mercure de France*, CCCXXXI (December, 1957), p. 581.
[22] "Max Jacob, épistolier," *Simoun*, p. 58.

Orlan, etc. . . . "Ce qu'on tapera là-dedans!" disait Mac Orlan; en effet, quelqu'un que je ne nommerai pas, quand il fut question d'une édition, se hâta de faire, sous un autre titre, . . . un recueil qui voulait être un pastiche et qui ne réussit pas à l'être. Triomphe des copains! Enfoncez Max!" et moi à Picasso: "C'est vrai que X . . . c'est mieux que moi?—Tu sais bien que l'imitateur c'est toujours mieux que l'inventeur!" Cela ménageait la chèvre, le chou et la vérité. (p. 9)

["Oh what a title!" said Miss Hastings (English lady writer and wife of Modigliani). "In England, you know, they would have stolen it from you before the book even came out." The neighbors, Picasso Salmon, Mac Orlan, etc., used to come to 7 rue Ravignan in the morning to read the poem of the night before. "Are they going to help themselves to your stuff!" said Mac Orlan. In effect, when it came time to make an edition, someone who will remain nameless hastened to put out a collection under another title which was meant to be a *pastiche* but which did not succeed in being one. It was a triumph for the cronies: "Get the better of Max?" And I to Picasso: "Is it true that X is better than I?" "You know perfectly well that the imitator is always better than the inventor." That spared both his feelings and my feelings, and saved the truth.]

Here Jacob exhibits a touching need for solidarity with his *copains* and for their approval, as well as a truly pathetic gratitude when they accord him these things. Nor is he devoid, at the end, of a kind of cynical lucidity.

We know the success they were all to achieve, a success that would deliver them from their personal anguish, raise them from their low social status, take them out of their squalid surroundings, to bring them fame, a measure of luxury, and chic mistresses. But Jacob was to know practically none of this soul's balm. He remained poor, his works enjoyed a strictly limited *succès d'estime*, or he was regarded with amused and patronizing tolerance by those successful *littérateurs* whose sensibilities remained steeped in the previous century.

Another and valuable insight into this aspect of Jacob's character is contributed by Marcel Béalu:

Le plus petit malentendu devenait pour lui [Jacob] drame horrible; la moindre querelle: épouvantable catastrophe. Souvent, simple témoin d'un commérage, il en devenait la victime par cette propension morbide à le répandre en le grossissant. Il avait le privilège d'accumuler autour de lui une inquiétante atmosphère que clarifiait seul

son sourire sous-jacent, invisible au profane. "Le vrai monde distingué," me disait-il un jour, "c'est celui où la gaffe n'est pas possible."

Pauvre Max! Trop souvent la gaffe fut possible, irrémédiable, retentissante.[23]

[The slightest misunderstanding became for him (Jacob) a horrible drama, the least quarrel, a dreadful catastrophe. Often, if he had simply been witness to a bit of gossip, he became the victim of it through that morbid propensity for spreading it around, exaggerating it all the while. He had the privilege of accumulating around him an upsetting atmosphere that only his underlying smile, invisible to the profane, was capable of neutralizing. "The truly distinguished society," he said to me one day, "is the one in which a blunder is not possible."

Poor Max! All too often the blunder was possible, irremediable, thundering.]

In spite of his material poverty and moral abjection, Jacob, after his conversion, began to seek out affluent and elegant people and to be sought out by them.

A partir de l'apparition de 1909, . . . la vie de Max devint meilleure. Il commença d'aller dans le monde et d'y faire le dandy. Le pauvre employé en blouse blanche de l'Entrepôt Voltaire devint un Monsieur en habit noir, que l'on trouvait spirituel.[24]

[From the time of the apparition in 1909, Max's life became better. He began to go out into the world and to play the dandy; the poor employee in his white smock of the Entrepôt Voltaire became a gentleman in a black tuxedo whom people found witty.]

He loved to frequent the brilliant salons where he was invited because of his dazzlingly witty conversation, his excellent piano renditions, and the modish reputations that his arty friends were beginning to acquire. Traces of these frequentations, too, find their reflections throughout Jacob's prose and in much of the poetry.

To complete the picture of these *fréquentations mondaines*, Carco has left an illuminating reminiscence of Edouard, a mutual friend who belonged to the smart set.

[23] "Pauvre Jacob," *Simoun*, p. 32.
[24] Guiette, p. 253.

Il passait le plus clair de son temps à se polir les ongles ou à remettre à leur place ses collections d'étains, de vieilles armes et de faïences que la femme de ménage laissait en désordre, après les avoir époussetées. Cette besogne accomplie, il se plongeait gravement dans la lecture de minces revues éphémères dont il était souvent l'unique et déconcertant abonné.[25]

[He spent the best part of his time polishing his nails or rearranging his collection of pewter, of antique firearms and of porcelain that the cleaning woman had left in disorder after having dusted. This chore accomplished, he plunged gravely into the perusal of thin, ephemeral "little magazines" of which he was often the sole disconcerting subscriber.]

Edouard, archetypal fop that he was, turned Jacob's talents to his own uses.

Edouard organisait à la maison de petites réunions. Les dames étaient reçues. On récitait des vers. Max Jacob se livrait à des improvisations, parlait théâtre, cubisme, orphisme. Il était cancanier et sublime, serviable, empressé, badin, profond, coquet, persifleur, homme du monde. A lui seul, il occupait la sellette une soirée.[26]

[Edouard organized small gatherings at his house. Ladies were also invited. The guests took turns reciting verses. Max Jacob indulged in improvisations, spoke of the theater, of cubism, of orphism. He was gossipy and sublime, obliging, eager, bantering, profound, coquettish, ironical, sophisticated. He alone did all the talking one evening.]

And Jacob himself left a veracious record of this period, written as late as 1943, in the "Petit historique du *Cornet à dés.*"

From the foregoing, it becomes clear that there are very many schools of thought regarding Jacob's conversion. Upon closer scrutiny, however, they tend to group themselves into two major positions: that of the resolute, right-thinking Catholics who see in the conversion a touching example of God's grace, and that—more skeptical and imbued with the inflexible French common sense—of Jacob's own Bohemian comrades who regarded it as one more prank. In any case, while there exist many

[25] *Montmartre à vingt ans,* p. 31.
[26] Ibid., p. 32.

factors to which Jacob's conversion may be attributed, each, despite even substantial contradictions, only adds another dimension to a seemingly paradoxical religious turnabout incomprehensible from any single point of view.

After a great many tribulations—several priests having refused him baptism—he was baptized Cyprien Max Jacob in 1915, Pablo Picasso acting as godfather. "Sa vie désordonée, il eut bien du mal à la discipliner." [He had the greatest difficulty in disciplining his disordered life], and he continued to lead an existence in which the abject was liberally intermixed with the spiritual. For example, he loved the Sacré Coeur and "y allait prier et pleurer à la fin des nuits" [would go there to pray and cry at the end of his nights out].[27] In 1921, the Abbé Weil suggested that he seek refuge at the beautiful cloister of St. Benoît-sur-Loire.

His friends saw him retire there to live the life of a simple monk, serving as porter and composing religious meditations. During that time, he found a great interior peace, spent his mornings gossiping "with the carver of wooden shoes, the wagon maker, the saddle maker," and finally wrote *Filibuth*. But by 1928, he had had enough of the simple saintly life and returned triumphant to Paris and to the debauchery and abjection that exerted such a fascination for him. He stayed eight more years, or until 1936, when he returned to St. Benoît to finish his days.

In 1944, however, Jacob was arrested by the Gestapo and despite desperate efforts on the part of the directors of the abbey as well as of influential friends in Paris, he was herded off to the frightful relocation center at Drancy where prisoners were kept preparatory to being sent to the German concentration camps. His chest had always been weak—indeed, he had suffered at least two serious attacks of pneumonia in his life—and conditions were hard; soon he contracted pleurisy and died there within a few weeks.

[27] Guiette, p. 257.

Max Jacob and the Poetics of Cubism

1. Cubism and Poetry

O F THE MANY PROBLEMS adumbrated in the introduction, none is
more challenging than that of Jacob's cubism. Questions flock to
the mind. What exactly *are* the fundamental attributes of cubism?
Are they not rather to be found in the techniques of painting? If so, how
then can a poet be a cubist? Can one find parallels between the work of
any of the recognized cubist painters and the poems of Jacob, and what
sorts of parallels can they be? Just what is the importance of cubism
after all and in what ways does it manifest its influence? Since the last
question is the easiest to document, it will be discussed first and then
the others treated in inverse order.

If, in the past two decades, the public has tended to forget cubism, its
presence continues to make itself felt and remains undeniable in informed
artistic circles (whether among painters or critics). Critics leave no
doubt about the importance they ascribe to cubism, as witness this state-
ment of Christopher Gray: "In the art of the twentieth century, cubism
occupies a position as important as that of romanticism in the nine-
teenth."[1] Henry Kahnweiler, dealer for the movement from its very

[1] *Cubist Aesthetic Theories* (Baltimore, 1953), p. 3.

inception, has affirmed that there is no contemporary art that "was not anointed with a drop of cubist oil."[2] And Alfred Schmeller has said that, since cubism, "the unity of the artist's medium is broken up for the first time since medieval Gothic."[3]

Cubism's great intrinsic value and the enormous influence it has exerted on later artists are virtually undisputed by present-day critics. But what interests us here is how the poet, Jacob, may have utilized the procedures implicit in cubist paintings, and how he may have as poet and critic incarnated and given voice to certain malaises of the epoch which themselves may have been at the bottom of the cubist mystique.

Cubism and *Le Cornet à dés*

Jacob's *Cornet à dés,* generally considered to be a work of cubist inspiration, appeared in 1917 but we know that most of the poems in it were written or at least conceived between 1903 and 1910. The little *poème en prose* which gives the book its title would seem to bear out much of the criticism that has been addressed to Jacob:

> Vous êtes comme une écumante soupe au lait sous l'aérostat, montagnes, et, de là, sort bientôt, comme d'un gigantesque cornet à dés, le bonhomme globe, le front du Père Double Sphère. (*C. à d.,* p. 62)

> [You are as a foaming pot of boiling milk under the balloon, mountains and from there soon emerges, like a gigantic dicecup, good natured Old Man Globe, the forehead of Father Double Sphere.]

This poem is disturbing from several points of view. First, its optic belongs to a man aboard a balloon leaving the earth, a receding or diminishing optic. As the optic recedes, however, the perceived images become more meaningful: the mountains fade into the globe that is the earth, and the earth becomes that conventional mapmaker's representation, a double sphere. But that double sphere itself takes on a mystic cast, owing largely to the use of personification, *bonhomme,* and *père,* and the capitalization of the last three words.

[2] Quoted by Alfred Schmeller, *Cubism* (New York, n.d.), p. 5.
[3] Ibid., p. 12.

As the optic recedes, the reader seems to have been presented with three consecutive images. The initial one is that of the airship (called here by the quaint name of *aérostat*, which unmistakably dates the entire scene) rising over a chain of mountains shrouded in mist and fog. This vision is notable, contributing to the overall "period piece" quality of the poem, in that it combines man's added—and only recently discovered —dimension of flight as a quasi-magical experience, with flight as one of the technological advances that were transforming the world. In other words, it combines an extreme of the irrational with an extreme of the rational the way scientific discoveries often do.

Gertrude Stein, in her book on Picasso, has touched on this strange phenomenon of the virtually miraculous in science being somehow foreshadowed by the artist's sensitivity.

> When I was in America I for the first time travelled pretty much all the time in an airplane and when I looked at the earth I saw all the lines of cubism made at a time when not any painter had ever gone up in an airplane. I saw there on the earth the mingling lines of Picasso, coming and going, developing and destroying themselves . . . and once more I knew that a creator is contemporary . . . and . . . the twentieth century is a century which sees the earth as no one has ever seen it.[4]

After the first image of the airship over the mountains, the second image is a dynamic or even explosive one, culminating in a dicecup. It proceeds from the first simile which likens the mist-covered peaks to the foamy ebullience of milk boiling over, transforming the coolness and impersonality of the one into the boiling and turbulence of the other. But aside from the literal sense of *soupe au lait*, its very frequent application to an excitable, emotional, easily angered person points toward the humanizing effect of the concluding phrases.

Now that the image of a *soupe au lait* has introduced turbulence into the poetic surface, the syntax takes over the task of further agitating this surface by becoming interrupted and fragmented: *et, de là, sort bientôt, comme,* thus creating unrest. Then appears, as a parallel image to *une écumante soupe au lait, un gigantesque cornet à dés.* This is the second image. It focuses the attention down to a homely object, now expanded,

[4] *Picasso* (London, 1948), p. 50.

however, to titanic, even global proportions: a dicecup big as the earth agitating itself violently up and down and spewing out into space, in that gloriously haphazard way, the universe, human consciousness, and the poem.

The third image is a more tranquil and reassuring one. Syntactically, it is separated from its verb by the interposed clause, and the lack of verbal movement confers upon it a sort of immobility. Moreover, the familiar terms, *bonhomme* and *père,* usually referring to a harmless, little, elderly man (and containing a hint of popular style), act to reduce the foregoing cosmic turbulence to something very anodyne indeed, and then to create a calm and benevolent God-figure. This brings a measure of peace to the scene.

Aside from the overlapping images, language plays a major role in creating these three visions. For example, the first clause, *Vous êtes comme une écumante soupe au lait sous l'aérostat, montagnes,* possesses a rhetorical sweep, with *montagnes,* terminal in the sentence, assuming a vocative quality. The extreme and unnatural (especially as to punctuation) fragmentative effect of the second clause culminates in the cosmic *cornet à dés* tumbling out its planetary dice. When they have come to rest, the language turns suave. The assonance of *bonhomme-globe* and the rhyme of *père-sphère* act in such a way as to make the dice become the two hemispheres of the earth viewed simultaneously but enormously enlarged as if seen through a microscope.

It now becomes clear that the poem has several levels of significance corresponding to a variety of literary techniques. It begins with a quasi-fantastic (at least for the first decade of the twentieth century) image of an airship hovering over mist-clad mountains. But even before this image can be registered by the reader, the *soupe au lait* simile sets it into violent motion. The volcanic dice cup image destroys and supersedes the initial one, and is destroyed and superseded in turn by the third and last *Père Double Sphère.*

When Jacob presents an image, whether airship, mountains, *soupe au lait,* or *cornet à dés,* he hardly gives us time to assimilate it before replacing it with another image. All the images have their counterpart in simple reality (though the airship participates in what the surrealists were to call *le merveilleux quotidien,* and the dice cup has been magnified to titanic size). After this play of images, however, the poem finally

comes to rest on an image which is pure fantasy: the bulbous forehead of "Old Man Earth."

It would appear that Jacob has preferred to destroy all the images based on reality in favor of a final image which is purely fantastic. He employs many fairly subtle techniques to accomplish this. For example, there are three distinct types of diction: sweepingly rhetorical, hesitantly fragmented, and musically "immobile." These three constitute virtually right-angle turns in the line of the poem, as do the three really unrelated images. The agularity of these individual procedures confers a kind of iridescence to the overall poetic texture.

The final *Père Double Sphère* image, though it would appear to be of an essentially symbolic nature, presents a decidedly dual point of view. One is looking simultaneously through a microscope at a pair of dice magnified to cosmic proportions, and through a telescope across stellar reaches of space at the earth, reduced to the size of a pair of dice. Here space has become fluid, and opposites, telescopic and microscopic, are equated with each other. (And after all, might not *père* be a pun on *paire?*)

Jacob exploits this same "rising-from-the earth" theme (more graphically representational though not substantially different from Baudelaire's "Any where out of the world") twice in the *Cornet à dés*, exhibiting in both cases elements of a mystical and religious, as well perhaps as of a sexual, preoccupation.

COSMOGONIE

Dieu par son tonneau (il y a un Dieu) regarde la terre! il la verra comme quelques dents cariées. Mon oeil est Dieu! mon oeil est Dieu! Les dents cariées ont comme une goutte infiniment petite qui les classe. Mon coeur est le tonneau de Dieu! mon coeur est le tonneau! l'univers pour moi est comme pour Dieu. (*C. à d.*, p. 192)

[COSMOGONY

God through his barrel (there is a God) looks at the earth. He probably sees it as several rotten teeth. My eye is God! The rotten teeth have something of an infinitely small drop which classifies them. My heart is God's barrel. The universe is for me as it is for God.]

In this *poème en prose* (with its overtones of Diogenes and his barrel), Jacob is quite specific about identifying God with spatial elevation, while *tonneau*, by its cylindrical form, unmistakably reminds us of the *aérostat*.

Jacob implies a contrast in nearly everything he writes between the baseness of all that partakes of the terrestrial, such as rotten teeth, and the purity and detachment (quite literal in this case) of the Godhead. Those who participate in this latter are able, by their faith and God's grace, to raise themselves above the human condition and to soar in the rarefied, quasi-celestial atmosphere of beatitude, analogous to the soaring of the *aérostat*.

Syntactically, the poem exhibits the same choppy, intermittent sequences as the previous one. That one begins with what is probably meant to be the voice of God addressing the mountains. This one begins with God's being named, and the initial naming of God deprives the poem of its impact because the immanence of God should correctly be the terminal word, that is, the end and final aspiration for the declared mystic and not a point of departure. *Tonneau*, simultaneously conjuring up both Diogenes and the previous *aérostat*, interpolates itself between the subject and verb, logically expected but delayed.

The interjection within parentheses, *il y a un Dieu*, inappropriately pietistic and thereby droll in this context, further delays the verb from completing the action. Finally the verb and its object, *la terre*, finish the sentence, depicting much the same scene as was found in the earlier poem: a lofty consciousness looking down at the earth from a great height. The same type of homely image is used to give the reader a relative idea of the enormous distance, the earth seen as a pair of dice (white with black dots) or rotten teeth, which one could well imagine to resemble the dice in this particular.

At this point, Jacob cries out emotionally the oneness of his vision and of God. Then he returns to his original theme only to abandon it again in favor of another impassioned declaration of oneness in which he seems to have relinquished his entire being to be one with God, symbolized by the man's heart becoming the support and dwelling place and the instrument of vision of the Deity, a fairly standard example of mystical effusion. At the end, the transposition has been effected and he sees the universe through God's eye.

One may discern purely linguistic manipulations in this passage: the manner in which the [ɛr] element of the noun *terre* has as its echo the first syllable of *verra* (there is no apparent temporal reason for the future tense); the word *oeil* of which *Dieu* suggests the plural *d'yeux;* the repetitious thrumming of the word *comme,* plus a certain alliteration: *comme, quelques, cariées, classe, coeur,* all of these contributing to the verbal music, which in turn creates a hypnotic effect.

A few pages later, Jacob presents the reader with another poem in which these elements appear again, but somehow as if negatively transfigured.

Dégénérescence Supérieure

Le ballon monte, il est brillant et porte un point plus brillant encore. Ni le soleil oblique qui jette un éclair comme un mauvais monstre jette un sort, ni les cris de la foule, rien ne l'empêchera de monter! non! le ciel et lui ne sont qu'une seule âme: le ciel ne s'ouvre que pour lui. Mais, ô ballon, prends garde! des ombres dans ta nacelle remuent, ô ballon malheureux! les aéronautes sont ivres. (*C. à d.*, p. 199)

[Superior Degeneration

The balloon rises; it is shining and carries an even more shining point. Neither the oblique sun which casts its flashing rays as an evil monster casts a spell, nor the shouts of the crowd, nothing will stop it from rising! No! The heavens and it are but one single soul: the heavens open only to receive it. But oh balloon, take care. Shadows in your gondola are moving, oh unhappy balloon! The aeronauts are drunk.]

In this poem, one finds the *aérostat* quite literally represented though referred to by a more generic term, *ballon.* Jacob depicts it as a bright sphere gleaming like a planet in the nearly horizontal rays of a waning afternoon sun. It must be noted that this is the time of day when objects receive striking illumination from a lateral angle without receiving heat, to be contrasted with the overhead sun of noon which, while radiating great heat, never directly illuminates that plane that the human eye gazes upon, a notion possibly symbolizing the cold lucidity of the intelligence in contrast to the blind heat of the passions.

The balanced negative statement, *ni le soleil . . . ni les cris,* combines a kind of sympathetic magic with a measure of negative suggestion to urge

the balloon upward. Other declarations such as *rien ne l'empêchera de monter! non! le ciel et lui ne sont qu'une seule âme: le ciel ne s'ouvre que pour lui* reinforce the inevitability of the balloon's flight, like a boy murmuring encouragement to himself while trying to fly a kite.

But an instant later, their vehemence begins to produce the opposite effect. Starting with the ominous warning, *ô ballon, prends garde! des ombres dans ta nacelle remuent* gives us an intimation of imminent failure. The second *ô ballon* with *malheureux* added to it this time already acknowledges defeat, the reasons for which are presumably given in the very last clause, for *les aéronautes sont ivres*. Instead of rising steadily to a victorious climax, the line of the poem curves ultimately downward like the balloon in its dying fall. Yet the fall is only implied and the poem ends on that note of immobility already familiar to readers of Jacob.

In spite of the fact that the balloon does not reappear as such in any of Jacob's other works, a shining sphere with its sharp peak reflecting the light occurs in the *Matorel* (p. 17), as we shall see. In this passage, Matorel's belly is described as a pumpkin and then likened to a *montagne d'or* with, as Matorel says, its *corne en obélisque*.

It is difficult to escape the sexual implications of this particular combination of images and not see in it a round belly with a penis projecting from it. *Nacelle*, in this context suggests a scrotum. There is even some verbal interplay between *oblique* and *obélisque*. It becomes likely then that these passages and therefore these images are related and that, even from so premature and scanty a *rapprochement*, the *aérostat-ballon* image can be seen to contain sexual overtones, as does nearly everything else Jacob wrote.

The rather desperate and ultimately vain efforts to keep the balloon off the ground could well represent the attempt to attain or sustain erection with, as we have seen, the final outcome symbolizing the drama of impotence. Impotence, since it is widely believed to be a symptom of homosexuality, could very well have afflicted Jacob himself and, in this series of poems (as well as in other contexts, as will also be shown presently), is equated by Jacob with failure in rising to the beatified state; that is, a failure in achieving erection is analogous to failure in achieving salvation, as if sexual fulfillment were a kind of Paradise.

Now that we have examined the "balloon" image-complex as it relates to the "pumpkin-golden mountain" image, and have drawn some con-

clusions about its sexual referent, we may now leave it to undertake the analysis of another and more complicated example of Jacob's poetic technique. The extreme turbulence, the constant shifting of images, the incessant play on words, the plurality of emotional level have all served to indicate a dynamic poetic creation. In the next poem, we shall discover a flatter surface of jumbled patterns like that of a mosaic, but a mosaic in action.

Omnia Vanitas

Ce ne sont pas les roses d'un champ, ce sont les visages de ses admirateurs. La selle de son cheval est une peau de tigre, les Japonaises habillées d'un seul trait de plume portent des godets bien propres et le soleil est changé en arbre, mais voilà que la selle du cheval s'allonge et griffe toutes les roses et le cheval et les Japonaises et tout disparaît, et cette hydre même n'est plus qu'une peau de tigre pour le dénudé cavalier qui n'est plus qu'un vieillard en prières et en sanglots. Le trait de plume des Japonaises s'est fondu dans l'arbre; il ne reste plus que les godets sur la peau de tigre. (*C. à d.*, p. 216)

Omnia Vanitas

[Those are not the roses of a field; those are the faces of his admirers. The saddle of his horse is a tiger skin, the Japanese ladies dressed in a single pen stroke are carrying very clean mugs and the sun is changed into a tree. But look here! The horse's saddle stretches out and claws all the roses and the horse and the Japanese ladies and everything disappears; and the hydra itself is no longer anything more than a tiger skin for the destitute horseman who is no longer anything more than an elderly man praying and sobbing. The pen stroke of the Japanese ladies has melted into the tree. All that is left are the mugs on the tiger skin.]

Like the poems previously examined, this one demonstrates the destruction of images by a system of metamorphosing one image into the other but without sweep. "Roses" are suddenly "faces of admirers," the "horse's saddle" turns into a "tiger skin," the "sun" changes into a "tree." When the "tiger skin" becomes a *real* tiger, as is implied, it destroys all the previous pairs of images and indeed the entire tableau, turns into a "hydra," turns back into a tiger "*skin*" for the "horseman," now an "old man sobbing and praying," and the "Japanese ladies" (who, after all, were no more than a "stroke of the pen") fade into a "tree." The reader

is left with a highly complicated, nearly *pointilliste* tableau, one whose *points* have become magnified and taken on an independent identity and life of their own. There is relatively little of the verbal volatility that marks much of Jacob's work except the assonance of *tigre-hydre* fortified by the voiced stop plus the liquid in both cases, and possibly the [ɔ]'s of *portent-propre* with the reversed R's and voiceless stops.

Prières et sanglots refers to the author's conversion; *les Japonaises* alludes to the vogue for Japanese drawing, which, several decades past its peak with the Goncourt and Lautrec, was still very much alive. Other referents remain obscure and we are left with the uneasy sensation of being unable to relate them to anything tangible. The final image is especially difficult. One wonders what *les godets sur la peau de tigre* could have had as their real-life counterpart. Perhaps it was only some everyday object disfigured through the half-light of a dingy room or through the haze of alcohol or narcotics and which the poet resolutely declines to identify for us. Or it could have been some purely imaginary, personal image filtered through too many layers of consciousness to be readily identifiable, even by the poet.

In the throes of this probing of the "unconscious," Jacob seems entirely conscious himself, or at least deliberate. He is obviously striving for a fundamentally new type of vision and an appropriate way to exteriorize that vision, a new type of intelligible experience in art. He says: "L'Art est la volonté de s'extérioriser par des moyens choisis . . . car l'œuvre d'art n'est qu'un ensemble de moyens." ("Pet. hist.," p. 15) [Art is the will to exteriorize one's self by chosen means . . . because the work of art is only an ensemble of means.] This definition in no way attempts to explain or justify the bizarreness of his chosen images. There remains, after all, that dazzlingly close link between vision and expression, where the one seems to have turned instantaneously and naturally into the other.

Cubist Poetics

We have set ourselves the task of tracing, insofar as is possible, the parallel lines between forms of cubism as they might have been practiced in differing art media:

> The cubist doctrines, it must be admitted, were on the whole more than a little confusing. Among themselves the exponents of these

doctrines showed considerable divergencies of temperament and out-look. Moreover, as certain of the most gifted cubist painters were not in the least inclined to metaphysical speculation, they were only too glad to have a Guillaume Apollinaire or a Max Jacob refer to their work with undoubtedly brilliant, though rather fantastic arguments.[5]

No easy task as is plain to see. The painters generally conceded to be cubist, Picasso, Braque, Gris, and later Gleizes, Metzinger, and Léger, most of them living in and around the rue Ravignan (Picasso sharing Jacob's room for a time), left no definitive manifesto.

The first poem from the *Cornet à dés* in which Jacob actually mentions cubism is the following:

Cubisme et soleils noyes

L'eglisiglia del Amore, l'odore del Tarquino, bref, tous les monu-ments de Rome sur une *bouteglia* de vin et le registre correspondant pour démontrer qu'on en a bu copieusement, mais qu'on s'abstiendra: le godet du goulot et la goulette du goût d'eau. S'il faut s'en repentir, autant s'en abstenir. L'arc-en-ciel volatil n'est pas plus qu'une décora-tion volcanique à l'angle de l'étiquette. Motus! et comparons un litre avec l'autre: *el spatio del Baccio et l'Bacco nel cor.* (*C. à d.*, p. 84)

[Cubism and Drowned Suns

L'eglisiglia del Amore, l'odore del Tarquino, in short, all the monuments of Rome in a *bouteglia* of wine and the corresponding bill to show that we have drunk copiously but that we will in the future abstain: the mug of the bottle's neck and the *goulette* of the drop of water. If we must repent, it is just as well to abstain. The volatile rainbow is no more than a volcanic decoration on the corner of the label. Mum's the word and let us compare one liter with another: *el spatio del Baccio et l'Bacco nel cor.*]

Some of the obscure elements of this poem may be explained by reference to a brief holiday Jacob had spent in Italy. Here he is making the Frenchman's classic jokes about the orthography of cognate words which varies from French to Italian. The most obvious of these is between the French palatalized L and the Italian orthography for rendering a

[5] Georges Lemaître, *From Cubism to Surrealism in French Literature* (Cam-bridge, 1941), p. 79.

similar sound: -GL-. *Egli* exists as a common word in Italian, though one would suspect that Jacob and his companions encountered the word *bottiglia* (grotesquely altered here) even more frequently. The model for this mispronunciation was very probably the name of Modigliani whom they already knew as one of their group and whose name they *did* pronounce *à la française,* that is, Mo-dig-lia-*ni.*

Jacob plays the same interlingual nonsense word game at the end of the poem, making an even more grotesque pun which probably means: the size of the kiss equals (the size of) Bacchus in one's heart. The rest of the poem probably refers to their drinking more wine than they could afford and then wishing they had not. Jacob, with his love for paradox and his religious preoccupations, points out the contradiction between repentance and not abstaining in the first place. Of course, the labels on Italian wine bottles, in contrast to French ones, are occasionally colorful and apt to be overloaded with tiny representations of famous monuments or decorated with rainbows, suns, and stars.

But it would seem that the nucleus of the poem is in that preposterous play on words, *le godet du goulot et la goulette du goût d'eau,* which brings *godet* back as a figure and introduces the nonsense word *goulette.* It is entirely possible that this little group of words occurred to Jacob and that he built up the poem around them with suitable nonsense elements. He probably chose the title as a double element joke implying that both the cubist comrades and the sun depicted on the bottle were finally drowned in wine. But his recognition of the existence of a cubist movement is evident although here he may be practicing it and mocking it at the same time.

Still another poem from this series in which Jacob mentions cubism is this one:

PORTRAITS PEU FLATTEURS

Le sujet de concours donné par mon frère à ses frères est l'image du Christ en croix. Le plus jeune s'attire ces mots: "Oh! quelle anatomie!" Je sors des Christ cubistes avec membres tombant à terre d'une hauteur de trois mètres: "Max a étudié son anatomie hier!" me dit-on. Le goût me vient de regarder les dictionnaires illustrés: j'y vois au moins vingt sortes de croix, les unes doubles, les autres triples, les autres renversées. Le Christ en gloire sur l'une, autrement ailleurs. Il y a aussi des Pieds colossaux: *pieds de pierre provenant*

du Christ du village d'O . . . Pourtant il n'y eut qu'un Christ: Laquelle a-t-il choisie de ces images? (*C. à d.*, p. 219)

[PORTRAITS THAT ARE ONLY SLIGHTLY FLATTERING

The subject of a contest given by my brother to his brothers is the image of Christ on the Cross. The youngest gets these words: "Oh, what an anatomy." I turn out cubist Christs with their limbs falling to the ground from a height of ten feet. "Max studied his anatomy yesterday," they tell me. The desire to look into illustrated dictionaries comes upon me: I see at least twenty sorts of crosses, some double, others triple, others upside down. Christ is in glory on one, otherwise elsewhere. There is also a pair of *collossal stone feet from the Christ* of the village of O . . . And yet there was only one Christ. Which of these illustrations did he choose?]

Here again, there is the same succession of images without transition, the same kaleidoscopic reeling from focal plane to focal plane, the same religiosity, the same mildly disrespectful humor, the same word play, the same underlying humdrum setting, and a kind of immobility at the end. This extreme plurality of consciousness would seem finally to neutralize the reality of the image, to attenuate the horror of the crucifixion, to equate the Calvary to *ces images*. The colossal stone feet of the village Christ are probably a reference to some statue in Brittany since he makes frequent allusions to this, his native province.

Jacob often used such a shifting of appearances for dramatic or comic effect. In a letter to Guillaume Apollinaire, written during a trip to Spain in the company of Picasso, Jacob achieves a humorous tone in describing Spain.

Le paysage dans ce pays a moins d'importance que les villes, et les villes moins que les gens, et les gens moins que leur costumes, de même que les maisons ont moins d'importance que les balcons et les balcons moins que les stores.[6]

[The countryside in these countries has less importance than the cities, and the cities less than the people, and the people less than their costumes; just as the houses have less importance than the balconies and the balconies less than the blinds.]

[6] Letter to Guillaume Apollinaire, quoted by André Billy, *Max Jacob* (Paris, 1946), p. 69.

13 CUBISM AND POETRY

Jacob here operates a diminution of focus so that the focus slides from the larger external object to the smaller, closer one. There occurs at the same time a corresponding intensification of meaning, from the external and banal to the internal and subtle. For the uninitiate the countryside and the cities present the greatest interest to the traveler, while for the sensitive observer the colorful costumes and drawn blinds are much more revelatory of the true Spanish character. So that, in spite of a diminution of size and a dilution of obvious meaning, these latter features participate in a closely-perceived higher reality.

Thus far, we have been able to observe a fundamental negative or destructive pattern. From the initial image, there occurs a sort of progression. As one image disintegrates—"mist covered mountains" or the "Spanish countryside"—another springs from it—a *cornet à dés* or "Spanish cities"—and replaces it. And as these images grow one out of the other, the poem takes on greater depth and power. Jacob often uses another technique for multiplying images: he simply sweeps a field of observation, as it were, in a lateral movement, illuminating successively a series of ostensibly unrelated images as he has done in "Omnia Vanitas."

Now either or both of these techniques create a near simultaneity of vision on the esthetic plane, that is, in the tension of the poem. But Jacob practiced this also on the simple literal plane as well. In the *Cabinet noir*, he purports to publish a series of letters, purloined or otherwise obtained from their rightful owners. Each letter is followed by a penetrating *commentaire* of the worldly editor who, from his privileged position, bursts the bubble of subterfuge and pretentiousness of the letter writers. One such *commentaire* declares:

> Entre parenthèses, toutes les fois qu'on touche à l'histoire de près ou de loin, il y a matière à réflexions. (*Cab. noir*, p. 63)

> [Parenthetically, each time that one comes into either close or distant contact with this story, there is material for reflection.]

There follows a *1re réflexion*, three pages in length; then, while the reader holds his judgment in abeyance waiting to aggregate the first reflection to those which may follow, Jacob presents: *2me réflexion: . . . il n'y a pas eu de 2me réflexion.* This constitutes a rather unsubtle simultaneity by

contradiction, that is, actually announcing a reflection which he then refuses to deliver up to the reader.

In the letter to Guillaume Apollinaire, quoted earlier, Jacob presents still another example of this contradictory spirit.

> Il paraît que la foule hurlante des arènes crie aux combattants des mots très spirituels, mais comme je ne les comprenais pas, ils n'ont pas réussi à m'égayer.[7]

> [It appears that the screaming crowd of the arena shouts very witty things to the combatants but, since I couldn't understand them, they didn't succeed in amusing me.]

And in just such another letter:

> Le café n'y est pas buvable, c'est peut-être pourquoi je n'en bois pas. Il paraît que les montagnes embaument le thym, la rosée, la lavande, et le romarin, je n'y vais pas.[8]

> [The coffee is not drinkable there; that's perhaps why I don't drink it. It seems that the mountains are fragrant with thyme, dew, lavender, and rosemary; I don't go up there.]

It is interesting to note that these last examples do not come from a work of literature but represent the manner in which Jacob expressed himself when he was writing informally to friends. He was capable of doing more than simply posing members of contradictions in an obvious way, however; contradictions form the veritable tissue of one of the *poèmes en prose* from the *Cornet à dés*.

Encore le roman feuilleton

Robert s'appelait plutôt Hippolyte. Il eût été habillé à la dernière mode, s'il y avait eu une dernière mode, mais il n'y a pas de dernière mode; alors, il était habillé comme tout le monde, c'est-à-dire mal. . . .

Robert s'installa à table et mangea comme il n'avait pas mangé depuis longtemps, c'est dire qu'il mangea peu, car il mangeait toujours beaucoup. . . . S'il eût eu quelque tâche, il n'eût pas su s'en tirer,

[7] Ibid., p. 69.
[8] Ibid., p. 70.

aussi n'en prenait-il pas. Robert ne faisait rien, ce qui vaut mieux que de faire mal, et ceci ne l'empêchait pas de mal faire. . . . (*C. à d.,* p. 124)

[ONE MORE NEWSPAPER SERIAL

Robert's name was really Hippolyte. He would have been dressed in the latest style had there been a latest style but there is no latest style; so he was dressed like everybody else. That is to say: badly.

Robert sat down at a table and ate as he had not eaten for a long time. That is, he ate very little because he always ate a lot. . . . If he had had some task, he would not have known how to do it properly; he therefore never undertook any. Robert did nothing which is better than doing harm and this did not prevent him from doing badly.]

This excerpt shows more than a destruction of images. What Jacob does here is to parade before our eyes a number of proverbial turns of phrase, commonplaces of the popular vocabulary, or well-worn clichés, only to block them at every step. The reader feels the destructive pattern seeping over into social criticism. The old-fashioned name, Hippolyte, is possibly suggested by Taine whose bombastic style and literal-minded ideas made him a source of intense merriment to the young cubists in general and to Jacob in particular who lampooned him mercilessly.

Hippolyte might also sound an echo of Racine's *Phèdre.* Jacob loved to parody the dignity and formality of classical tragedy and would declaim long passages, taking all the parts, for his convulsed comrades. His humorous intent is unmistakable here in *dernière mode,* along with *habillé comme tout le monde, comme il n'avait pas mangé depuis long-temps,* the repetition of the pluperfect subjunctive, and the sententious *faire mal* and *mal faire,* all of which lend a stuffy nineteenth-century air.

Jacob's dual vision becomes explicit here in that he presents both the *idées reçues* as well as their refutation at each step in the unfolding of the poem. Like his friends, the cubist painters, however, he was not always so explicit in allowing the reader (or beholder) to grasp both aspects of the dual vision. We find, for example, the following in a poem entitled "Le Chevalier de la Barre."

'Ce garçon-là a des livr'-z-anarchistes,'
Dit un évêque avec indignation,
'J'en fais serment, m'sieur l'chef de la police

Il nous prépare un' grande Révolution. . . .
Il n'salue pas quand passent nos bannières
Il chant' sur Dieu des refrains inconv'nants.

—Pour ce méfait tout supplice est trop tendre
Coupez ses bras, arrachez-lui l'gosier
Brûlez-le tout et dispersez les cendres' (*St. Mat.*, p. 223).

["That young man there has anarchist books,"
Says a bishop with indignation.
"I swear to it, Mr. Police Chief,
He's preparing a great revolution for us. . . .
He doesn't salute when our banners pass by,
He sings disrespectful couplets about God.

For this crime any torture is lenient:
Cut off his arms, tear out his throat.
Burn him all up and scatter the ashes."]

Marcel Raymond tells us that Jacob "se plaît à mimer les gestes du bon sens bourgeois et à répéter avec un tour de voix inimitable des idées reçues ou des propos d'une sentimentalité banale" [enjoys imitating the gestures of bourgeois common sense and repeating with an inimitable inflection *idées reçues* or statements of a banal sentimentality].[9] It is not *entirely* obvious here, however, given the violence of Jacob's conversion and his desire to appear orthodox, that he is jesting. Or let us say that, as with his Breton "romances" and his *flonflon* lyrics, the reader can never be sure just how far the parody extends and how real Jacob's empathy for one or another of the contradictory elements is.

Thus far, we have seen demonstrated a duality—one is tempted to say a duplicity—of vision on three planes: (1) the esthetic, as in the poem about the dicecup where fantastic images seem to come bounding out of one another; (2) the representational, as in "Omnia Vanitas" where various real objects or persons are named in a juxtaposition contrary to reality; and (3) the literal, as in the letter to Apollinaire or in "Encore le roman feuilleton" where rational propositions are systematically negated. Jacob plays this game on still another plane: the purely verbal.

In the poem entitled "Roman feuilleton," he writes:

[9] *De Baudelaire* (Paris, 1947), p. 225.

Donc, une auto s'arrêta devant l'hôtel à Chartres. Savior qui était dans cet [sic] auto, devant cet hôtel, si c'était Toto, si c'était Totel, voilà ce que vous voudriez savoir, mais vous ne le saurez jamais. (*C. à d.*, p. 89)

[So, an auto stopped in front of the hotel in Chartres. Who was in that auto in front of that hotel, whether it was Toto, whether it was Totel, that's what you'd like to know but you will never know it.]

The T is repeated no less than fifteen times and the S sixteen before the poem disperses itself into that patent evasion: *vous ne le saurez jamais.* The main purpose of such repetition would seem to be to mock the "correct" sound of elision. That is, popular speech usually eliminates all optional elision so that when an uneducated speaker wishes to give himself airs, he often resorts to *pataquès,* that is, the making of elisions where there are no elisions of the type of *quatre-z-yeux.*

Another poem from the *Cornet à dés* demonstrates Jacob's prodigious facility at juggling like sound patterns, sometimes at the beginning, sometimes in the middle, and sometimes at the end of words, into several different words:

Le toit, c'est quatre, quatre, quatre: il y en a quatre. Le perron est une pelouse que nous opérons et qui les jalouse. Les toits sont amarante: reflet d'orage! rage! rage! et l'ensemble est en sucre, en stuc, en ruche, moche, riche. (*C. à d.*, p. 63)

[The roof is four, four, four: there are four of them. The steps are a lawn which we operate and which makes them jealous. The rooves are amaranth, reflection of the storm, rage, rage, and the whole is of sugar, stucco, like a hive, shoddy, rich.]

For example, *perron* gives the last two syllables of *opérons* while the -*louse* of *pelouse* finds itself repeated in the last syllable of *jalouse.* There is an amusing dissolution of -*ucre* to -*uc* to -*uche,* which represents a systematic downgrading, and then the slangy *moche* plus *riche,* which repeat the -*che* and which suggest a sumptuous house in poor taste.

The most celebrated example of Jacob's playing with words, and one which was repeated far and wide at the time, is this:

Comme un bateau est le poète âgé

ainsi qu'un dahlia, le poème étagé
Dahlia! Dahlia! que Dalila lia. (*C. à d.*, p. 60)

[The aged poet is like a boat
The tiered poem is like a dahlia
Dahlia, Dahlia that Delilah tied together.]

As Jacob exploits the device of punning in this instance, one might venture to call it *trompe l'oreille.* It is worth analyzing carefully.

Jacob begins with three probable allusions. The first is to the Bateau Lavoir where they all lived. The second, though brief and veiled, is to Rimbaud's "Bateau ivre," a poem which describes a boat floating through a series of hallucinatory vicissitudes. These vicissitudes might be likened to a man passing through the experiences of life. Because of Rimbaud's extreme youth (he was only seventeen when he wrote the poem), and the fact that Jacob actually knew and frequented the aging Verlaine, then in the last stages of physical and mental decay, the third allusion is perhaps to that association between *bateau* and the *poète âgé.*

The syllables *-ète âge* could easily call forth *étagé* as a logical description of the poetic structure. *Poème,* in turn, is partially suggested by the sound of *poète,* and partially by the need for a progressive creative development, that is, from *poète* to *poème.* Nor is it difficult to understand the analogy between the expanding expression of a short poem around a central theme or image, and the dahlia spreading outward from its center.

The second statement asserts that the tiered poem is just like a dahlia. But then abandoning this image, Jacob suddenly gives in to a senseless desire for repetition and simply reiterates: *Dahlia! dahlia! Dalila* obviously derives from this; and from *dahlia* to *Dalila* to *lia* is just a series of short steps.

Since these words are of foreign origin—*dahlia* from the name of a Swedish botanist, and *Dalila* from the Hebrew—and the *passé simple, lia,* is normally never heard in conversation and therefore has an unfamiliar ring, the phrase: *Dahlia! dahlia! que Dalila lia,* at first appears to be no more than a string of nonsense syllables. Upon an instant's reflection, however, these syllables separate into words to assume an objective meaning of the simplest kind. And the reader is left with a vision of Delilah binding dahlias into bunches perhaps, and the successive verses of the poem resemble the tiers of petals of a puffy flower.

II. Cubism and Painting

MARCEL RAYMOND SAYS of cubist poetry:

> Le propre de cette poésie, que l'on a souvent dénommée cubiste
> —pour marquer ses affinités avec la peinture d'un Picasso—est
> d'être protéiforme et quasi-insaisissable. Le mieux est de mettre en
> lumière quelques-uns des aspects de ces pseudo-cubistes et d'indiquer
> une ou deux des routes qu'ils ont ouvertes à l'activité effervescente
> d'une nouvelle jeunesse.[1]

[The essence of this poetry which has often been called cubist—to
mark its affinity with the painting of a Picasso—is that it is protean
and virtually inaccessible. The best thing is to bring to light a few
elements of these pseudo-cubists and to trace one or two of the routes
that they have opened to the effervescent activity of a new generation.]

In other words, for Raymond, there exists only the most tenuous connec-
tion between the painting of a Picasso and that poetry which he char-
acterizes as "protean and virtually inaccessible."

It is the thesis of this book, on the contrary, that precise relationships

[1] *De Baudelaire* (Paris, 1947), p. 253.

and valid correspondences may be established between actual paintings of recognized and accepted cubist inspiration and the poetic productions of Max Jacob, such as those we have examined thus far. To demonstrate this, it is first indispensable to look at some of the writing devoted to analyzing and interpreting cubist painting. It will be well to avoid, at least in this study of the precise rapport between cubist painting and Jacob's poetry, those critics and cubist writers who have limited themselves merely to setting down their *impressions* of cubism.

Before approaching what Winthrop Judkins[2] calls the "specific and irreducible aspects" of cubist technique and attempting to ascertain the extent of their application to poetry, a few loose ends must be tied up, questions having mainly to do with painting but which again may be shown to possess literary ramifications. But first a word of warning: this study does not pretend to concern itself primarily with a highly specialized analysis of painting techniques but rather with the general tendencies of cubism which may be shown to have parallels in literature, and which often tend to persist throughout cubist development of various periods.

Theories of Cubism

Cubist painting is considered by common agreement to have passed through three stages: (1) facet or analytic or, as it is sometimes called, functional (1905–9), (2) hermetic (1909–11), and (3) synthetic (1911–20). Each of these stages is characterized by distinctive aims and procedures. Analytic cubism, the easiest to define and consequently the one upon which the critics find themselves most in agreement, is marked by a rejection of conventional reality in favor of a "truer" and more "appropriate" reality and a vigorous resolution to accomplish this by conscious and deliberate means.

Christopher Gray has isolated "the most basic characteristic of the earliest phase of cubism as a return to realism,"[3] but to a new and unconventional realism, and he cites the examples of André Salmon, Gleize and Metzinger, and Juan Gris. Gris himself has explained this return as

[2] Winthrop Judkins, "Toward a Reinterpretation of Cubism," *The Art Bulletin*, XXX, no. 4 (1948), p. 270.

[3] *Cubist Aesthetic Theories* (Baltimore, 1953), pp. 44–45.

a "way of natural reaction against the fugitive elements employed by the impressionists,"[4] amounting, as Gray adds, "to a new approach to the problem of form, for it was form which had been neglected by the impressionists in their attempt to reduce all reality into the phenomena of the senses produced by light."[5]

Gris states that "in the beginning, cubism was a sort of analysis"[6] and Gray continues, "analysis implies the use of logic to interpret the significance of raw sensation."[7] The majority of the explications to follow, and especially those of Judkins, from which will be drawn the analogies with Jacob's poetic procedures, deal with manifestations of this first or analytical phase.

The second or hermetic phase of cubism, according to André Salmon, one of the more authoritative spokesmen for the movement, imposed the need for "making concrete the abstract and reducing [the] concrete to the essential," as well as for looking at the object "from all sides at once,"[8] in order to give the "totality of the thing as it appears to the intelligence. . . . The new art, then, was to deal with the intellectual concepts of things and not the ephemeral sensations."[9]

Christopher Gray has called this a "representation of the dynamism of Nature, [the] creation of a new view of reality" and lists three ways in which it was accomplished: (1) the idea of "moving around an object to seize several successive appearances, which, fused in a single image, reconstitute it in time," (2) the idea that "form and color are so inextricably intertwined that neither can be complete without the careful control of the other," and (3) "the rejection of the human element in art."[10]

A third or synthetic stage may also be distinguished in which "cubism enters a phase of calm and clarification." The picture is no longer split apart but summarized, becoming a "newly created esthetic object in itself."[11] The object is intertwined with its own form, or, as Gris has

[4] Henry Kahnweiler, *Juan Gris* (Paris, 1946), p. 145.
[5] *Cubist Aesthetic Theories,* p. 45.
[6] Quoted by Kahnweiler, *Gris,* p. 145.
[7] *Cubist Aesthetic Theories,* p. 45.
[8] *La Jeune Peinture française* (Paris, 1912), p. 42.
[9] Gray, *Cubist Aesthetic Theories,* pp. 56–57.
[10] Ibid., pp. 86, 88, 90.
[11] Alfred Schmeller, *Cubism* (New York, n.d.), p. 12.

expressed it, "the analysis of yesterday has become a synthesis by the expression of the relationships between the objects themselves."[12] At the end of this section devoted to tracing parallels between cubist procedures in painting and poetry, synthetic cubism will be taken up again in relation to some of Jacob's last poems.

Judkins warns that "the proportion of that literature which has specifically come to grips with the actual bones and marrow of these paintings is surprisingly small." He then presents a brief compendium and digest of the "existing literature on this primary phase of the subject."[13] If we now take Judkins' summary and compare it with the observed phenomena we have been able to isolate from a reading of Jacob's poetry, what general conclusions may we draw?

The first attribute of cubism that Judkins distinguishes, "the liberty taken by the artist in pulling his objects to pieces and then rebuilding them into an independent composition,"[14] breaks down into *two* processes: (1) the tearing down or tearing apart of the image; and (2) the rebuilding of the elements of that image into an independent composition. We have encountered the relentless and systematic destruction of the visual image in every example of Jacob's writings examined thus far. Sometimes Jacob effects this by allowing the images to grow one out of the other; sometimes by a reeling focus or by parading before us a succession of unrelated images; and sometimes by persistent contradiction on several planes.

As for the "rebuilding into an independent composition," this too Jacob has done with much facility. We have seen how each poem appears at first reading to be a kind of chaos of images, an interruption of continuity of outline, a disturbance of uniformity of local tone (as these features are understood in the "normal" rendering of an object—whence the "destruction"). But then the poem takes on a character and quality all its own, building up a mysterious tension and finally leaving the

[12] Kahnweiler, *Gris*, pp. 42–45.

[13] Judkins, p. 270; see also two capital books published since Judkins' study, the first primarily concerned with the historical aspects of cubism, the second with the esthetic: John Golding, *Cubism* (New York, 1959); and Edward F. Fry, *Cubism* (London, 1961).

[14] Ibid., p. 270.

reader with a distinct, even a unique poetic impression which constitutes its unmistakable identity and singular charm.

Judkins' second point is "a placing side by side . . . of views of objects or parts of objects taken from an unrestricted range of observation points."[15] This is substantially the deliberate reeling focus encountered in Jacob and caused, not only by its own sweep of "the unrestricted field of objects," *but also by a lack of any firm or stable base from which the observer may depart.* Jacob practices this double shifting of base and object at many levels. We have already seen its application in the tableau where the "Japanese ladies" turned into a "tree," a "tiger skin" changed into a real tiger and then into a "hydra," and so on; in other words, a tableau where a single object assumes many identities according to the vantage point of the observer. All these images are often none other than facets of a single familiar object seen from varying angles.

For Judkins, these three foregoing aspects of cubism are all part of one single principle and actually constitute one half of the cubist esthetic. The "second" principle, for him, is "the return to preeminence of the two dimensional composition on the flat surface within the enframement."[16] This concept, essentially applicable to visual perception, has been quite widely accepted. We find Barr speaking of "an emphasis not upon the reality of the objects but upon the reality of the painted surface,"[17] substantially the same idea.

Still another critic, J. J. Sweeney, expresses a nearly identical idea in these words:

> The representation within the picture-space no longer attempted to simulate a slice of the world of nature. It became now aggressively an object to be considered for itself—a plastic organization of forms suggested by line and color on a flat surface.[18]

It is clear that the perception of the artistic creation did not extend outside the limits of that creation itself, did not "recede behind the surface of the picture much like any view seen through the enframement of a window,"[19] but was concentrated in the self-contained esthetic structure.

[15] Ibid., p. 270.
[16] Ibid., p. 270.
[17] A. H. Barr, Jr., *Cubism and Abstract Art* (New York, 1936), p. 78.
[18] *Plastic Redirections in Twentieth Century Painting* (Chicago, 1934), p. 28.
[19] Judkins, "Toward a Reinterpretation of Cubism," p. 270.

Are these concepts basic to painting adaptable to cubist poetry? If we look at what we have read of Jacob, we will see that the wholesale destruction of the subject (in poetry, the realistic image) and along with it the wholesale destruction of conventional reality have tended to concentrate the esthetic attention, *not* on that everyday reality, but almost exclusively on the mysterious elusive tissue of the poem, a process analogous to the abandonment of realistic portrayal and the shift of emphasis to the painted canvas or esthetic object.

When the art critic speaks of plastic elements, we must substitute visual elements, and when he speaks of painted surface, verbal coherence, in order to transpose the concepts from one medium to the other. Enframement and the two-dimensional composition are very suggestive concepts for understanding the structure of Jacob's short and limited poetic focus. As with the painters, the programmatic content has ceased to be important, and again like the painters, Jacob has ceased to use conventional procedures to attempt to portray an external image. On the contrary, he employs, in much the same manner as Picasso, Braque, or Gris, non- or anti-esthetic means (understood from the traditional viewpoint of a not-too-distant past) to create an *esthetic* surface.

Duality, plurality, and simultaneity of vision are the tools Jacob has used to demolish the everyday world and also to build up a new world, a world of art. That is, cubism demonstrates a curious antithetical tendency both to *retain* as well as to *demolish* the plastic image. Christ on the cross becomes a multiplicity of encyclopedia illustrations and ends up as a pair of colossal stone feet from a village statue. It is still the world, even our everyday world, but seen as if "through prisms pointed and interlocking in angles."[20] There is a shift of emphasis from outer to inner reality. All that remains important is the finished perfection of mood and tone, the delicate cantilevered tension between polarities, the sudden immobility due to the stress of simultaneous "readings."

The preeminence of two-dimensional composition was enhanced, thinks Judkins, "particularly after the advent of *collage*."[21] Reading Jacob, one encounters a wholesale incorporation into the literary texture of large chunks of prosaic reality. Jacob does this discreetly in the poem

[20] Schmeller, *Cubism*, p. 54.
[21] "Toward a Reinterpretation of Cubism," p. 270.

about the Italian wine bottle. It is more in evidence in the poem about Robert whose name is really Hippolyte and whose every utterance is a frightful commonplace. Most of all, it appears in "Le Chevalier de la Barre," where the most exaggerated punishments are called for. We find it on the verbal plane when Jacob ridicules the sound of liaison: *Cet* [*sic*] *auto, cet hôtel.*

Mimer le bourgeois, to assume the most unintelligent conventional postures, to revel in *idées reçues,* in short to do exactly what Jacob is constantly doing, amounts to the same thing as pasting (or painting) representations of scraps of newspaper, bits of label from a wine bottle, or sections of cane from a chair onto a canvas. This introduction into the esthetic surface of homely objects, relics of the humdrum world, is *collage* and, as we have seen, it may be practiced either on the verbal or on the visual plane. Its objective is not only to confound the outside world by incorporating its objects and symbols into a flagrantly fantastic texture, but to corrupt, in an act of final nihilism, that very texture itself.

Max Jacob has given over entire books to the exercise of this type of *collage,* books which constitute no more than one enormous *grosse blague* from beginning to end. And even their titles, *Le Roi de Béotie, Philibuth ou la montre en or, Tableau de la bourgeoisie, Bourgeois de France et d'ailleurs,* reveal this intent. If the painters grew tired of it, Jacob never totally abandoned it. In fact, nothing he ever wrote, except perhaps a few of the last poems and religious meditations, is entirely free of this bitter, ironic mocking.

Collage is an especially revelatory technique in that it probably represents both the patent admission of a considerable penetration of the artist's psyche by environmental factors as well as a deliberate attempt on the part of the artist to exorcise that penetration through ridicule and derision of it. What had started out as an anti-social, anti-conventional joke, grew to be an indispensable part of the esthetic arsenal. Or perhaps the stultifying clichés actually did well up to haunt and humiliate Jacob in his unguarded moments. In any case, this device, in which scraps and tatters of the bourgeois "reality" (symbolized by homely objects) are evoked only to be redisposed into a nightmarish set of patterns, smacks of a discreet residual romanticism.

Still another basic element of cubism "is the geometrizing tendency

... from which the whole movement derives its name."[22] It is clear that Cézanne's perception of space was the basis of cubist geometrizing although "cubist prismatic and pyramidal forms are not heavily and weightily at rest like the stones of an edifice, but are set in motion— pictures of an earthquake."[23] "The cubists no longer aim to create spatial illusions related to reality but to create irrational space in a transcendental world."[24] The tightness and compactness of the cubist landscape, whether in painting or in literature, becomes an impenetrable and opaque mass whose "blinking facets give the impression of crystal enclosures in barren rock."[25]

We have already observed the literary counterpart to that "angularity" of cubist painting in Jacob's incessant shifting of the poetic line, in a constant turning from the path in which the images seem to have been oriented. We have also seen how Jacob created, in the *poèmes en prose*, a similarly oppressive hermetism. He abandons any tendency toward expansion beyond the lines of the poetic structure in favor of a space-time immobility. There is no orientation toward objective reality. Nor is there any attempt to portray any figure external to the esthetic texture. Thus space itself seems turned inside out and comes to represent a kind of negative space, inverted and irrational. And as space and time blend into one another, the poem, instead of being a portrayal of anything, ends on a note of rapt immobility and becomes in effect an esthetic mood.

The last general element attributed to cubist technique, according to Judkins, is *passage*. Barr defines this as "the breaking of a contour so that the form seems to merge with space,"[26] or "more normally, with the space behind it,"[27] as Judkins emends the definition. Of this too, we have had abundant examples in the *poèmes en prose,* where the transformation from image to image or term to term was effected by verbal volatility: *poète âgé, poème étagé, godet du goulot,* and so on. And of course, as we pursue this examination of the works of Max Jacob, we shall encounter many more.

[22] Ibid., p. 270.
[23] Schmeller, *Cubism*, p. 7.
[24] Ibid., p. 8.
[25] Ibid., p. 9.
[26] *Cubism and Abstract Art*, p. 31.
[27] "Toward a Reinterpretation of Cubism," p. 270.

We have considered the general principles defined in the "existing literature on this primary phase" of cubist technique, namely: (1) a pulling to pieces of the object; (2) a rebuilding of the pieces into an independent composition; (3) a placing together of objects (or parts of objects) from an unrestricted range of observations; (4) a shifting of emphasis from the "reality" of the object to the "reality" of the esthetic surface. It seems plausible that Jacob, in his cubist poetry, is furnishing a literary counterpart to each of these features.

Not to grasp the transposition onto the verbal plane of these basically figurative techniques is perhaps to insist too stringently on the exclusive application of such concepts to the medium of painting. Illustrious critical precedents exist for such transference, and the cubists themselves were thoroughly imbued with the spirit—and perhaps the letter—of the Baudelairean *correspondances*, as we hope to demonstrate convincingly in the following chapter.

It might be protested that the duality, plurality, and simultaneity treated in connection with Judkins' discussion of "basic cubist practice" are truly applicable to painting alone since, after all, one sees the many elements in a painting (with very few exceptions) nearly all at once (although one may then concentrate on a succession of specific aspects or details afterwards). No poetry can be read "simultaneously," however. And yet, given the terse expression and simple, half-materialized images of Jacob's poems, there takes place the *near* simultaneity of the rapid oscillatory movement, while the punning makes for retarded action and doubled meanings.

Two other aspects of cubist painting technique, primary aspects at that and thereby legitimately preliminary to any extended or close examination of the *genre*, find counterparts in Jacob's (and other) poetry of the movement. Jacob's poetic "angularity" may be equated with the "two-dimensional geometrizing" of the cubist painters. But it may also be likened to inappropriately formal or classical diction in poetry, a diction whose very inappropriateness renders it meaningless.

If at first the beholder of a painting is taken in by the formalistic semblance, he realizes nearly at the same time (1) that it *is* just a sham, and (2) that he *has* been taken in. This is because immediately afterwards, the eye falls upon the most unpretentious objects or parts of objects imaginable: in Picasso's earlier periods, it encounters that most *déclassé* of mortals, the *saltimbanque* (possibly inspired by Baudelaire's

poème en prose of the same name) ; later, there are heavy, idle, stolid, sculptural "goddesses" looking like so many charwomen; if the technique is *collage,* the eye over and over again encounters the masthead of a popular daily newspaper, an advertisement for a cheap department store, or an actual playing card; in other cases, it is a bottle of wine, the victuals for a modest lunch, or that common and indispensable object in a Spaniard's household, a guitar, all eminently plebeian.

Picasso himself has succinctly expressed this preoccupation with proletarian values as follows:

> Les tableaux, on les fait toujours comme les princes font leurs enfants: avec des bergères. On ne fait jamais le portrait du Parthénon; on ne peint jamais un fauteuil Louis XV. On fait des tableaux avec un paquet de tabac, avec une vieille chaise.[28]

> [We always make our paintings as princes make babies: with shepherdesses. We never do the portrait of the Parthenon; we never paint a Louis XV armchair. We make paintings with a package of tobacco and an old chair.]

So one can see how futile and misleading any attempt to ascribe apparent formal mathematical geometrizing might be, and how contrary to the cubists' true intentions.[29]

Jacob employs in his prose, and with what is evidently pleasurable malice, the conceits of the woman of the people and the "little clerk," of the *titi parisien* and the Breton farm maiden. Furthermore, as protagonists he chooses social outcasts like himself: *saltimbanques,* prostitutes, kleptomaniacs, and assorted derelicts. Or, rising a few steps higher in the social scale, he concentrates on the *concierge* of Montmartre, the *bonne à tout faire* and other members of the working class. When he does choose a bourgeois subject, Mme Ballan-Goujart, Mme Patience-Riminy, M. Odon Cygne-Dur—even their names are ridiculous—he does so in order to satirize them mercilessly.

Jacob could be uninhibitedly "low class" as the following verses show.

[28] Quoted by André Breton, *Anthologie de l'humour noir* (Paris, 1950), p. 254.

[29] For an illuminating discussion of the mathematical intentions or lack of mathematical intentions in the development of cubist esthetic theory, see Gray, *Cubist Aesthetic Theories,* pp. 71–74.

Loïe Fuller, c'est épatant.
Sur le bi, sur le bout, sur le bi du bout du banc,
Mais ce Rodin est un salaud,
C'est zéro!
Otéro!
Ah, voilà un numéro! (*La Déf. de Tartufe*, p. 11)

[Loïe Fuller, she's terrific.
On the bee, on the boo, on the bee of the boo of the bench.
But that Rodin is a skunk.
He's zero.
Otéro,
Now there's a character.]

And yet in a rollickingly playful, almost childish way he captures something very real of the zestful side of the Belle Epoque. Lois Fuller, Rodin, and La Belle Otéro, all mixed into an incredible but nonetheless savory and authentic cocktail, spiced by familiar, coarse, and even disrespectful language—*c'est épatant, salaud, c'est zéro, voilà un numéro*—are full of irresistible verve.

But an intimate contact with the *basses classes* did not at all suffice for the cubists. Picasso indeed seemed to be seeking an absolute negation of established values. In the midst of his fixed and immobile "interior" landscapes, one discovers figures that are sculptural rather than linear. Here are the stolid Grecian women, intensely plebeian, but above all placidly idiotic, "pneumatic giantesses" who exude "the dull torpor of complete imbecility," as Wyndham Lewis has so maliciously observed.[30]

No such total abdication of conventional values was possible in literature, however, and Wyndham Lewis goes on to explain (speaking of Gertrude Stein, but in words which apply equally to Max Jacob):

The massive silence of the full idiot is, unfortunately, out of her reach, of course. In her capacity of writer, or word-knitter, she has to stop short of that, and leave it to her friend Picasso. For words, idle words, have one terrible limitation—they must represent human speech in some form. The silent canvas is their master there.[31]

[30] *Time and Western Man* (Boston, 1957), p. 63.
[31] Ibid., p. 63.

It is exceedingly difficult to ascribe poetic equivalents to sculptural or painterly productions. Nevertheless, much the same unprogrammatic immobility, now fixed in a grimace, now in bovine contemplation, that is encountered respectively in such widely separated period works as *Les Demoiselles d'Avignon* (1906) or *La Source* (1921) is also encountered abundantly in Jacob's *poèmes en prose*. But, as Wyndham Lewis has already observed, it was impossible for Jacob, working as he did with the spoken word (indispensable to the literary text), to have recourse to "the massive silence of the full idiot."

So Jacob, in an effort toward an increasingly absolute negation of conventional values including that of human speech, retreats into the mysterious, egocentric, inexplicit, naive irrationality of childhood. No expression of infantilism, no matter how inappropriate, is excluded; neither stammering, nor flagrant mispronunciations, nor shrieks of joy or of pain, nor even senseless punning (*la goulette du goût d'eau, si c'était Toto, si c'était Totel*), quite in the manner in which children play with language: "What's your name? Puddin' tame." There is also the captious playfulness encountered in the young child, the eternal refusal to be serious, the infinite frivolity.[32]

Literary Painting

We have translated into their literary equivalents the two supplementary aspects of cubist subject matter, that is, the proletarian, and the "mentally deficient"; we now proceed to a direct scrutiny of specific and irreducible details "to witness the very procedure of the abstraction itself."[33] To this end let us examine *Violon et Damier* (1913) of Juan Gris.

At first glance, the painting seems to represent a man in a white shirt and black trousers playing the guitar, against a background of monotonous wallpaper. A checkerboard stands or lies (it is difficult to know since the checkerboard is in a different plane) at his side on a suggested bare wood floor or table. The finger board of a large stringed musical

[32] For an exhaustive investigation of this aspect of Jacob's art and of the infantile playfulness to be found in much twentieth-century art in general, see Jean Piaget, *Le Langage et la pensée chez l'enfant* (Neuchâtel, 1957).

[33] Judkins, p. 270.

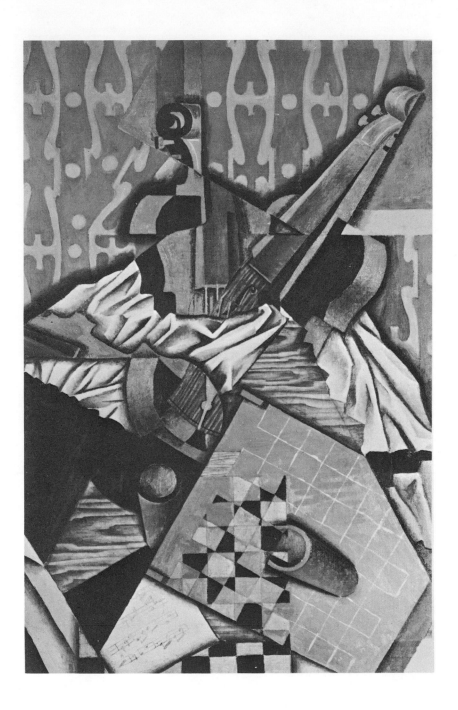

instrument begins high in the upper right corner and directs the beholder's gaze downward toward the left. Its descending line is interrupted just below the center of the picture by what seems a rumpled white-sleeved arm perpendicular to the line of the strings, going off to the left.

The stringed instrument then culminates in the man's crotch with the right thigh extending upward, parallel to the aforementioned arm, and clothed in black tight-fitting material like the pants of a Spanish dancer. As this thigh extends a short space toward the upper left, its inner contour makes a right-angle bend downward like the bend of a knee (or rather the back of the knee). The lower part of the leg is raised and not perpendicular to the ground as if the invisible foot were resting on something, as a guitarist's foot rests on a stool when he plays. Indeed, the extreme lower left limit of the canvas is sectioned by some sort of little step.

The left leg, whose black lower portion is only suggested, furnishes a black punctuation to the finger board, a line which had been taken over by the upper (left) contour of the right hand checkerboard which we shall refer to hereafter as checkerboard A. That same line becomes an oblique dividing line between the black upper third and the white lower two-thirds of a single large square (about one quarter the size of a complete checkerboard). This square is superimposed upon the bottom of another checkerboard lying to the left and which we shall refer to as checkerboard B. Strangely enough, the extreme left tip of checkerboard A is superimposed in turn upon the edge of the outsized single square, the black upper third of which suggests the guitarist's left pant leg.

The overall "guitar" atmosphere is heightened by three small expanses of white cloth whose rhythmic shading makes it resemble a shiny, wrinkled, draped, or even ruffled material, appropriately the silk shirt of a Spanish dancer. The center expanse constitutes the playing arm as it were. Just below it to the left, and parallel to it as if it were a continuation of the playing arm from which a section had been taken, there is a smaller expanse. This could imply a movement of the arm by its doubled image quality. But the beholder tends to reject that interpretation owing to the illusion that the bottom or hip of the guitar is nestling against it, and interpret it rather as the part of the shirt that is tucked into the waistband of the pants. The third section of white cloth seems to stream out behind the man (to the right).

Checkerboard B rises vertically, its bottom row of black and white squares flush with the bottom of the tableau. Four things interrupt the contour of this checkerboard: first, the above-mentioned outsized square, one-third black, two-thirds white, which stands on the same plane as checkerboard A, though diagonal to it; then, the fact that a small expanse of realistically depicted wooden board (bounded roughly by the guitarist's leg and the top of the outsized square) recurs surprisingly to the right of the outsized square and over checkerboard B; then, checkerboard A; and last, a dicecup which seems to stand on checkerboard A but thrusts through checkerboard B.

Checkerboard B, distinctly black and white where it materializes, turns out to be a perfect square, at least on three sides. Checkerboard A, however, is dun colored, rectangularly shaped, and its squares are only indicated by slight wavering chalk lines. Gris has created a staggeringly effective game of planes here. Suppose one ascribes checkerboard B to plane I, the outsized square to plane II, and checkerboard A to plane III. Thus plane I is farthest from the spectator, plane II is closer, and plane III is closest.

One may assume from the evidence just examined that the outsized square overlays checkerboard B, obscuring a fair-sized portion of it. The square must therefore lie in a plane closer to the spectator than that of checkerboard B. Checkerboard A or at least the tip of it that extends all the way to the left, projects in turn over the outsize square and thus establishes itself as being "on top" or closest of all. But the right vertical contour of checkerboard B (occupying plane I at the bottom of the "pile"), extends upward and *covers* checkerboard A (or plane III which we had agreed is the closest). So the farthest also becomes the closest.

This is a startling anomaly and not the only one in the composition. Where the squares of checkerboard B, black and white on the bottom one and one-half rows, intersect with the squares of checkerboard A, normally sketched in white chalk against a dun background, the black and white of checkerboard B becomes somehow transferred to checkerboard A. That is, the regular pattern of black and white squares becomes interrupted and is resumed *only where a square of checkerboard B coincides with a square of checkerboard A.*

Naturally this produces an effect of transparency in the upper portion of checkerboard B and has the effect of establishing it in a plane contrary to the one we have seen it in, i.e., covered by two other planes. In addition

to these effects, a dicecup, standing on checkerboard A, rises in an exaggerated perspective and extends itself, by means of a typical *passage*, into the play of transparencies that we have just finished discussing in checkerboard B.

The dicecup's outward perspective seems to impart to it a tendency to rise off the canvas upward and to the left. But if it is considered on a flat plane, it points directly to another and slightly smaller dicecup. This second dicecup is about the same dun color as checkerboard A with a black line outlining its circumference, and seems to project upward from what we had tentatively identified as the "guitarist's crotch." It also stands clearly behind checkerboard B's upper limit which casts a decided shadow on it. Checkerboard B, on the other hand, would have covered most of it (according to its size and shape) had it not already dissipated itself, by the above-mentioned transparency which constitutes another *passage*, into checkerboard B.

Once a preliminary identification of the central figure and the diagonal instrument has been made respectively as "guitarist" and "guitar," we experience an uneasy sensation—this probably because one of the first features, faintly identifiable at the top of the finger board is the characteristic violin scroll and four pegs. And as the attention travels toward the left, it encounters a second scroll which mirrors the first scroll. This second scroll, clearly outlined in black and dun, contains a highlight which we might at first have taken to be the "guitarist's" eye thus contributing to the continuity of the primary illusion. It also contains, however, two pegs thus sending us back eventually to the first violin scroll for confirmation. Aside from the four pegs of the right view—which we shall refer to as violin A—and the two pegs of the left view—which we shall refer to as violin B—more violin signals impinge themselves on our consciousness. The top half of an F hole becomes visible, very precisely sketched in alongside the strings of violin B, and just above what we had taken for an arm. Another representation of the same F hole is barely distinguishable through the strings of violin A. Suddenly the tableau seems permeated with violin images; even the repeated design in the wallpaper vaguely participates in this atmosphere.

As our eyes grow accustomed to reading the instrument for a violin and not a guitar, they also recognize that the body of the "man" is none other than the body of the same violin. Violin A reposes diagonally from right to left, from top to bottom, and turned three-quarters toward the

left. Its lower contour, instead of continuing its curve around sharply and up as it should to complete the figure in a diagonal plane, flattens out and then continues upward in a general vertical direction.

In other words, the bottom of violin A is common with the bottom of violin B, and its left border, instead of cutting back diagonally to the upper right, turns shallowly upward to form the left vertical border of violin B. Violin B, however, stands in another plane, even though it virtually grows out of violin A; it is sectioned from violin A and then rotated in a three-quarter view to the right so that the two views of the same violin almost form the two faces of a right angle. This perpetrates, on the beholder accustomed to looking at more conventional painting, a contradiction of spatial logic.

And this contradiction of spatial logic is only compounded by the fact that the upper plane or face of violin A is an undifferentiated black with sides the same dun color as checkerboard B in all its parts, even its bottom section. That is, the lower left hip of violin B (and the one it has in common with violin A), delimited by a sort of rounded right angle sectioning, is the same color scheme as the rest or top portion of violin A, black on top and dun on the sides. In the second section or "waist" of violin B, this scheme is reversed, the top plane being dun and the sides black. The third or upper section of violin B, however, reverts to the original checkerboard scheme of attenuation.

At this point in our analysis it is not particularly difficult for us to see the split image of the violin, reposing on a table with, at its lower extremity, a checkerboard. Even the juxtaposition of the planes of various materials can be unscrambled and regrouped with a certain cogency. But the angle of light that makes the sides of violin A lighter in tone, leaving the top in obscurity, does not illuminate the central portion of violin B in a consistent manner. Aside from this lack of consistency in the treatment of light angles and the transparency and interpretation of the two checkerboard patterns, there is also an extremely interesting play of prismatic sections in the upper parts of the violins, play which is carried over into the wallpaper background and which further imparts a disturbing "blinking" quality to the entire tableau.

Painterly Literature

Now, keeping in mind some of the techniques just observed in *Violon*

et Damier, we may return to the *Cornet à dés* in order to examine a *poème en prose* of Max Jacob.

EQUATORIALES SOLITAIRES

Quatre doigts de pied noueux servent de frisures au taureau haut qui n'est qu'un homme et qui combat, bas! Les fourneaux sont des maisons qui ne paient pas d'impôts des portes et fenêtres, nâitre! langues ou trompes en sortent. Sur les marches qui marchent car ce sont toutes les bêtes errantes de la création, le Bouddha, qui ennoblit une feuille bordée d'or, tient une bourse avec l'intention d'en faire des colliers pour plus tard. Ne vous en effrayez pas! ce n'est qu'une bordure, dure! Mais à double entente. Il a tant plu sur tout cela qu'une épine dorsale a poussé là qui leur passe au travers avec une sollicitude insolente ou insolite. Un million de souris . . . de sourires. (*C. à d.,* p. 152)

[EQUATORIAL SOLITAIRES

Four knotted toes serve as curly bangs to the tall bull who is actually no more than a man and who fights dirty. Ovens are houses which do not pay taxes on doors and windows, to be born! Tongues or trunks emerge from there. On the steps which move because there are all the wandering beasts of creation, Buddha, who ennobles a leaf bordered with gold, holds a purse with the intention of making it into necklaces later. Do not be afraid, it's only a hard edge. But in *double entendre.* It has rained so hard on all that that a dorsal spine has grown there which passes through them with unaccustomed or insolent solicitude. A million mice, smiles.]

This poem presents nearly the entire cubist game played at once.

The first problem is the meaning of the title. One wonders which word is a noun and which an adjective. *Equatoriales,* it can be seen from the final E, is feminine and thus precludes the possibility of *solitaires* being diamonds. The only possible feminine meaning of *solitaires* is recluses or hermits so that the reader is left with female hermits at the equator, not a very satisfactory solution.

Equatoriales, however, suggests vast tropical storms smashing down over untamed jungles or perhaps focuses on the horizontal lines circling the globe: the equator and the tropics. This latter is not unrelated to the previously encountered vision of the balloon rising from the ground and, like it, transports the reader off the earth and into a

supraterrestrial region from which one can gaze down on the earth as a man would look at a globe. Here are, in short, all the mythic, symbolic, and fantastic elements that we have found to be typical of cubism. In any case, *équatoriales solitaires* can mean feminine or effeminate creatures alone in the tropics.

Max Jacob may have had himself in mind, for the only concrete analogy that we encounter in his personal writings is among that series of letters he wrote to Guillaume Apollinaire in 1913 from Spain where he had gone with Pablo Picasso.

> Ce petit nombre d'habitants tient sans doute à l'abondance des pédérastes et des éthéromanes qui se bornent à peupler les cafés.[34]

> [This small number of inhabitants is due no doubt to the abundance of pederasts and ether addicts who limit themselves to peopling the cafes.]

He is obviously poking fun at himself here and it is not at all implausible that the solution to the enigmatic title lies in some such association. And, of course, there is no place an effeminate Frenchman would feel more solitary than at a Spanish bull fight.

There are two ways of approaching such a poem: by tracing the relationships between the sounds of the words, and by isolating the successive images. Let us begin with the latter in this instance. The opening, bounding sentence presents a bull fight. The initial image is probably taken from Picasso's manner of representing the bull in the ring and sometimes horses, often giving the forelock a dramatically stylized effect as of gnarled or spastic fingers. The second sentence shows us some ancient houses, perhaps on fire (*fourneaux, langues ou trompes en sortent*). The third introduces the Buddha holding a leaf and standing surrounded by all the beasts of creation. The rest of the poem disperses itself into a kind of linguistic dissolution and then a resolution in which the preceding elements of the tableau are run through on a spine or thorn.

The language serves to volatilize the images. *Equatoriales,* aside from suggesting perhaps *quatre doigts,* and also *taureau,* provides a semi-vowel pattern in [w] and [j] which is repeated in *doigts, pieds,* and *noueux.* Another phonetic pattern, the repetition of syllables in assonance,

[34] Quoted by André Billy, *Max Jacob* (Paris, 1946), p. 70.

is continued throughout the poem: *au taureau haut, combat bas, fenêtres naître, marches qui marchent, bordure dure,* and *souris sourires.*

This repetition of syllables (often nonsense syllables) is characteristic in general of popular ballads, and in particular of Celtic ballads. In all the foregoing examples, however, the detached syllable possesses its own independent meaning—it is not just a repeated nonsense sound—and adds a note of reinforcement to the meaning of the preceding word: *taureau haut, combat bas, bordure dure.* Where the word does not lend itself to the procedure, Jacob utilizes a similar device, one which recalls the first one: *marches qui marchent, sollicitude insolente ou insolite.*

One finds as well an excessive number of repetitions of consonants or of combinations of consonants: *qui n'est qu'un homme et qui com-,* provides repetition of [k] and [n]; *ne paient pas d'impôts des portes* of [p] and [d]; *Bouddha . . . ennoblit . . . bordée d'or . . . bourse . . . bordure* of [b] and [d]; *plu . . . épine . . . poussé . . . passe* of [p] again; and *sollicitude insolente . . . insolite!* of [ɛ̃], [sɔl], [li], [s], [l], and [t]. It is very likely here that Jacob, aside from succumbing to the volatility of verbal association, utilizes this exaggerated repetition of consonants with satirical intent. It powerfully suggests alliteration, one of the mainstays of the romantic poetic arsenal much abused during the nineteenth century.

At times the suggested alliteration is not so obvious, occurring in reversed combinations of a stop plus a liquid: *portes et fenêtres, naître . . . trompes . . . sortent.* Sometimes the consonants are scrambled, occurring at the beginning, in the middle, and then at the end of words: *taureau . . . trompes . . . toutes . . . bêtes errantes . . . ennoblit une . . . tient une . . . l'intention . . . tard . . . entente . . . tant . . . tout . . . travers.* At other times a vowel, the closed o [o], for example, will echo through several widely separated sentences: *au taureau haut . . . fourneaux . . . impôts.* This little poem is shot through with conventional poetic devices in spite of its surface unconventionality, just as cubist painting is shot through with conventional painterly devices.

In addition to these verbal tricks, there is a distinct manipulation of intonation. The bounding first half of the opening sentence ends on a high tonality and also on the word *haut,* conjuring up a huge, rearing bull with a twisted forelock. The second half of the sentence immediately gives way to a descending pitch in which the proud bull now turns into "only a man" who fights *bas,* or perhaps both antagonists are meant to

be present in the same figure. Then Jacob operates his volatilization of images: from the bull ring, the scene suddenly shifts to an *image brouillée,* half "ovens" with tongues or similar appendages flickering out of them suggesting the licking of flames, half "little old-fashioned houses"[35] with no windows (or with only one window).

The expression *marches qui marchent* injects a certain fluidity as if the very earth under one's feet were set in motion. In a contrasting image, a calm Buddha emerges who, by "holding" a leaf and a purse, contributes a sense of peace and immobility to the previous strife and excessive mobility. The word "intention," denoting a *projected* and not a concurrent action, and also the supposedly motionless act of ennobling (perhaps blessing) the leaf add their weight to the sum of this immobility. The Buddha, a patriarchal figure, holding a leaf before *toutes les bêtes errantes de la création* might suggest a naive representation of Noah holding the olive branch before the animals of the Ark.

Syntactically, there is distinct parallelism between the two members of the clauses (1) *taureau haut* (2) *qui n'est qu'un homme* and (1) *une feuille bordée d'or* . . . (2) *ce n'est qu'une bordure dure.* In other words the *feuille bordée d'or* (which was "ennobled" by "Buddha") forms a pair with the *taureau haut* while that which *n'est qu'un homme* forms a pair with that which *n'est qu'une bordure dure.* This last pair, incidentally, presents the only examples of the *ne . . . que* construction in the poem, thereby highlighting the parallelism. One might conclude that the author is suggesting: man is inferior to the bull as the "hard border" is inferior to the ring of gold about the leaf.

At this point, Jacob suddenly breaks into the tissue of the abstraction with a rational admonition to the reader not to be afraid. The overt ad-

[35] The double theme of paying taxes for doors and windows and the subsequent practice of painting them on the outer walls of houses to give the appearance while avoiding paying the taxes is well known in France. A celebrated and much-photographed example is a "little old-fashioned house" in the Place du Tertre. It is incontestable that Jacob was familiar with this square (and probably with this quaint house) as the following sentences would indicate: "Un soir que nous étions attablés à une terrasse de la place du Tertre, Max passa, se rendant de la rue Gabrielle au Sacré Coeur. . . ." (Billy, p. 36). [One evening when we were all sitting at a table of a sidewalk café in the Place du Tertre, Max passed by on his way from the rue Gabrielle to the Sacré Coeur. . . .] Both *Tertre* and *Montmartre,* incidentally, continue the predominant sound pattern of the poem to its fullest extent, the R plus a stop plus R. One also thinks of the fire painted on the wall in Pinocchio's father's house and of the pot boiling merrily over it.

mission of *double entente* continues the warning but it is difficult to know of what. The last syllable of *entente* [ãtãt] seems to tie up with the *tant* [tã] immediately following it but suggests a *tante* [tãt] consistent with the preponderance of feminine endings in the poem. The possibility of a reference to pederasty, *tante* being the commonest slang word for a homosexual, is not diminished moreover by *épine dorsale . . . qui leur passe au travers* immediately following.

At the end, Jacob waxes cynical, playing on the words *insolente ou insolite* and allowing them to assimilate to each other, not just on the phonetic plane but on the plane of meaning as well. In other words, solicitude which proves to be *insolite* is by that very token *insolente*. And in the last sentence, Jacob continues the cynical tone by equating, again on the dual planes of sound and meaning, a "million mice" and a "million smiles," all fleeting, impersonal, and rodent-like.

In spite of the differing media and the differing exigencies of the two media, in spite of different temperaments and different nationalities, how many analogies there are between the canvas of Gris and the poem of Jacob. Images and parts of images, words and planes, perspective and rhyme are never what they seem. Of course, here the poet has an advantage over the graphic artist in that poetry is less bound by the spatial materiality of illusory phenomena. For example, the "gnarled toes" suddenly turn into the "bull's forelock," the "bull" itself, into a "man." Or, "ovens" are "houses," "steps" are "animals," and it has rained so hard that a spine has run them all through with solicitude! There is in picture and poem the same fine disregard for the conventions of rationality and logic, the same lack of transitions, the same arbitrary fragmentation. In both, one has only a scrap of reality, portrayed as such, for the reader to hang on to.

The same sort of confusion of images occurs in this passage from the *Cornet à dés:*

La Mendiante de Naples

. . . Or, comme je regardais, je vis que ce que j'avais pris pour une mendiante, c'était une caisse de bois peinte en vert qui contenait de la terre rouge et quelques bananes à demi pourries. . . . (*C. à d.,* p. 142)

[The Neapolitan Beggar-woman
So as I was watching, I saw that what I had taken for a beggar-

woman was a wooden crate painted green containing some red earth and a few half-rotten bananas.]

Here the image shifts from beggar to box just as our perception of the Gris canvas shifted from guitar to violin. In this instance, the metamorphosis is uncomplicated by verbal volatility and, of course, Jacob tells us with unaccustomed frankness what the real components of the vision are.

A similar, though less clear, example of protean imagery is afforded by another *poème en prose:*

KALEIDOSCOPE

Tout avait l'air en mosaïque: les animaux marchaient les pattes vers le ciel sauf l'âne dont le ventre blanc portrait des mots écrits et qui changeaient. La tour était une jumelle de théâtre; il y avait des tapisseries dorées avec des vaches noires; et la petite princesse en robe noire, on ne savait pas si sa robe avait des soleils verts ou si on la voyait par des trous de haillons. (*C. à d.*, p. 161)

KALEIDOSCOPE

[Everything seemed to be in mosaic: the animals were walking with their paws toward the sky except the donkey whose white belly carried written words which kept changing. The tower was an opera glass: there were gilt wall hangings with black cows; and the little princess in a black dress, you couldn't tell whether her dress had green suns on it or if you were seeing her flesh through the holes in her rags.]

The words "kaleidoscope" and "mosaic" warn the reader of a cubist *mise-en-morceaux*, with an unreal and constantly shifting field of focus.

The poem states very definitely that the donkey is the only animal not walking with his feet toward the sky—a patent impossibility since there is no point of contact for the feet at all. But when we learn that there are words written on his white belly, this implies that the donkey too must be walking upside down or we would be unable to see them. After this, Jacob presents another dual vision, "tower"/one of the tubes of a pair of opera glasses, but again, as with the *mendiante/caisse de bois*, he is exceptionally explicit. Even the light colored suns in the black dress which may be skin seen through holes in the cloth is a plausible optical illusion, except for the fact that the patches of skin are green!

III. The Mechanics of the Abstraction

T HE POINT OF THESE ANALYSES has been to show that cubist tech-
niques, whether of painting or of poetry, work in essentially the
same way. One finds the same infinite contradiction, splitting the
logical structure of the work of art down to the finest and most tenuous
strands. One finds the same chopping into blocks, the same disappearance
and reappearance of images or suggested images, the same nihilistic
symbolism, the same unreality in reality, the same reality in unreality.
Furthermore, all the cubists partake of the same atmosphere, are pre-
occupied by the same simple objects which they then transform into
miraculous visions.

Cubism as Destructive Activity

Studying cubist works closely, one eventually comes to look at the
very process of the disintegration of familiar objects and the disaggrega-
tion of spatial planes. Indeed Judkins, as a result of a practically micro-
scopic examination of five cubist canvases, has formulated fourteen
conclusions, lettered A through N, which, he claims, get at the very fiber
of the abstraction. These conclusions appear eminently applicable not

only to the Gris *Violon et Damier* but equally to the poetic abstractions of Max Jacob.

In the interest of economy, we need only consider Judkins' *own* summary of what he calls "the primary components of cubism." They are four in number and represent a digest of the first eleven "primary components," or *a* through *k*. They are "(1) A Deliberate Oscillation of Appearances; (2) A Studied Multiplicity of Readings; (3) A Conscious Compounding of Identities; and (4) *An Iridescence of Form*."[1] (It seemed advisable in the transcribing to retain Judkins' capitalization and his italics since they reflect the absolute certainty of his judgments.)

He then goes on to describe the effects of these procedures:

l. parts of an object displaced from the whole so that its recognition is made elusive, fugitive intermittent

m. objects seen from two (or more) directions at once

n. sections of objects shifted and adjusted so that they become either involved in other continuities or new forms in their own right[2]

Let us consider these in inverse order, proceeding from the specific to the general. In the Gris canvas, the central expanse of ruffled cloth, removed from its continuous identity, seems to become an arm; in the Jacob poem, a mountain range covered with mist seems to become a *soupe au lait*. A checkerboard is seen from two directions, in two contradictory planes (or three, if one counts the single outsize square), and in a kind of transparent superimposition; just as, in the Jacob poem, the Crucifixion is seen from myriad points of view as in the illustrations of an encyclopedia.

The violin was split and the two views set obliquely to each other and rotated to face each other in such a manner as to resemble a man playing a guitar; in Jacob's *poème en prose*, "Omnia Vanitas," a single object or perhaps a single facet of an object is seen through its displaced elements and thereby rendered unrecognizable. Does this not constitute

[1] Winthrop Judkins, "Toward a Reinterpretation of Cubism," *The Art Bulletin*, XXX, no. 4 (1948), pp. 275–76.
[2] Ibid., p. 276.

"a deliberate oscillation of appearances, a studied multiplicity of readings, a conscious compounding of identities," and above all, "an iridescence of form"?

As Judkins and every other commentator has observed, cubism is both a tearing down and a building up, a negative and a positive movement, a destructive and a constructive esthetic philosophy. And all the critics agree that, above all else, cubism effected a destruction of the familiar plastic image, but that it also produced many positive effects. If we divide cubism into its positive and negative aspects, and begin by isolating the latter, it seems to divide naturally into four categories: the aforementioned destruction of the plastic image, simultaneity, verbal duality or volatility, and subversion.

Each of these can be subdivided in turn. For example, Jacob's primary technique for destroying the plastic image, or what may be called a destructive technique, is a metamorphosing or fusing of one image into another. At times the images succeed one another like cards being riffled in a pack; at other times an image does not quite materialize fully before edging into another image, or it may recur in a slightly altered form. At still other times, the images call up strange associations, often because of the sound of a word. There are frequent leaps from high to low style, or from literary to familiar speech, or a brusque switching of frames of reference without explicit transitions. An example would be the poem "Omnia Vanitas" in which each half-glimpsed image fades into another or into the background.

Another destructive technique might be considered in contrast to the foregoing welling up of successive scraps of vision: a way of sweeping an "unrestricted field of observation" in which the objects looked at are easily discernible but in which the optic, proceeding from a stable vantage point—and this stability may be recognized by the unity of the style—creates a reeling focal plane. An example of this would be "Portraits peu flatteurs" where well-formed glimpses of assorted Christs pass rapidly before the eyes.

Still another method for accomplishing the destruction of the plastic image is the device of diminishing focus. This is demonstrated in Jacob's letter to Apollinaire in which he focuses from the largest entity, the Spanish countryside, down to the minute details of the costumes, thus bringing closer the intimate aspects of the overall vision in order to

tighten the significance for the reader. Jacob, by playing complicated games with space (rendering it fluid or actually turning it inside out, as the art critics have observed), possesses a powerful means for manipulating the emotive content of any referent.

The last device is a persistent obscurantism, a refusal (except in rare instances) to provide the reader with a tangible referent, or to furnish him explicit transitions. So that in addition to the three other techniques, already disastrous to the existence of a long-standing concept of plastic imagery, Jacob further complicates any reassembling of the fragments by refraining from telling us what their general outlines should be. It is almost as if the reader were trying to solve a jigsaw puzzle without knowing the overall final shape. There can be no relation of object to conventional structures.

We have already mentioned a second essential category of cubist art (and one directly related to the first), simultaneity of vision. If we continue to examine systematically the techniques by which the negative aspects of cubism are brought about, we find that simultaneity comes from taking one object for another, or one aspect for another, or one sentiment for another. A guitar is actually a violin; a Japanese, a tree; a *soupe au lait,* mountains. As quickly as the senses perceive the image, it becomes something else; the reader is constantly obliged to superimpose another impression on the original one, but without discarding the original.

This we may call the intertwined image. Sometimes one element recurs thus weighting the image in favor of the recurring element, but generally the reader is dazzled by sheer rapidity of oscillation, by the volatilization and nearly immediate replacement of half-grasped images, by the *double entente.* It seems, moreover, not only that Jacob desires to inspire confusion in the reader's mind, but that there existed a serious ambivalence in his own mind about what he wanted to emphasize, an ambivalence that ever prevented him from taking a stand or allowing himself a posture for very long.

Another technique for achieving simultaneity is that of the studied reversal. It is again as if the artist were working against himself. We have seen how Jacob refuses to deliver up a previously announced 2^{me} *réflexion.* Or it may take the form of contradicting someone else's stated or known attitudes or attributes as in "Encore le roman feuilleton," in

which *Robert s'appellait plutôt Hippolyte,* and various platitudes of the bourgeois vocabulary are systematically negated immediately as they are conjured up.

Still another technique is the destruction, simultaneous with the description, of the person or object described. This is like the foregoing method but on a less rational plane. For example, in the *Matorel* Jacob describes a woman thus:

> La femme avait une tête de boeuf avec des bandes violettes autour des yeux, des cornes. Son corps était invisible. (*St. Mat.,* p. 95)

> [The woman had a steer's head with violet bands across the eyes, horns. Her body was invisible.]

Sometimes *voilà que la selle du cheval s'allonge et griffe toutes les roses et le cheval et les Japonaises et tout disparaît.* And sometimes, the two components merge only to cancel each other out ultimately.

A technique for achieving simultaneity is that of ideological duplicity where the author depicts sentiments which can hardly be his own. We have seen this in the poem on the "Chevalier de la Barre" where the most vicious chastisement, wedded to a kind of right-thinking righteous indignation, is dramatized. This cannot be considered a likely attitude for one of Jacob's background and associations, especially the cubist group, to entertain. And yet, since Jacob refuses to be explicit in his moral stance, he only compounds the contradiction. And, as we have remarked, this *affichage* of conventional posture with destructive intent is comparable to collage in the realm of painting.

Of the essential characteristics of cubism analyzed thus far, none is more significant or influential than verbal volatility or duality on the exclusively verbal plane. This is usually accomplished by elaborate punning, often, although by no means always, deliberate and nonsensical. One of the titles in the *Cornet à dés* is "Capital: Tapis de Table,"[3] whose two parts, if read rapidly and with a Parisian inflection, sound almost alike: [kapital-tapidtabl]. In the *Matorel,* Jacob says:

> —Quand on est par malheur devenu un gueux fou, . . . il ne faut

[3] See n. 3, Ch. VII. A passage from the *Matorel* which renders this title from the *Cornet à dés* meaningful is quoted on p. 115.

point paraître un fougueux, ou bien le propriétaire de cette chaste nuque, qui est l'eunuque, on l'enverrait à Saint-Maurice se faire faire un complet blanc! (*St. Mat.*, p. 15)

[When one has, due to misfortune, become a mad beggar, one must absolutely refrain from appearing an impetuous fellow or else the proprietor of that chaste nape who is a eunuch they might send to Saint-Maurice to have a white suit made.]

Aside from this gratuitous punning, there is a more directed and meaningful type of literary device used principally for ridicule. For example, *liaison* tends to have some influence on raising or lowering the level of speech so that its inclusion where it is optional or its omission where it is compulsory is certain to make an impression on a French speaker. There is also the phenomenon of *pataquès* where ignorant speakers make non-existent *liaison*. Jacob ridicules this, for example, in "Roman feuilleton." Or when he talks about *sollicitude insolente ou insolite*, he is letting the sounds produce their own sarcasm.

Thus we have those cases in which Jacob allows the sound of a word to pull its meaning into another thought compartment, a qualification suggested solely by sound and having, in most instances, no ideational connection whatever. In its more extreme forms, this verbal duality effects a nearly total disaggregation of the meaningful content of a poem, although it can and does produce dazzling and unlooked-for effects much like the accidental effects produced by the dripping or running of paint. This further allows the medium, the painted or poetic surface, to take ascendancy over non-esthetic reality.

And the last of the verbal phenomena is that of mimicry or *pastiche*. Jacob is truly a master of *pastiche* as has been widely recognized; in fact, it is one of the relatively few aspects of his genius that have been adequately appreciated. As one critic has said, "If the novelist is above all an observer and mime, Max Jacob was the most prodigious novelist of his generation."[4] He is equally capable of passing from an approximation of pure eighteenth-century style to the most bombastic parody of romantic rhetoric, or from the speech of the Breton peasant to the *bagou* of the *faubourien*.

[4] André Billy, *Max Jacob* (Paris, 1946), p. 41.

The last of the four basic negative characteristics of cubist thought is subversion. Jacob overthrows social and literary conventions primarily by a wholesale and systematic subversion of the language. Every conventional usage of language is totally and deliberately violated as often and as violently as possible. Puns are abused and allowed to become incomprehensible and even nonsensical: *le godet du goulet et la goulette du goût d'eau,* or *savoir si c'était Toto, si c'était Totel.*

Along with this, there is the subversion of accepted and revered literary practices and practitioners. One has only to glance at the table of contents of the *Cornet à dés* to see titles such as "De la Peinture avant toute chose," and "Du Dilettantisme avant toute chose," both mocking Verlaine, and "L'Horrible aujourd'hui" and "Encore l'horrible aujourd'hui" obviously with reference to Mallarmé's "Bel aujourd'hui." And "Un Peu de critique d'art" (*C. à d.,* p. 83) is actually a gross satire on the positivistic method of Taine.

The most intense and determined subversion of all is that of bourgeois social values, or perhaps one might better say, of all received collective values. In an epoch that had recently witnessed the ultimate triumph of the bourgeoisie and the enshrinement of materialist values, the chief practitioners of cubism lived in ostentatious indigence. And in a world where hereditary distinctions had been superseded by the criterion of commercial success (based on all the Horatio Alger qualities) Max Jacob and the other cubists were notably, fantastically, and laughably inept at money-making and getting ahead.

A final element of this negative aspect of cubism, and related closely to the previous one, is that sliding toward mental incompetence. We are reminded of the huge, imbecile women of Picasso and of Jacob's childishness, its literary counterpart. We have also encountered it in the plethora of still life painting of the movement, with never a ray of human intelligence allowed to shine through. Even the strangely distorted and fragmented portraits resemble still life rather than the representation of an intelligent being.

Cubism as Constructive Activity

The forgoing negative characteristics of cubism show us the debit side of the ledger; what shall we find on the credit side? There, too, four

main categories seem to disengage themselves from the welter of cubist ideologies and techniques and, as before, may be subdivided into various procedures. The four main positive categories are: (1) a fundamentally new type of verbal and visual experience, (2) a broadening and expansion of the range of art, (3) a profound involvement of the artist in the work of art, (4) and a pivotal function in the development of art.

Or if we may quote Judkins again in his ultimate conclusion which seems to sum up the first positive category:

> Whatever may have been the significance of cubism as a reaction to what had gone before, positively it was to give to representation as such a form which it had never known before and to create in the process a fundamentally new type of visual [and here, for "visual," we may substitute "verbal"] experience.[5]

Aside from its immensely important transitional character, cubism forged ahead to new horizons in representation and expression, thus creating a truly new esthetic experience, valid in its own right.

The first way in which it did this one should call a new dynamism. If we bring to these works of art and poetry a fundamentally nineteenth-century vision, as most critics have, we are continually dazzled by the apparent motility of the esthetic texture. Jacob's poems are energetic, they are explosive, they are full of movement. A thousand jagged fragments, some displaced, some rotated on their axes, some distorted, each producing its own minor reaction, blend uncomfortably into a gorgeous patchwork. It is the small town flashing suddenly by a train window, a countryside glimpsed from an airplane—in short, a distinctly twentieth-century vision.

Next there occurs a new intensity of esthetic and emotional concentration. This intensity stems principally from Jacob's profound capacity for identification even in metamorphosis, so that he emphasizes with totally dissimilar and even conflicting points of view and easily assumes an enormous number of contradictory identities. His poetry and prose both speak in the accents of truth whether the protagonist is the author speaking with his own voice, a Breton peasant, a bilious bishop, or a "little clerk." Dilettantism and posturing are dead and we glean from the poem

[5] "Toward a Reinterpretation of Cubism," p. 278.

a heartbreaking sincerity that never or only very rarely becomes syrupy.

Another means of creating a new verbal experience is an internal-external cohesion of mood and mode. Cubism discovered a union between the new "reality" of contemporary consciousness (which was no longer the "reality" of the previous century) and an immediate rendering of that "reality." It shortened the lines between vision and technique, between emotion and expression, or rather between the emotionality of the artistic creator and the esthetic reality of the created object so that a smaller gap remained. Jacob, by some magic peculiar to himself, managed to regain that rich and vital internal-external cohesion that had, perhaps, ceased for a time to be an attribute of poetry at the *fin de siècle*, a poetry which was lost in the azure of speculation on the nature of the absolute.

The last of the ways in which cubism made itself into a new artistic entity was through its *extreme* contemporaneousness. Jacob deals with real problems of values and significances, of emphases and renunciations, problems of meaning which were torturing the *nouvelle vague* of 1900–15. The *morale laïque*, positivism, an increasingly hermetic, idealistic symbolism, and even more illusory "objective" naturalism had proven themselves incapable of providing ready-made solutions to the more pressing current problems, whether social or intellectual.

The second major positive function of cubism was to broaden the bases of art. One way in which cubism accomplished this was to include an unrestricted choice of objects for the esthetic composition. *Bienséance*, of course, along with most literary conventions had already been seriously undermined by the naturalists, while the symbolists, heeding Verlaine, "had taken Eloquence and wrung its neck," but with Jacob and Apollinaire "on ne recherche plus la poésie dans les rares fils d'or qui sillonnent une terre vulgaire: la poésie est partout."[6] [We no longer seek out poetry in the rare golden strands which run through vulgar earth: poetry is everywhere.] So we can see that cubist poetry was a poetry of "no holds barred," or "catch as catch can," a *poésie actuelle*.

Still another of the broadening processes was that of imitation, mimicry, *pastiche et mélange*. Not only was everything grist for Jacob's poetic mill but the most unlikely people are presented in the most serious

[6] Gaëtan Picon, *Panorama de la nouvelle littérature française* (Paris, 1949), p. 29.

and straight-faced manner imaginable. Finally, and this is intimately tied in with Jacob's great capacity for empathy, the poetic texture appears overrich, bizarre, contradictory. It becomes difficult to assimilate so much confusion, so many anguished penitential cries interspersed through so much acidulous social commentary. There remains nevertheless the distinct impression of an expansion of matter.

Associated with the often excessive verbal play, there is a great deal of humor within the serious poetry, some of it black humor, some of it *grosse blague,* some of it infantile, and all of it disrespectful of and destructive to poetic conventions or decorum. At times, Jacob seems to have combined the depth probing of the decadents and the minute observation of the naturalists with an added humorous dimension, and to have created thereby a richer, more variegated poetic texture.

If the symbolists reached ever upward toward an esthetic absolute, Jacob's contribution was to reach always downward. He tries to plumb the depths of the self and as the images of his poems build up and burst, the emotional content seems to grow in depth. We might call it a persistent penetration of the poetic texture by the genuine emotional expression of the poet's being. And this brings us to another general category of positive aspects: involvement or, in existentialist parlance, *engagement,* which is made manifest in four ways. The first manifestation of it can be credited to the tenacious retention of the plastic image, strange as this may at first appear. Judkins expresses it thus:

> . . . It is usually pointed out, and not without a certain hint of disappointment, that the cubists never quite broke free from the final vestiges of recognizable forms, as though this were indeed their goal. In the light of our observations we feel confident in saying that nothing could be farther from the truth. For no matter how indispensable to that ultimate development may have been the inroads made by the cubists in their quest for compounded appearance, it is clear from the very nature of this objective why those last vestiges of recognizability could never be thrown off.[7]

In other words, in order to accomplish his task of destruction, Jacob needed a target ever-present within the work itself to aim at, one which was part and parcel of his background and formation. In his ridiculing

[7] "Toward a Reinterpretation of Cubism," p. 278.

of certain conventional literary or social modes, he shows that he remained deeply attached to them and is, in short, expressing at one and at the same time both aspects of a dual vision, backward and forward. He reveals the profoundest folds of his individual psyche by not ever adopting, at least not for long, some mere posture.

A contributory factor here was Jacob's undeniable anguish. He was tiny, weak, a pervert, a pauper, a failure at everything, in short, the unhappiest of mortals. Along with this, he remained mired in all the most unattractive manifestations of bourgeois culture and hated himself vigorously for it, so that whether viewed from one point of view or the other, he had constantly within himself the elements of his own dissolution. Even his conversion, surely an act of *engagement*, failed to bring him a large enough measure of peace, as we see from the *Derniers poèmes*.

The third factor was a truly brilliant lucidity. Jacob proved to be, at worst, only a *partial* dupe of any given ideological position. He was perfectly aware of the sham, hypocrisy, and contradiction of the Belle Epoque, even though he participated in it, but in the end, he invariably saw through the futility of all its maneuvers. Not only did Jacob behold the world of the past with perfect lucidity, he lived with equal acuity a contemporary moment of palpitating immediacy always unfurling around him.

And this brings us to the last facet of the cubist *engagement*, a sense of "becoming." Jacob, along with the other cubists, had transformed all the dramatic instants of a life of privation and suffering, of humor and fantasy, into the marvelously rich texture of the work of art. And art had become for these men total penetration, or rather total interpenetration, the work, without exception, reflecting in one way or another the tension of the life. Art, moreover, became the uniquely satisfactory means of responding to the harsh exigencies of an absurd world, the sole adequate offense one could give to a hypocritical social order, and the turning point into a path of authentic contemporary expression.

Closely related to the foregoing is cubism's pivotal function. It should be emphasized that although cubism's importance does not lie here, its destruction of older forms, its virtually unlimited range of subject matter, and its immense fertility establish it as *the* great transitional movement. Janus-like, its practitioners gaze in two directions: to-

ward a past century of literary and artistic conventions and toward an era of changing preoccupations and dynamic expression. Cubism then, viewed from the standpoint of art history, shows itself the hinge upon which all other genuinely modern movements were to turn.

Of the obvious ways in which cubism served as a transition, the first and foremost is cubism's retention of the conventional plastic image, if only in the interest of demolishing it afterward. And without the "old," there is no continuity in the "new." In fact it is not until much later, when successive developments had further liberated artistic canons, that the plastic image becomes increasingly fragmented, more grotesquely manipulated, and finally disappears altogether into a sea of non-objectivism or reappears in a still more recent contemporary dress as "pop" art, but liberated from any meaningful connotations.

The cubists liberated the subject-matter of art by daring to strike out into heretofore unexplored or little-explored realms of expression. All aspects of modern life were treated without false modesty: new words, slang, peasant speech, preposterous dirty jokes, the deepest unconscious stirrings, religious meditation, as well as utterances of the most bombastic and conservative stripe (for parody)—all contributed by adding a new dimension to the poetic texture. Madness, perversion, helplessness, bitterness, unabashed sexual portrayals, all of these are to reappear in the literature of the century, especially in surrealism and post-surrealism.

Still another factor of cubist poetry was the virtual obsession with language, especially puns. This tendency, of course, consigns it to a historical place in the development of French literature, representing a long-standing but only intermittently practiced current. Punning was to have a capital influence on surrealism, and on the post-surrealist movements including many current individual practitioners who find precedents and excellent models among the cubists and above all in Jacob. And presently specific lines of force between the punning of Jacob and the punning aspects of surrealist poetry will be demonstrated (pp. 147–69).

The last of these factors is the astonishing projection of cubist themes and techniques—and again especially on the part of Max Jacob—into those of future artistic movements. The mixture of real and unreal, the lengthy inventories (as if a child were detailing the contents of his pockets), the emotional leaps and bounds, the disrespect for institutions,

the nihilism, the lyric flights, the unmistakable sincerity, and above all, an implacable hatred of sham and injustice, these are among the themes already adumbrated by the cubists that will preoccupy the surrealists and the post-surrealists. As for techniques, a dazzling verbal volatility and an emphasis on all sorts of humor are only two of the many which we have found so abundantly in Jacob.

Now it is essential to sum up these factors gleaned partially from the Gris canvas and which trace so many parallels between the painterly expression of the cubists and the poetic one of Max Jacob. It is furthermore interesting to note that these tendencies so carefully compiled by critics of painting not only apply to Jacob but to many other writers of the movement, notably Guillaume Apollinaire, as well as to the foremost literary exponents of surrealism and post-surrealism (although this is not the place to trace additional and perhaps more tenuous lines of force between other writers and Jacob).

As has been stated at the beginning of this chapter, there are three major recognized periods in cubist evolutionary development. Judkins, in his analyses often tends to disregard them or, at least, to overstep the boundaries between them and, in fact, it does not seem indispensable in pursuing our analyses of the relationships between cubist painting and cubist writing to distinguish between them. The third or synthetic stage, however, does show particular affinities with Jacob.

It was, as will be remembered, a phase of "calm and clarification" in which "the tableau is no longer split apart but summarized and the object is intertwined with the form."[8] This too can be found in Jacob's later poetry, especially in the *Méditations religieuses* and in *Derniers poèmes*. The former are simply long monologues addressed to God, full of a spirit of humble piety and supplication but devoid neither of the perilous leaps and bounds nor of a certain wry humor.

> Maintenant vous avez atteint votre bienfaisant but qui était de me relever jusqu'à votre troupeau de brebis, comme vous dites, et me voici, moi, pauvre juif vieux et stupide, au milieu de cette merveilleuse cohorte de chrétiens aux âmes d'ivoire. Quel bonheur vous dois-je: la rémission de mes péchés, le don du repentir. . . . (*Med. rel.*, p. 134)

> [Now you have attained your beneficient end which was to raise

[8] Alfred Schmeller, *Cubism* (New York, n.d.), p. 12.

me up to the level of your flock of lambs, as you say. And here I am, me, a poor Jew, old and stupid in the midst of that marvellous cohort of Christians with ivory souls. What happiness I owe you: the re-mission of my sins, the gift of repentance.]

This meditation is imbued with a kind of appeased anguish. But a hint of something less respectful, perhaps a trace of the *bagou parisien* in the *troupeau de brebis, comme vous dites*—one can almost hear *tu parles, on peut le dire, comme qui dirait*, and other expressions of this sort—leads one to wonder whether Jacob's sincerity goes as far as it at first appears to. One wonders if he is completely serious in comparing himself, a poor and stupid Jew (which he knew he was not), to Christians with ivory souls (which he knew they were not either).

Again in the *Derniers poèmes*, he exhibits a certain *recueillement* perhaps not so much in evidence in the earlier works, a kind of unity or integration of mood.

Amour du prochain

Qui a vu le crapaud traverser une rue? C'est un tout petit homme: une poupée n'est pas plus minuscule. Il se traîne sur les genoux: il a honte, on dirait? . . . non! Il est rhumatisant. Une jambe reste en arrière, il la ramène! Où va-t-il ainsi? Il sort de l'égout, pauvre clown. Personne n'a remarqué ce crapaud dans la rue. Jadis personne ne me remarquait dans la rue, maintenant les enfants se moquent de mon étoile jaune. Heureux crapaud! tu n'as pas l'étoile jaune. (*Dern. po.,* p. 172)

[Love of One's Fellow Man

Who has seen the toad crossing the street? He's a tiny little man: a doll is not more diminutive. He drags himself along on his knees. He is ashamed, you might say. No! He is arthritic. One leg drags behind and he pulls it along after him. Where is he going that way? He is coming out of the sewer, poor clown. Nobody has noticed the toad in the street. Formerly, nobody noticed me. Now children make fun of my Yellow Star. Happy toad! you don't have a Yellow Star.]

Incidentally, this poem has become relatively celebrated since the war, read in connection with the ordeal undergone by the Jews in general and Jacob in particular during the infamous racial persecutions. Seen against the perspective of Jacob's death in the relocation center of Drancy where

he was waiting to be shipped to Germany, it has probably inspired more sympathy for the author than any other piece published during his lifetime.

In any case, the poem reflects the selfsame cubist procedures: images which refuse to materialize, a constant metamorphosing of half-formed images, an ever-increasing plumbing of the emotive texture with a corresponding intensity of significance. The central personage is first announced as a toad, but then becomes a little man. We must notice that, *after* the figure has sufficiently materialized to permit identification, Jacob attenuates the image by adding the word, doll. Then he is a tiny man walking on his knees for shame, but no, it is not as bad as all that, he walks on his knees only because he is arthritic! None of these metamorphoses completely replaces the preceding ones; the fragments remain suspended.

The *dénouement* presents a tragic picture etched in scorching vividness by a system of overlapping planes (somewhat like those of Gris' checkerboard), in this instance, overlapping planes of degradation. The image wavers between toad, tiny man, doll, and cripple—all paltry or negligible things—before finally materializing into a Jew, thus demonstrating the depths of scorn that Nazi persecutions had imparted to the word Jew and to the people it denotes. With the rueful accents of the last phrase spoken in the first person, one comes to know the puzzled bitterness, the mortal disappointment of the innocent human being awakened to the hatred of which he is the object.

In the first section of this study, we have examined short texts of Max Jacob ranging probably from 1903 to 1943. It has been possible to catch glimpses of new creative processes, not unrelated to those found in painting, taking their point of departure from an altered vision of reality and combining elements of earlier visions. Many of Jacob's techniques too were quite original but neither vision nor technique was so far-removed from traditional modes as to preclude apprehension, defy analysis, or escape classification. The depth of Jacob's cubist vision can be intimated from the fact that, as with his friends Picasso and Braque, after forty years of experimentation he remained substantially a cubist to the end of his days.

IV. Sense versus Nonsense

OUR CONFRONTATION OF CUBIST PAINTING and poetry has revealed a body of common features within the very fiber of the abstraction itself, features moreover which seemed successfully to bridge the physical gap between the two media. These common features existed not only vertically, between parallel artistic techniques, thematic preoccupations, and ideological animosities, but horizontally as well, between parallel developments of both media in this particular esthetic system through its various stages and also in its implications, historical, social, and psychological.

The two media were shown to share a common optic, a common *mystique*, a common revolutionary ideal, and a common (though often carefully dissimulated) attachment to the past. Joined to these was a much-advertised hatred for all that was bourgeois: conventional artistic composition, accepted social institutions, personal values generally considered praiseworthy, and traditional intellectual logic. Both painting and poetry had evolved a common method for the perception and transformation of reality.

Acquaintance with the method has now enabled us to penetrate somewhat below the checkered surface of the work of art, to follow lines of force out to their logical conclusions, and to restore a measure of rational order to the first-impression crazy-quilt pattern. It has also permitted

us to infer other and deeper meanings than those often flamboyant can-
vases or *poèmes en prose* appeared to offer for immediate apprehension.
In other words, the method rendered the dynamics of the abstraction
cogent.

Now armed with a reasonably clear notion of cubist procedure, we
shall go on to analyze earlier and perhaps more basic texts of Jacob,
chiefly from the *Matorel*. These, at first presenting a dense and nearly
impenetrable surface texture, may eventually be made to give up their
complicated secrets. To this end, they will be treated in three stages.

In the first stage, these passages will be subjected to close reading
and analysis by *explications de texte* which can bring out a certain sum
of meaning. Ultimately, however, it will become apparent that some
essential ingredient is lacking in our data, its absence persistently pre-
venting us from making our synthesis. Further examination reveals that
missing ingredient to be an understanding of Jacob's private symbolism,
which consists of historical, literary, and ideological models for many of
the seemingly arcane features of his prose.

In the second stage, an exhaustive comparison will be made between
these sources and the use Jacob makes of them throughout his work,
especially in the *Matorel*. They will be identified in each of their principal
manifestations and their social, psychological, and philosophic implica-
tions for the work traced. Finally, in the third stage, these recurrent
models will be seen to be "obsessive images" and identified in their sev-
eral incarnations within the poetic tissue.

The *Saint Matorel* (1911) is Jacob's first book of consequence, pre-
dating the *Cornet à dés* by six years.[1] One imagines the reactions of a
reader upon opening it and finding this:

A Picasso

pour ce que je sais qu'il sait
pour ce qu'il sait que je sais

Max Jacob

[1] The title page, however, carries the following information: "N.B.—Ce livre,
écrit en 1909, a d'abord paru en trois volumes, tirés à peu d'exemplaires, par les
soins de la Galerie Simon, 29 bis rue d'Astorg, avec des illustrations de Picasso et
d'André Derain." In other words, although the *Matorel* is dated 1911, there exists a
gap of three years between the *end* of its completion and its publication. This would
indicate that the *Matorel* and the *Cornet à dés* were composed during approximately
the same period, 1903–9.

[To Picasso

for what I know that he knows
for what he knows that I know

Max Jacob]

Prologue

"Satan n'est pas plus gros qu'une marionnette; on en connaît les
fils, mon vieux! D'abord, remarquons que, si tu as des cornes, ce
sont les mêmes qu'a Moïse! Remarquons ensuite que, si tu as des
ailes de chauve-souris, le hibou est l'oiseau de Minerve, Pallas-
Athênê! Ceci entre nous pour ce que tu sais et pour ce que je sais.
Remarquons ensuite! . . . Oh! tu trouves à qui parler, va! j'ai étudié
au monastère de Barcelone! Remarquons, dis-je, que tu n'as pas le
fameux sabot de cheval, le même dans lequel on buvait les noires
eaux du Styx d'Arcadie. Le fameux sabot de cheval, pourrait peut-
être faire peur à l'état de mon âme! Mais nous remarquons, nous
remarquons, dis-je, que tes chaussures de marionnettes au bout de
tes fils sont les plus exquises chausses qu'aient jamais chaussées
chausseurs de chausses, ce sont chaussettes et non chaussures, chaus-
settes de velours noir à fils rouges. Donc, Satan! nous n'aurons plus
peur ici même dans ce séjour de la mort, plus peur, dis-je que de
l'Octogonal! Houm! l'Octogonal, ce qui veut dire l'irrégulier ou le
régulier, je ne sais. . . . A vous Messieurs les Kabbalistes, s'il en est
dans l'Hadès. . . . Cependant le chapeau jésuitique en croissant de plat
à barbe m'induit peut-être en erreur. Calomniez! calomniez! il en
reste toujour quelque chose! et c'est le chapeau qui tient les fils. . . .
Je ne dis pas! Ouais! mais chapeau n'est pas sabot! Or, je ne vois pas
la moindre trace du sabot de cheval dans lequel on buvait les eaux du
Styx, si mes souvenirs ne me trompent point. Je conclus donc de ceci
que mon âme est sauvée; et c'est tout ce que je voulais savoir!"

Ainsi parla Victor Matorel, en religion Frère Manassé, lorsque les
cloches sonnèrent sa mort. Cloches, sonnez! Sonnez, cloches! Ténè-
bres et obscurité de ténèbres, ouvrez-vous! Frère Manassé est mort de
faim, d'abstinence, et Victor Matorel est mort. . . . Qui lui eût dit de
son vivant qu'un jour il serait mort? . . . (pp. 9–11)

[Prologue

"Satan is no bigger than a marionette. We know the strings, old
chap. Let us observe first that, if you have horns, they are the same
as those of Moses! Observe further that, if you have batwings, the
owl is the bird of Minerva, Pallas Athene! This, confidentially, for

what you know and for what I know. Observe beyond this! . . . Oh! you've found the right man to talk to! What else? I've studied at the monastery of Barcelona! Observe, I say, that you do not have the famous horse's hoof, the very one in which they used to drink the black waters of the Styx of Arcady. The famous horse's hoof might perhaps be capable of inspiring fear as to the state of my soul! But we observe, we observe, I say, that your marionette shoes at the ends of your strings are the most exquisite pair of hose that ever wearers of hose stepped into; they are stockings and not shoes, stockings of black velvet with red cords. Therefore, Satan! we will be afraid no longer even here in this sojourn of Death. No longer afraid, I say, but of the Octagonal! Hum! The Octagonal which means the irregular or the regular, I don't know. . . . It is up to you gentlemen, the Kabbalists, if there are any in Hades. . . . However, the Jesuitical hat in the shape of a shaving bowl induces me perhaps into error. Calumniate! Calumniate! Some trace of it remains! And it's the hat that holds the strings. . . . I don't say! Yup! But hat is not hoof! And here I do not see the least trace of the horse's hoof in which they used to drink the waters of the Styx, if my memory serves. I conclude therefore from all this that my soul is saved; and that is all I wanted to know."

Thus spoke Victor Matorel, in religion Brother Manasse, when they tolled the knell for his death. Bells, toll! Toll, bells! Shadows and darkness of shadows, open up! Brother Manasse is dead of hunger and abstinence and Victor is dead. . . . Who would have thought during his lifetime that one day he would be dead?]

There is nothing particularly "modernistic" about the dedication; on the contrary, it depends for its effect on a simple, traditional device, a chiasma. Jacob creates word-play equilibrium between two personal pronouns and two phonetically identical forms of the verb *savoir*, repeating the rest of the phrase intact. He thus produces the tension of a small closed circle which symbolizes the deep reciprocal understanding between these two men, who were at the time of composition, 1909, close friends who had briefly been roommates. (It is also noteworthy that Picasso had not yet obtained much more than a modest success as a painter, so Jacob cannot be accused in this instance of name-dropping.)

Turning to the "Prologue" proper, however, the reader is virtually swept off his feet on wave after wave of the many-faceted prose. In the best cubist manner, the prose is composed or, one might say, compounded of mystical fantasy, rhetorical declarations, allusions to antique culture, references to the real world, and familiar asides, disconnected

and without transitions. As it takes shape in the reader's mind, it turns out to be Matorel addressing the Devil in a series of six exclamatory sentences.

These establish themselves in a pattern: an unpleasant thesis expressed in a first clause followed, in the second clause, by a palliative antithesis. For example, the awful presence of Satan is palliated by his being scaled down, optimistically, to puppet size. Indeed, Matorel is so comforted by the knowledge that the strings are there that he uses the familiar *mon vieux*, out of keeping with the tone of the rest, as a spot of relief. In the next sentence, the Devil's horns are equated with those traditionally attributed to Moses, perhaps a way for Jacob to equate Satanism and his own Jewishness.

We are here again in the presence of typical cubist procedures: a myriad of images, in several stages of materialization and without or with only questionable transitions, varying levels of diction, a *mélange* of the serious and the comic. On the contextual plane, one meets the Devil, a penitent sinner, and the sinner's frightened, garrulous, and not entirely convinced optimism. On the stylistic plane, there is a strident exclamatory tone, with the interjection of a confidential tone referring archly back to the dedication, gratuitous word-play, and a duality of expression.

After the initial reassuring sentence, the interjectory *d'abord* directs our attention to the *remarquons*, first in a series of six uses of the word to appear within the space of thirteen lines. Thus exaggeratedly repeated, *remarquons* acts as an admonition, while at the same time it defines Matorel as a fatuous character whose inflated "eloquence" unexpectedly gives way, when he is not watching himself, to an ordinary level of speech. This lapse corresponds somewhat to Jacob's own giving way to a latent romanticism when he forgets to be "modern," as is claimed by his critics. The first person plural imperative *remarquons*, also introduces the gratuitous and garbled allusions to the Old Testament and to Greek mythology: *Moïse . . . Minerve . . . Pallas-Athênê . . . le Styx.*

Then the dedication to Picasso is interpolated into the text as a statement to the interlocutor, a device which breaks up the dramatic verisimilitude of the frantic allusions and introduces a note of the *quotidien*, the familar and commonplace into an otherwise fantastic tissue. This is the

cubist practice we have observed in which formal language and matter give way to informal language and matter in the destruction of a realistic surface that is, after all, anti-literary. The passage is interrupted with, *Oh, tu trouves à qui parler;* that is, Matorel feels called upon to remind his listener that, after all, he, Matorel, is a learned man having studied at the monastery in Barcelona and that, consequently, what he says must be worth listening to.

The fourth *remarquons,* followed by the unconventional *dis-je,* leads through more classical allusions (such as drinking the waters of the Styx rather than the Lethe, a significant mistake immediately following Matorel's claim to learning)[2] and finally into some Rabelaisian word-play. The repetition, reminiscent of the dialogue of a marionette theater, of several variations on the word *chausse* and *chaussette* suggests the bobbing and jerking of the puppet. It ends, inappropriately enough, on a description that might have been taken from the style of fashion reporting with an enumeration of black velvet and red cords.

An incongruous *donc* affirms Matorel's confidence of having nothing to fear even where he now finds himself, that is, in the Valley of Death. But that hopeful affirmation immediately dissipates itself in a thought of the mystical "Octogonal," the meaning of which, Matorel candidly admits (raising the tone slightly by omitting the *pas*) he does not know. Instead, he leaves the problem to the Kabbalists yet expresses a most unorthodox neutralism about whether there actually are any Kabbalists in Hades. He then concedes that the Jesuitical hat, like a shaving bowl (might not this be a veiled reference to Judaism's injunction against shaving?) and symbol of casuistic theology, perhaps induces him into error.[3]

In the light of Jacob's intense concern with religion (he had his first vision in 1909, the year the *Matorel* was completed) and against the background of Catholic theology, one might interpret these lines to imply that this Jesuitical hat not only holds but *pulls* the strings. This jumble

[2] As for drinking the waters of the Styx in a horse's hoof, the only tradition even remotely resembling this in classical antiquity is that of the Hippocrene fountain which is supposed to have gushed forth on the spot where Pegasus struck Helicon with his hoof. See Oskar Seyffert, *A Dictionary of Classical Antiquity* (New York, 1956), pp. 465–66.

[3] It is not impossible that Jacob is thinking here of St. Thomas Aquinas.

of pious exclamations intermixed with vague allusions to classical, numerological, and Kabbalistic lore, and condimented by formal turns of phrase (the above-mentioned *je ne sais* omitting the *pas*, the *s'il en est* for a more usual *s'il y en a*, and the emphatic *point*) brings the entire statement to that ironic non sequitur: *Je conclus donc de ceci que mon âme est sauvée*, serving as a climax and putting an end to the zig-zag pattern.

The "Prologue" is actually a comic sermon with tragic overtones, as the persistent and pitiable attempts to minimize its implications indicate. Matorel, notwithstanding his hopeful protestations to the contrary, finds himself in Hades. The rush hour pace of the declamation, seemingly devoid of poetic intent, along with the rapid exclamatory diction and the jumbled succession of preposterous ideas foreshadows the episode that is to take place in that other Hades, the Paris Métro, where Matorel turns up as a guard.

The childlike, weak, wish-fulfillment quality of Matorel's "logical" conclusions are to be found abundantly throughout Jacob's later work whenever he feels oppressed by unpleasant, restrictive, or frightening reality. Certain definite stylistic traits have already made their appearance: the admixture of the real and the supernatural—here the dedication to Picasso intruded in the midst of these mystical declarations; Jacob's continued giving in to the associative attraction of the sound of words such as *chapeau-sabot*, with its semantic polarity; and two expressive levels maintained side by side, the lofty and the slangy.

The anti-poetic quality of the discourse is made more evident by contrast with the next paragraph which reeks of heavily "poetic" intent. Using the most transparent of devices: somber nasals, open posterior vowels, and a slow-measured, repetitive diction, the poem imitates the solemn tolling of bells. The neat duality between Frère Manassé and Victor Matorel is maintained, the two names and identities being intertwined until at the end, they become one in death. One might say that this passage is written in the key of *or:* Vict*or*, Mat*or*el, m*or*t, all repeated several times; and the obvious poetic intent is heightened by the total lack of dialogue.

Next occurs an ostensibly disconnected speculation on the proper placing of the Prologue:

Il aurait peut-être fallu réserver ce Prologue pour l'épilogue. . . .
Victor, en religion Frère Manassé, est mort. . . . Mais les formes sont
immobiles et mobiles éternellement dans le ciel et il n'y a pas d'ordre
chronologique pour Dieu. Or, nous sommes dans nos oeuvres comme
Jéhovah dans les siennes. Il n'y a pas d'ordre chronologique pour
nous. . . . Donc, Prologue. (*St. Mat.*, p. 10)

[It would perhaps have been better to reserve this Prologue for
an epilogue. . . . Victor, in religion Brother Manasse, is dead. . . . But
forms are immobile and mobile eternally in the sky and there is no
chronological order for God. Now we are to our works as God is to
His. There is no chronological order for us. . . . Ergo, Prologue.]

Here is another typical cubist expression of temporal-spatial volatility:
prologue equated to epilogue, a polarity much like mobility and im-
mobility being simultaneously present.

The same notion, by no means an unfamiliar one to our recent con-
temporaries, turns up in Albert Camus where he maintains that

les méthodes impliquent des métaphysiques, elles trahissent à leur
insu les conclusions qu'elles prétendent parfois ne pas encore con-
naître. Ainsi les dernières pages d'un livre sont déjà dans les
premières.[4]

[Methods imply metaphysics. They betray, unbeknownst to them-
selves, the conclusions which they sometimes claim not to know of in
advance. Thus the last pages of a book are already present in the
first.]

while Gide makes Edouard take the idea into account, only to reject it
and contend the reverse:

X. soutient que le bon romancier doit, avant de commencer son
livre, savoir comment ce livre finira. Pour moi, qui laisse aller le mien
à l'aventure, je considère que la vie ne nous propose jamais rien qui
. . . ne puisse être considéré comme un nouveau point de départ.[5]

[X. maintains that the good novelist must know, before beginning
his book, how that book will end. For me, I let mine go where it will.

[4] *Le Mythe de Sisyphe* (Paris, 1942), p. 26.
[5] André Gide, *Les Faux-Monnayeurs* (Paris, 1925), p. 258.

I maintain that life never proposes anything to us that cannot be considered as a new point of departure.]

The reader should keep this idea of simultaneity in mind for the later development.

The "Prologue" concludes:

D'abord un Jésuite à face verte agita un petit diable. Victor Matorel lui adressa le discours qu'on vient de lire. Ensuite il y eut des chiffres! Il résultait des chiffres que Victor Matorel, avant et après la conversion, avait été un être flegmatique propre à recevoir plus qu'à donner, vindicatif, prompt à s'enivrer, plus insensible qu'un porc et plus étourdi qu'un moineau. . . . Cependant, Victor Matorel s'aperçut qu'il avait une auréole, qu'il montait au ciel à cheval, et qu'un cygne volait au-dessus de sa tête. Ensuite, Victor Matorel s'aperçut que son double était en croupe du cheval qu'il montait. Il reconnut dans le double son ami Cordier. Le cheval suivait le chemin du zodiaque; le cheval leur recommanda le silence et la gravité, puisqu'ils étaient morts, et Victor Matorel se souvint qu'il avait été dix-neuf mois Frère Manassé au couvent Sainte Thérèse à Barcelone, chez les Lazaristes. Il se tut et observa. (*St. Mat.*, pp. 10–11)

[First a Jesuit with a green face shook a little devil. Victor Matorel addressed the discourse that we have just read to him. Then came the numbers! It resulted from the numbers that Victor Matorel, before and after the conversion, had been a phlegmatic creature, more apt to receive than to give, vindictive, quick to intoxication, more unfeeling than a pig, and flightier than a sparrow. However, Victor Matorel observed that he had a halo, that he was riding up to heaven on a horse, and that a swan was hovering over his head. Then Victor Matorel noticed that his double was riding with him seated behind on the horse that was rising. He recognized in the double his friend Cordier. The horse followed the path of the Zodiac. The horse warned them to be silent and grave since they were dead and Victor Matorel remembered that he had been nineteen months Brother Manasse at the convent of Saint Theresa at Barcelona with the Lazarists. He was silent and observed.]

A noteworthy feature of this passage is that it provides us in specific terms that initial stimulus, lacking at the outset, which had set off the whole series of delirious associations: a doll-like devil being shaken over the dying Matorel by a Jesuit. This is the object about which the entire

fantasy turns. Again Matorel's and Jacob's fascination with numerology is in evidence but treated in a humorously off-handed manner, and this serves as a pretext for a fairly detailed *mea culpa*. In the *avant et après la conversion*, there is again typical cubist polarity but here heightening the effect rather than cancelling it out. The essential for Jacob is that, all indications to the contrary not withstanding, Matorel has gone to heaven, a good augury for Jacob himself. At the end, we catch an abrupt glimpse of Emile Cordier, that archetypal cad, as he is portrayed later in the book, seated on the horse's rump and ascending to heaven behind Matorel.

The relatively short prologue leads directly and without transition into the text:

PREMIERE PARTIE

LA TERRE

CHAPITRE PREMIER

UN EMPLOYE DU METROPOLITAIN

Ai-je le droit de révéler des secrets que Dieu seul connaît, puisque Matorel ne s'est confessé qu'à Dieu après qu'il s'est fait moine Lazariste? . . . Surprenant garçon, en vérité, ce Victor Matorel, le futur Frère Manassé! Surprenant garçon que j'ai connu lorsque j'étais moi-même balayeur à la maison Chieret et Cie, faubourg Saint-Antoine! O mânes du timide Matorel! je ne troublerai point votre définitif repos céleste pour que vous m'autorisiez à révéler les tristes beautés de votre âme. Aussi bien, je n'ignore pas, petit Parisien du faubourg, que la littérature n'est point pour vous déplaire, et que, du haut du ciel, vous sourirez en lisant au-dessus de mon épaule vos aventures terrestres et célestes. Que Dieu nous pardonne à tous deux de telles vanités! A moi-même que Dieu pardonne mille indiscrétions touchant nos religions à tous. Peccatoribus misericordia. Ave.

—Quand on est par malheur devenu un gueux fou, prononça Victor Matorel que je rencontrai employé du Métropolitain prodiguant des amabilités aux voyageurs de première classe, il ne faut point paraître un fougueux, ou bien le propriétaire de cette chaste nuque, qui est l'eunuque, on l'enverrait à Saint-Maurice se faire faire un complet blanc! Savez-vous pourquoi les Chinois . . . Barbès-Rochechouart! République, Bastille, Italie changent de train! Savez-vous pourquoi les Chinois? . . .

Mon petit ami Victor était devenu fou; il semble pourtant qu'il m'ait assez intéressé puisque, devant quitter la voie à Villiers,

j'écoutais encore à Dauphine les divagations du malheureux Matorel!

—Il y a des toiles d'araignée aussi dans l'absolu! disait-il.

Il me parla de l'importance de l'amour sur terre, du cube et du cercle, des armées vibratoires qui sont les démons et les anges, de la nécessité d'écorcher le dos aux hommes pour les rendre sensibles, à cause des ouvertures de la colonne vertébrale:

—La bouche, les oreilles, les yeux sont des endroits maigres, les pieds aussi et les mains! Au lieu de se moquer des ventres, on devrait plutôt rire des dos gras!

Il m'étonna si profondément que je ne fus pas surpris quand je connus les effroyables hallucinations qui l'attaquaient en dehors du service des trains:

—Hier soir, mon cher, me disait-il, un matamore de ma chambre tenait son pif cyranique dans un col blanc! Il voulait saisir un nain, mais ce nain était un énorme paquet de tabac. Le tabac me mordait les doigts en ricanant, mon cher!

Pauvre garçon! il était pourtant de bonne santé il y a trois ans: petit homme mal chaussé! les passants des rues se moquaient de lui; un chef de rayon le traita un jour de grotesque. Sous l'uniforme il était moins ridicule.

Je lui demandai des nouvelles de Léonie sa maîtresse, de mademoiselle Berthe la téléphoniste, et du beau Cordier: Emile Cordier, le comptable aux caleçons de soie rose!

—Mademoiselle Berthe est mariée! Emile Cordier a épousé la fille d'un patron du faubourg; sa belle-soeur est amoureuse de lui: il les trompe toutes les deux avec la bonne.

—Et vos maux d'estomac, Matorel?

—Vous voulez dire ce potiron! Ah! la montagne d'or! elle a la corne en obélisque! une procession en velours s'y délace! ou plutôt une palissade! ah! qu'on a mal à . . . mal à la . . . Walhalla . . . on a si mal à . . . mal à la . . . mal à l'estomac . . . Thomas! Si l'on y regardait de plus près, on connaîtrait à ce pèlerinage des faces de vieilles dames! . . . Vous a-t-on jamais parlé d'une histoire de malle? Moi, voleur? Ah! par exemple! . . . D'abord on n'en a jamais rien su et puis, en somme, je n'ai pas été congédié! Un jour, la tente de la maison de détail étant baissée, le chef me dit: "Vous avez baissé la tente, Matorel.—C'est pour vous faire voir quelqu'un! En effet, entre le comptoir et la glace apparaissaient deux chères ombres absentes, deux réalités tenant des accessoires de cotillon!

Des accessoires de cotillon! Oh! Matorel! Matorel! le malheureux! Je ne puis m'empêcher de l'aimer et de le plaindre: après la conversion, il devint mystique. Il écrivait des lettres à Dieu, à Jésus, aux saints, aux puissances de l'air. . . . (pp. 15–17)

Do I have the right to reveal secrets that God alone knows since Matorel only confessed to God after he became a Lazarist monk? Surprising young man really that Victor Matorel, the future Brother Manasse! Surprising young man whom I knew when I myself was a sweeper at Chieret and Company, Faubourg Saint-Antoine! Oh shades of the timid Matorel! I will not trouble your definitive celestial rest so that you authorize me to reveal the sad beauties of your soul. In addition, I am not unaware, little Parisian of the slums, that literature does not exactly displease you and that, from your place in Heaven, you will smile reading your terrestrial and celestial adventures over my shoulder. May God pardon us both such vanities. Myself, may God pardon me a thousand indiscretions touching our common religion. *Peccatoribus misericordia. Ave.*

"When, through misfortune, one has become a mad beggar," pronounced Victor Matorel whom I encountered working as a subway guard, lavishly complimenting the first-class travellers, "one mustn't at all appear to be an impetuous fellow or else the proprietor of that chaste nape [of neck] who is a eunuch would be sent to Saint Maurice to have a white suit made. Do you know why the Chinese? . . . Barbès-Rochechouart! République, Bastille, Italie change trains! Do you know why the Chinese? . . ."

My little friend Victor Matorel had gone quite daft. It seems, however, that his talk interested me enough for, although I was supposed to get off at Villiers, I was still listening at Dauphine to the digressions of the unhappy Matorel.

"There are spider webs also in the sky," he used to say.

He spoke to me of the importance of love on the earth, of the cube and of the circle, of the vibratory armies which are demons and angels, of the need to flay men's backs to render them appreciative because of the openings of the spinal column.

He astounded me so profoundly that I was not surprised when I learned of the frightful hallucinations that afflicted him when he was not on duty.

"Last night, my dear fellow, a bully in my room held his Cyrano de Bergerac schnozz in a white collar. He was trying to catch a dwarf but the dwarf was an enormous package of tobacco. The tobacco bit my fingers, snickering all the while, my dear fellow."

Poor chap! He was, however, in good health three years ago: a

little man with torn shoes! Passersby would mock him; his depart-
ment chief called him "grotesque" one day. In his subway uniform
he looked less ridiculous.

I asked him news of Léonie, his mistress, of Mademoiselle Berthe,
the telephone operator, and of the handsome Cordier: Emile Cordier,
the accountant with the pink silk undershorts!

"Mademoiselle Berthe is married! Emile Cordier married the
daughter of a boss in his neighborhood; his sister-in-law is in love
with him: he is unfaithful to both of them with the maid."

"And your stomach troubles, Matorel?"

"You mean that pumpkin? Ah the golden mountain. It has a horn
like an obelisk! A procession of velvet wends its way through. Or
rather a picket fence! Ah! how it hurts . . . how it hurts the . . . Val-
halla; it hurts so . . . it hurts so the. . . . The tummy hurts, Tommy! If
you were to look at it closer, you would recognize in that pilgrimage
the faces of elderly ladies. Did anyone ever speak to you of a trunk?
Me, a thief? Not on your life! First, nobody ever knew anything about
it and besides I wasn't even fired for it! One day when the awnings of
the retail department were down, the chief said to me: 'You've low-
ered the awnings Matorel so you could have a vision.' In fact, between
the counter and the glass appeared two dear absent shadows, two
realities, holding all the accessories for a cotillion."

Accessories for a cotillion! Oh! Matorel! Matorel! Poor, un-
fortunate chap! I can't help loving him and pitying him. After the
conversion he became a mystic. He wrote letters to God, to Jesus, to
the saints, the powers of the air. . . .]

The "Prologue" at first suggested that it was not heaven but to
hell that Matorel had finally come. The dark, dusty, echoing reaches of
the Paris Métro are a further seriocomic representation of the under-
world. The clash of styles, the tissue of contradictions, the series of inter-
ruptions—in short, the whole implausible *mélange* of this passage evi-
dences all the characteristic procedures of cubism which we have observed
earlier.

Let us look successively at the various aspects of the passage. Sty-
listically, we find an opposition between a pompous formalism and the
ordinary speech of the lower class Parisian. Taken in minute detail, we
can see how Jacob builds the formalism from a word like *Métropolitain*,
which sounds stuffy and bureaucratic since *Métro* is in such common
usage that it has ceased to have the ring of an abbreviated form. The
title, however, could be considered merely a formal heading if it were

not immediately reinforced by the *ai-je*, substantially less frequent than *est-ce que j'ai* in conversation.

The *ai-je* then leads into an air of great personal worthiness and discretion with which the chronicler invests himself. Engaging in a serious speculation of a high moral order, he debates with himself about whether he has the right to reveal secrets which he shares with no less august a collaborator than God! It is incontestable that for Jacob and the cubists, both the sentiments and the language of this passage are those of an insufferable bourgeois *littérateur*, representative of all Jacob despised, who "loves and pities" Matorel with good-natured condescension.

Phrases such as: *Surprenant garçon, en vérité, ce Victor Matorel, le futur Frère Manassé! Surprenant garçon*, by their mincing cadence, their repetition, and a sort of well-bred exclamatory quality, lend an air of artificiality which Jacob probably means to be satirical. The sonorous *O mânes*, the sensitivity and discretion implied by the verb *troubler*, the emphatic and slightly archaic *point*, the sermon-like *définitif repos céleste*, the facetious *pour que vous m'autorisiez*, the confidential *tristes beautés*, the mannered *point pour vous déplaire*, the pious *que Dieu nous pardonne*, the smug tone of righteous humility, and, last but not least, the Latin, all impart an unmistakable artificiality and elevation of style.

The speaker tells us that Matorel is a "petit Parisien de faubourg" yet, in his first utterance, *he too* uses the same sort of high-sounding turns of phrase first used by the speaker. Matorel says *quand on est par malheur devenu*, placing the *par malheur* between the two elements of the compound past; he *prononça*, he *prodigue des amabilités*, but to whom? *aux voyageurs de première classe*. He too employs a *point* and, as we have already observed, puns the lower class *gueux fou* into a high-sounding *fougueux*. Then his discourse degenerates into a chain of seemingly unrelated declarations interrupted by shouted Métro stops and instructions to those wishing to change trains.

After a short interpolation by the urbane man of letters, again very much in the tone of the *honnête homme*, Matorel's next direct statement coincides with Jacob's own mystical symbolism: *Il y a des toiles d'araignées aussi dans l'absolu*. The chronicler then reports with infinite indulgence some of Matorel's preposterous mystic theories which at first seem to have a strong astrological flavor, and then lend themselves to distinct homosexual interpretations.

The *toiles d'araignées* expression is, in fact, quite revelatory of Jacob's compositional and ideological preoccupations. At the purely verbal level, the effectiveness of the phrase depends on the pun: *des toiles-d'étoile.* The verbal play evokes a visual image wherein stars merge with spider webs, the figure of wispy, infinitely far-away galaxies, an embodiment of the Hegelian and symbolist Absolute.

Now, as a means of intimating some quality of the Absolute, such a pun is a rather slight device. And had Jacob employed it this once in the *Matorel,* the reader could dismiss it as undeserving of further considera-tion of comment. But later on in the *Matorel,* it crops up again: *La vérité! c'est une étoile d'araignée!* (p. 70), and in a most explicit form this time for Jacob actually supplies the second element of the pun. It also appears in *Le Roi de Béotie* when a young boy, admonished by his parents for talking nonsense at the table, quotes Matorel's nonsense exactly: *Il y a des toiles d'araignées aussi dans l'absolu* (p. 93).

One finds the same image in the *Cornet à dés* but weighing heavily on the star element of the pun-image to the complete exclusion of the spider web element: . . . *une tête folle de poète au ciel de l'école mord une étoile de diamants* (p. 227). Here the star in the sky is of diamonds, hard and cold and sparkling as stars really are, though the sky seems to represent the ceiling of school, whether a school room or a poetic school is not made clear. This passage introduces, however, another element, that of the madness of the poet. And this reminds us that *une araignée au plafond* also indicates madness in colloquial French.

Jacob describes what is evidently the Bateau Lavoir (cf. the passage quoted on p. xiv of this study from the *Roi de Béotie,* p. 37) in the fol-lowing manner: *La maison était en planches et toute en caves. Les pla-fonds servaient de planchers et les poutres d'asiles aux araignées.*[6] The description, a perfectly realistic one, is carried on at a graphically rational level while the word *asile* continues at another level the madness theme (*tête folle*) hinted at in the previous quotation,[7] especially since the word *araignée* is a pun on *aliéné* with which *asile* is often paired.

The word *asile,* in turn, is reminiscent of various madness themes to

[6] Quoted by Robert Guiette, "Vie de Max Jacob," *N[ouvelle] R[evue] F[ran-çaise],* CCL, CCLI (1934), p. 13. Guiette gives no source for this passage.

[7] Cf. the following: "Aussitôt que l'idée du Déluge se fut rassise. Un lièvre s'arrêta dans les sainfoins et les clochettes mouvantes et *dit sa prière à l'arc-en-ciel à travers la toile de l'araignée*" [emphasis added]. Arthur Rimbaud "Après le déluge," *Les Illuminations.*

be found in the *Fleurs du mal,* such as those developed in "Spleen, LXXVII":

Quand la terre est changé en un cachot humide,
Où l'Espérance, comme une chauve-souris,
S'en va battant les murs de son aile timide
Et se cognant la tête à des plafonds pourris:

Quand la pluie étalant ses immenses traînées
D'une vaste prison imite les barreaux,
Et qu'un peuple muet d'infâmes araignées
Vient tendre ses filets au fond de nos cerveaux.[8]

[When the earth is transformed into a dank cell
Where Hope, like a bat,
Goes about brushing the wall with her wing,
And thumping her head against the rotted timbers

When rain, spreading out its immense rivulets,
Imitates the bars of a vast prison
And when a silent people of horrible spiders
Comes to spin its webs in the depths of our minds.]

The earth itself is here changed into a dank cell, as of a madhouse. The bat banging its head on the rafters again suggests madness both in the desperate physical act of banging its head and in the rotted beams of the ceiling representing the decayed interior of the cranium. In English, the bat is often associated with insanity, for example, "bats in the belfry," "batty," and so on; Baudelaire knew English well and probably is referring to this expression, an impression reinforced in the next verse by his use of the word *battant,* possibly a bilingual pun.

In view of the foregoing, it is illuminating that the spiders draw their *filets* (which may be equated to *toiles*) in the depths of the mind, another symbol of the Absolute. If we follow the progression: *filets-toiles-étoiles,* skipping from sense to sound, we move from the repressive webs of repulsive (*infâme*) spiders outward and upward to an Absolute which exists in, or can be known by, the mind.

The repeated linking of the notion of the Absolute with the image of the spider web can be traced from its punning first appearance in Jacob,

[8] Charles Baudelaire, *Fleurs du mal,* in *Oeuvres complètes,* ed. Alphonse Lemerre (Paris, 1941), p. 215.

in which it symbolizes the Absolute but implies madness, through its various metamorphoses in Jacob in which increasingly it emphasizes the element of madness, back to the poem of Baudelaire, in which it *signifies* madness but implies the Absolute. Its frequency and thematic importance justify our calling it an obsessive image. Several other comparable recurrent private symbols will be studied in later chapters.

The checkerboard pattern continues; Matorel recounts his nightmare using a mixture of high and low speech. The slightly precious *mon cher* occurs twice; the inexplicable *matamore de ma chambre* adds a strange and uneasy note; the slangy *pif* is opposed by the literary *cyranique*; *col blanc* evokes the bourgeoisie; *nain,* "small man," is juxtaposed with "an enormous package of tobacco," presumably illustrating the gigantic size an inanimate object assumes over a human being when habit or desire come into play. The bitten fingers, another frequently recurring image with Jacob (and a standard textbook equivalent for castration), accords itself well with the sadistic snickering.

When the author has brought us to this hallucinatory pass, he paints a realistic portrait of Matorel as the pathetic, half-crazy little man, wearing torn shoes, mocked at by passers-by (much as the "crapaud" was) openly called grotesque by his section chief, but now appearing somehow less ridiculous in his subway guard uniform (a master touch of irony). Some banal small talk, serving to introduce Mlles Léonie and Berthe and to reintroduce Cordier, leads us to Matorel's longest and most significant statement.

Replying to a solicitous inquiry about his stomach trouble, Matorel launches into a complicated fantasy. He first refers slangily to his stomach as "that pumpkin." Then the yellow pumpkin rapidly transforms itself into a golden mountain whose horn (probably summit) is shaped like an obelisk. This leaves us with a three-part image (working backwards): (1) mountain with pointed peak, (2) pumpkin with stem, and (3) belly with phallus (an inference the reader can hardly help drawing).[9] Matorel then likens the uneasy train of his digestion to a procession of velvety consistency wending its way slowly through his bowels (the velvet reminds us of the stockings in the Prologue).

There now occurs some rather subtle play between sound and meaning. On the semantic plane, a material tendency on the part of the "procession" to disperse as it glides softly onward is expressed by the verb

[9] See above, pp. 7–9.

s'y délace which echoes, on the phonetic plane, the sibilance of "procession." The phonemes of *s'y délace*, moreover, are approximately present in *palissade*. That is, the element *s'y* plus the element *délace* combines into [sidelas]. And these three syllables are easily manipulable into [alisad] which, when the initial P is added to it (probably suggested by the initial P in "procession") results in [palisad]. Because of the need to describe a sharper discomfort, the poet transforms *s'y délace* into "a picket fence."

In a similar way, the repetition of [mala], then of [malala], can suggest the only word with which [malala] rhymes, Valhalla (nor should one forget Matorel's and Jacob's preoccupation with salvation and getting into Paradise). The reader has already been introduced to this process of nonsense syllables materializing into words in the famous *Dahlia! dahlia! que Dalila lia*, and we encounter this process again when the last two syllables of *estomac* repeated, give the unlooked-for proper name, Thomas [tɔma]. These sounds [tɔ] and [ma], incidentally, participate in what might be called obsessive sound patterns; Jacob uses them incessantly in his early works: *Toto*, Vic*tor*, *Matorel*, au*toma*te, *Thomas*, ciné*ma*, Ciné*matoma*, *Ma*nassé, and so on.

The repeated word *mal* acts as the phonetic transition to a material object which is its homonym, the *malle* of Cordier. The sudden question phrased in the slightly stilted *vous a-t-on* brusquely changes the setting and makes a gratuitously incomprehensible reference to an episode which will occur later in the text when Matorel *does* steal Cordier's trunk (pp. 46–47), an episode for which the reader has been prepared only by the sound *mal*. Matorel roguishly gives the lie to the accusation, declaring, in a magnificent *non sequitur*, that no one ever found out about it anyway and, after all, he was not even fired for it.

The *Matorel* contains passages of such poetic complexity throughout. The exegete could easily multiply examples of linguistic singularities, especially that curious slippage between sound and sense which is so typical of cubist procedures and gives meaning and texture to Jacob's prose. One could continue to untangle metaphors and unravel images, showing by what approximate cubist technique Jacob achieves any given effect. But such efforts, however conscientious or rigorous, would nearly always be doomed to fall short of their goal because pure exegesis must be aided by a knowledge of literary and biographical events which assumed importance in Jacob's mind.

V. Sources

ALL THE CRITICS of Jacob have experienced a critical *malaise* before the blank wall of ultimate significance. Marcel Raymond has been troubled by the problems of identification that check and limit the reader's penetration of Jacob's writing:

> Venant après un grand siècle de poésie, et décidé à ne pas tenter de refaire ce qui fut maintes fois bien fait, il parodie les *vrais* poèmes tout comme il parodie le style journalistique sans que l'on puisse d'ailleurs, dans la plupart des cas, reconnaître ses modèles.[1]

> [Coming after a great century of poetry, and having decided not to try to do over what had already been done well time and again, he parodies *real* poems as he parodies journalistic style without one's being able, in the majority of cases, to recognize his models.]

As the exegete arrives at that critical point of total penetration, the point at which he might ideally be able to trace the poetic fiction back to the real object, episode, or ideology that had given it impetus, the exegesis nearly invariably stalls and founders in the smoke screen of

[1] *De Baudelaire* (Paris, 1947), p. 256.

Jacob's mystification. Only exceptionally does Jacob take the reader into his confidence to reveal the genesis, personal or doctrinal, of the poetic figuration. This refusal to disclose sources proves all the more regrettable because the intensity of the Jacobean poem derives in the main from one of three fundamental characteristics: the significance of the private symbol, the poignancy of the original situation, or the pervasiveness of a given doctrine.

Biographical Sources

From the examples already examined, we may isolate three basic poetic sources. The first, private symbol and the transformation of that original symbolic object, figures in such poems as "Omnia Vanitas" and "Equatoriales solitaires," in which Jacob refrains from ever identifying the proto-object, and again in "La Mendiante de Naples," in which he *does* supply the missing object.

Normally Jacob presents the reader with an incomprehensible or at least inexplicable image or succession of images (given the information at hand) and then refrains from identifying it. In "La Mendiante de Naples," however, he had at first presented the figure of the "mendiante" and subsequently told us that she was no more than a crate painted green containing some red earth and a few rotten pieces of fruit. Only exceptionally does he start from an object and work toward a vision or image.

An idea of how he does this in a few poems, however, a demonstration affording a clue to the reverse process, can be gleaned from the following:

PETIT POÈME

Je me souviens de ma chambre d'enfant. La mousseline des rideaux sur la vitre était griffonnée de passementeries blanches, je m'efforçais d'y retrouver l'alphabet et quand je tenais les lettres, je les transformais en dessins que j'imaginais. H, un homme assis; B, l'arche d'un pont sur un fleuve. Il y avait dans la chambre plusieurs coffres et des fleurs ouvertes sculptées légèrement sur le bois. Mais ce que je préférais, c'était deux boules de pilastres qu'on apercevait derrière les rideaux et que je considérais comme des têtes de pantins avec lesquels il était défendu de jouer. (*C. à d.*, p. 155)

[LITTLE POEM
I remember my room as a child. The muslin of the curtains over

the glass was crisscrossed by white trimmings. I strained to see the letters of the alphabet among them and when I found the letters, I transformed them into figures that I imagined: H, a seated man; B, the arch of a bridge over a river. There were in the room several wooden chests with open flowers sculptured into the wood. But what I preferred were two newel posts that you could see behind the curtains and that I thought of as heads of puppets with which it was forbidden to play.]

Here perhaps more than in any other of his poems, Jacob invites the reader to observe the mechanics of his abstraction. He has reversed his usual poetic procedure in that he *begins* by describing the homely and familiar objects of a child's bedroom and then passes on to the reveries and visions they inspire. The sensitive child manages to see in the trim of the curtains the letters of the alphabet and subsequently to transform them into figures and images.

Jacob's interpretation, "H, un homme assis; B, l'arche d'un pont sur un fleuve" is reminiscent of Rimbaud's "Voyelles" in which chromatic values are ascribed to the five vowels and then associated with suggestive images: "A, noir corset velu des mouches éclatantes." Or the child transforms the finials of pilasters hidden behind the curtains into puppets. He condenses this process in a shorter but equally explicit poem:

> Mes vêtements sur la chaise étaient un pantin, un pantin mort.
> (*C. à d.*, p. 240)

[My clothes on the chair were a puppet, a dead puppet.]

It is not at all difficult to visualize the abandoned clothing looking again like a "dead puppet" sprawled across the chair. The image of the *pantin* will be discussed further in Chapter VI.

A second basic source, the situational or personal source, of the poem has been illustrated by excerpts of letters from Jacob to Guillaume Apollinaire. These letters established a factual background which Jacob was to exploit in some of the *poèmes en prose*. Nowhere, however, is this process of transformation of real incident into the verbal fabric of the poem so easily observed as in the following poem, for which Jacob did not provide the real life background until the publication of the "Petit historique du *Cornet à dés*" (1943).

Je le croyais ruiné, mais il a encore des esclaves et plusieurs pièces à sa maison. Sur les rochers, les cantatrices étaient à demi nues dans leurs maillots. Le soir, on entrait dans les wagons et les petits trains glissaient sous les pins. Je le croyais ruiné! . . . il a même trouvé un éditeur pour moi! l'éditeur m'a donné une tortue dont la coquille est rose et vernie: le moindre ducaton ferait bien mieux mon affaire. (*C. à d.*, p. 50)

[I thought he was ruined but he still has slaves and several rooms in his house. On the rocks, the sopranos are half-nude in their bathing suits. In the evening, we entered the cars and the little trains rolled along under the pine trees. I thought he was ruined! He even found me a publisher! The publisher gave me a varnished pink turtle shell: the smallest coin would serve me better.]

This *poème en prose* divides itself naturally into two parts. The first part presents a setting of bizarre opulence; the Maecenas whom the poet thought to be ruined is not ruined at all, the word "ruined" by contrast enhancing the idea of opulence. What he has left are slaves and *plusieurs pièces*—Jacob does not specify whether *pièces* here means rooms or pieces of money—strange and inexplicable as symbols of wealth. The Lorelei-like sopranos singing on the rocks in scanty jerseys (one of Jacob's frequently recurring images) and the miniature trains gliding along under the pines seem to denote a garbled and fantastic tableau of villa life on some seashore estate near the Côte d'Azur.

In the second part of the poem, the theme of opulence changes to one that must have been close to Jacob's preoccupations, that of finding a publisher for his poetry, since on numerous occasions he was obliged to have it published at his own expense. In lieu of an advance, the editor has given him a rose-colored varnished turtle shell. The wistful last line points up the utter uselessness of such a quaint *bibelot*, redolent of over-stuffed Victorian parlors, to which the archaic *ducaton* with its seventeenth-century air opposes a world of princely patrons and adequately remunerated artists.

The mere assembling of the elements of this poem—it is one of those whose resolute hermetism offers no foothold for explication—indicates a dramatic situation: (1) acquaintance with a wealthy patron of the arts; (2) interruption of that acquaintance during which time the poet has heard or assumed that the man was ruined (the poem actually begins at

this point) ; (3) resumption of that acquaintance whence the poet learns that the man still possesses the enumerated elements of his fortune; (4) the man's aid to the poet in the form of an introduction to the publisher; (5) the gift of the turtle shell; and (6) the final disillusionment.

Though this summary does not appear in any way implausible, the little piece and especially its haunting last line ultimately refuse to connect with any intelligible factual referent. *Forty years* after the composition of this poem Jacob, in the "Petit historique du *Cornet à dés*" (1943), provided a clue to its general situation and tone, and a specific verbal echo for the last line.

> *"Pourquoi ne fais-tu pas une suite au* Cornet à dés," *me demanda le Comte François de Gouy d'Arcy. ('C'est le seul homme qui sache ce que c'est que la peinture, disait de lui Picasso'), "fais-en une pour moi!" Je m'y suis mis; un jour, dans le téléphone, j'annonçais que j'avais soixante pages. "Viens dîner! et apporte les soixante pages"; on les lut avec enthousiasme, on téléphonait aux amis et, à chaque nouvel arrivant, il fallait les relire. Après minuit on me fit conduire par le chauffeur rue Gabriel, 17, mon domicile, les bras pleins de fleurs. Le moindre ducaton aurait mieux fait mon affaire. (C. à d.,* p. 11)

> [*"Why don't you do a sequel to the* Cornet à dés?" *asked the Count François de Gouy d'Arcy. ('He's the only man who knows what painting is,' said Picasso of him.) "Do one for me!" I went to work on it; one day I announced over the telephone that I had sixty pages. "Come to dinner and bring the sixty pages." They were read with enthusiasm, friends were called up and, at each new arrival, they had to be read again. After midnight they had the chauffeur drive me home to the rue Gabriel, 17, my domicile, with my arms full of flowers. The least farthing would have served me better.*]

The parallels between the "historique" and the poem in question are striking and undeniable. Let us summarize the "historique" anecdote as we have summarized the poem: (1) acquaintance with the Comte François de Gouy d'Arcy, no doubt thanks to the notoriety of the *Cornet à dés;* (2) interruption of that acquaintance while Jacob worked on a sequel (this corresponds to the count's being "ruined" perhaps because he was denied Jacob's presence; or it may just express a desire for vengeance on Jacob's part because of a real or imagined snub) ; (3) resumption of that acquaintance when Jacob has produced the requested poems; (4) the

count's *largesse* in the form of adulation, a dinner, a chauffeur-driven car, and an armful of flowers; (5) the final disillusion couched in exactly the same terms as those of the poem.

In this context, *le moindre ducaton* finally assumes its true proportions against the perspective of the actual event whereas hitherto it had been no more than a caustic expression of dissatisfaction in regard to the preposterous turtle shell. And we see more clearly how Jacob transforms a living situation into the poetic form, how an ordinary anecdote with its underlying tensions is metamorphosed into a fiction, how the externals become all but unrecognizable while the inner anguish is carefully retained.

As for the third or doctrinal source of Jacob's poetic inspiration, this has in part already been demonstrated by our discussion of his attachment to general cubist practice—though only in part because, while he was not consciously striving to conform to an esthetic doctrine here, he *was* expressing a naturally cubist vision in a naturally cubist manner. Another form of doctrinal inspiration is his violent conversion to Catholicism and the subsequent permeation of his entire consciousness by religious images, as witness the ubiquitous allusions to Christ, the Crucifixion, Satan, grace, salvation, and so on.

It may be submitted that, of all the doctrinal influences that conspire to make Jacob's poetry the rich and variegated tapestry it is, none is more pervasive (encompassing to some extent even Jacob's religious preoccupations) and richer for its psychological implications than the influence of Baudelaire.

The first direct indication of Jacob's awareness of Baudelaire is negative and appears in that fairly knotty essay on literary esthetics that constitutes the "Préface de 1916" to the *Cornet à dés:*

> . . . la théorie de Baudelaire sur la surprise: cette théorie est un peu grosse. Baudelaire comprenait le mot "distraction" dans son sens le plus ordinaire. Surprendre est peu de chose, il faut *transplanter*. La surprise charme et empêche la création véritable: elle est nuisible comme tous les charmes. Un créateur n'a le droit d'être charmant qu'après coup, quand l'oeuvre est située et stylée (*C. à d.*, p. 16)

> [. . . the theory of Baudelaire on surprise: that theory is a bit crude. Baudelaire understood the word "distraction" in its most

ordinary sense. To surprise is very little. One must transplant. Surprise charms and impedes genuine creation: it is harmful as are all charms. A creator only has the right to be charming afterwards, when the work is situated.]

Later on the same page, he adds:

Rimbaud n'a ni style, ni situation: il a la surprise baudelairienne; c'est le triomphe du désordre romantique. (*C. à d.*, p. 16)

[Rimbaud has neither style nor situation. He has Baudelairean surprise: that is the triumph of romantic disorder.]

We shall not go into the problems raised by the meaning of Jacob's critical terms which have baffled critics for years, and whose value as terminology has often been questioned.[2] We shall, however, consider the fact that Jacob, in spite of his contentious tone, is deeply imbued with Baudelaire.

As has been seen (p. xiii), he uses "Surpris et charmé" as the title for one of his bitterest short stories. Jacob also occasionally employs the expression, *surpris et charmé*, in other stories but always in much the same context, as an ironic sign for an empty *dandysme*. The phrase is the overpolite gentleman's way of responding coldly to unlooked-for social inconveniences, and it had probably been used as an urbane foil against Jacob himself in some strained situation. For Jacob, social grace had become virtually synonymous with literary facility, or poetic virtuosity of the accepted type wedded to a futile social elegance.

Against a background of facile urbanity, Jacob's own lack of *bienséance*, his sudden frivolity, his poverty, his awkwardness, and above all his terrible anguish, stand out in marked contrast. In turn, Jacob

[2] Here is, for example, what André Billy (*Max Jacob*, Paris, 1946) says on the subject: "Mais que vaut sa théorie du poème en prose? Et d'abord en quoi consiste-telle exactement? Qu'entend-il par situation et par style? Ce qu'il en dit de plus clair, c'est ceci, qu'il a mis en note comme s'il y attachait moins d'importance qu'au reste:" [Jacob's theory of the *poème en prose* follows, after which Billy adds] "Que d'objections à faire à tout cela!" (p. 29) [But what is his theory of the *poème en prose* worth? And first of all exactly what does it consist of? What does he understand by "situation" and by "style"? The clearest thing he says about it is this, which he put in a note as if he attached less importance to it than to the rest. . . . How many objections there are to make to all that!]

associates this *dandysme* with Baudelaire and, illogically yet understandably shifting from social to poetic decorum, with romantic diction in poetry. Thus he sets the relative decorum of Baudelaire's poetic diction in contrast to the violence and rowdiness of his own montage of dictions, equates it to standard poetic procedure, and violently rejects it.

In a sense Jacob is justified because Baudelaire's form is closer to that of romantic poetry than to the unbridled experiments of the cubists. If we accept Baudelaire as the pivot between romanticism and decadence and LaForgue and Corbière as intermediate steps, Jacob represents a rather advanced stage in the evolution of poetic decadence. He has perhaps lost sight of the original revolutionary tactics of his illustrious predecessor, although the stages in the ironic inheritance remain well-defined to the critical observer.

The subtle work of destruction of conventional poetic norms initiated by Baudelaire and accomplished by the use of similar strophes, sound-sense slippage of language, *pierrot* themes, ironic pathos, *Hamletisme*, *pastiche*, and so on, persists to Jacob. With Jacob, the original *reductio* only hinted at or subtly indicated has now become paramount, to the extent that he uses it to reduce even his model, even his contemporaries, and even himself. The all-inclusiveness of his destructive irony is increasingly forced on the reader's attention as he pursues a study of Jacob's poetic forms.

Deeper into the *Cornet à dés*, Jacob presents a *pastiche* meant to satirize certain of Baudelaire's *poèmes en prose:*

POÈME DANS UN GOÛT QUI N'EST PAS LE MIEN

A toi, Baudelaire.

Auprès d'un houx dont les feuillages laissaient voir une ville, don Juan, Rothschild, Faust et un peintre causaient. (*C. à d.*, p. 34)

[POEM IN A STYLE THAT IS NOT MINE

To you, Baudelaire

Near a holly bush through the leaves of which one could see a city, Don Juan, Rothschild, Faust and a painter were conversing.]

Each states his innumerable triumphs, Rothschild in amassing fortunes, Don Juan in collecting mistresses, the painter in acquiring glory, and

Faust in exploring scientific mysteries; but each has also grown weary of the facility of his success. The poem concludes:

> Il y avait à côté d'eux une femme jeune couronnée de lierre artificiel qui dit:
> "Je m'ennuie, je suis trop belle!"
> Et Dieu dit derrière le houx:
> "Je connais l'univers, je m'ennuie." (*C. à d.*, p. 35)

> [There was alongside of them a young woman crowned with artificial ivy and she said:
> "I am bored; I am too beautiful!"
> And God said behind the holly:
> "I know the universe; I am bored."]

This poem is reminiscent of Baudelaire's "L'Etranger" and "Any where out of the world" which seem to achieve the ultimate in a distillation of blasé immobility. Then the poems end on a typically symbolist note of rapt attention to profound subjective glimmerings usually implied by some symbol of the Absolute: *J'aime les nuages!* [I love clouds!], or *Enfin mon âme fait explosion, et sagement elle me crie: "N'importe où! n'importe où! pourvu que ce soit hors de ce monde!"* [Finally my soul explodes and wisely it cries out to me: "Anywhere, anywhere as long as it is out of this world"!][3]

The phantasmagoria of the "Prologue" and opening chapters of the *Matorel* conceals rather than reveals Jacob's perhaps unconscious involvement with the Baudelairean poetic model or perhaps of the decadent school commonly associated with that model. But the first sentence of the "Prologue"—*Satan n'est pas plus gros qu'une marionnette; on en connaît les fils*—reinforced a bit further along by the *chapeau [jésuitique] qui tient les fils*, echoes Baudelaire's "Au lecteur" from the *Fleurs du mal: C'est le Diable qui tient les fils qui nous remuent.* Aside from the analogous function of "Au lecteur" to the "Prologue," and a similar homiletic diction, a host of other correspondences between Baudelaire and Jacob suddenly springs to mind. Jacob's preoccupation with the

[3] Charles Baudelaire, "L'Etranger" and "Anywhere out of the world," *Petits poèmes en prose, Oeuvres complètes*, ed. Alphonse Lemerre (Paris, 1941), p. 11. All citations from Baudelaire in this and later chapters are from this edition; subsequent references will include only an abbreviated title and a page number immediately following the quoted matter in parentheses.

tripartite image consisting of Satan-marionette-cords in the *Matorel*—
he uses *fils* in this context no less than five times in the first paragraph—
reflects Baudelaire's obsessively frequent use of the same images of
Satanic manipulation.

However, the ethical implications of Satanic manipulation are not
quite identical for the two men. For Baudelaire:

> Sur l'oreiller du mal c'est Satan Trismégiste
> Qui berce longuement notre esprit enchanté
> Et le riche métal de notre volonté
> Est tout vaporisé par ce savant chimiste. (*F. du m.*, p. 95)

> [On the pillow of evil there is Satan Trismegistus
> Who lovingly rocks our enchanted spirit
> And the rich metal of our will
> Is all vaporized by that wily chemist.]

In other words, Satan finally succeeds in eating away the precious but
soft metal of our will so that we remain in a state of constant and pro-
longed weakness, floating helplessly on a sea of temptation, beset by
paralyzing calms, or swept every which way by pitiless currents.

Thus in the normal cycle of temptation, sin, and remorse, the three
stages tend to lose their outlines and blend into one continuous debauch.
Above all, repentance is to be regarded lightly, even cynically, as a mild
sop to the conscience and a desirable prelude to further sin. Baudelaire
speaks after all of *nos aimables remords* and of how *nos péchés sont
têtus, nos repentirs sont lâches.*

For Jacob, on the other hand, the three stages have a sharp personal
reference. The Jacobean religious drama can be contained in the round
of temptation, sin, and anguished penitence, always set off anew by in-
fernal temptation. The *Défense de Tartufe* recommends among six pre-
cepts for a saintly life: *ne pas travailler jusqu'à l'échauffement,* qui fait
venir un autre démon (p. 209, emphasis added) [Do not work to the
point of becoming overheated *which makes another demon appear*] on
which his biographer has commented: *Résolution raisonnable, trop
raisonnable, et qui, autour de Max, permettait à trop de tentations de
mener leur ronde.*[4] [A reasonable resolution, too reasonable and which
allowed too many temptations to make their rounds.]

[4] Robert Guiette, "Vie de Max Jacob," *N[ouvelle] R[evue] F[rançaise]*, CCL,
CCLI (1934), p. 258.

After a first sojourn at the abbey of St. Benoît, Jacob returned to Paris and lived a life of debauchery, a life which he describes in this way:

> Le soir je retombe dans les grandes horreurs parce que je ne sais pas vivre sans certains de mes amis et qu'ils ne savent pas vivre sans horreurs.[5]

> [In the evening, I fall again into great horrors because I cannot see any way to live without certain of my friends and they cannot see any way to live without horrors.]

So we see that temptation plays an active role in drawing Jacob away from his good intentions. We feel that temptation in him is a sharp and compelling force, while for Baudelaire, on the contrary, its effects are muffled, more taken for granted, and counterbalanced by a correspondingly emphasized weakness of will.

In the *Matorel*, the future saint confesses:

> J'ai connu l'amour avec une douce horreur. Dois-je avouer que j'ai été sodomite, sans joie, il est vrai, mais avec ardeur. (*St. Mat.*, p. 28)

> [I have known love with sweet horror. Should I admit that I was a sodomite without joy, it is true, but with ardor?]

The remembrance of the *ardeur* has not disappeared, and although the fascination of the sin remains even in repentance, recognition of sinful compulsion in no way diminishes the sincerity of that repentance. It might be said to heighten it in this case, in fact, and it is in this particularity that Jacob differs most from Baudelaire.

There is no impugning the accent of absolute sincerity in Jacob's penitential outcries. His remorse is never casual or "amiable" as is Baudelaire's; it is frantic and desperate and painful even in its poetic embodiment. In his more lucid moments, he sees the impossibility of resolving the logical opposition between sin and penitence: *s'il faut s'en repentir, autant s'en abstenir.* But voluptuous sin and penitence are mutually intensifying in this *poème en prose:*

[5] Ibid., p. 259.

L'ENFER

Mes mémoires d'outre-tombe intéressent, me dit-on vos lecteurs, monsieur l'éditeur. Oui! j'ai connu le ciel et je connais l'enfer. L'enfer! Nous vivons terrés et nous craignons les puissances infernales, mais quelle entr'aide! et quelles jouissances dans les moments de péchés terrestres! Je ne sors de ta chambre infernale, ombre infernale, qu'épié par tes gens, mais sur le lit, quelles voluptés!

Je blasphème! je blasphème! j'avouerai tout malgré le blasphème! Les Saints du Paradis m'ont fait regretter l'enfer! aucun orgueil, c'est vrai . . . de la suffisance seulement! quel monstre est comparable à l'homme suffisant? (*St. Mat.*, pp. 241–42)

[HELL

My memoirs from beyond the grave interest your readers, they tell me, Mr. Publisher. Yes! I have known heaven and I know hell. We live dug in and we are afraid of the infernal powers, but what give and take and what pleasures in the moments of earthly sin! I only go out of your infernal room, infernal shadow, spied upon by your men but, on the bed, what voluptuousness!

I'm blaspheming! I'm blaspheming! I will confess everything in spite of the blasphemy. The Saints of Paradise make me miss hell! There is no pride, it's true . . . only smugness and complacency! What monster is comparable to the smugly complacent man?]

And yet each well-defined stage in the eternal cycle of temptation, sin, and remorse exists for Jacob not only independently of the other two, but oblivious to them for a period. And it is not in practice but in *literary retrospect* that he conjoins them to form a whole, a whole whose unity is compelling because its diverse elements intensify one another.

Literary Sources: Baudelaire and Gautier

Baudelaire's conception of Satan and the marionette is straight-forward enough. First Satan, by some mysterious process, weakens man's will; then he holds and manipulates man by the strings of irresistible but trivial and even disgusting desire: *aux objets répugnants nous trouvons des appas*. The quality of the objects which provoke desire is so question-able as to create a paradox:

Ainsi qu'un débauché pauvre qui baise et mange
Le sein martyrisé d'une antique catin,

Nous volons au passage un plaisir clandestin
Que nous pressons bien fort comme une vieille orange.
(*F. du m.*, p. 96)

[Like an indigent voluptuary who kisses and gnaws
The martyred breast of an elderly jade
We snatch in passing a clandestine pleasure
Which we squeeze hard like an old orange.]

and again:

Si le viol, le poison, le poignard, l'incendie,
N'ont pas encore brodé de leurs plaisants dessins
Le canevas banal de nos piteux destins,
C'est que notre âme, hélas! n'est pas assez hardie. (*F. du m.*, p. 96)

[If rape, poison, stabbing, and arson
Have not yet embroidered with their amusing patterns
The banal canvas of our pitiful destinies,
It is because our souls, alas! are not bold enough.]

Consequently, man becomes no more than a marionette dancing to the least pressure of those strings which represent the desire for an ironically paltry pleasure. Baudelaire emphasizes the paralysis of the will essentially to explain the wretchedness of the desire.

For Jacob, too, Satan Trismegistus exerts his nefarious influence on the sinner whose effort of will is insufficient to cope with the temptation. But Jacob does not speak of Satan's advance tampering with the will nor does he attempt to justify the singularity of his own temptations. That is, he wallows in a kind of voluptuousness that, although it might not tempt many men, is far from paltry to one who practices it.

The logistics of Jacob's treatment in the *Matorel* of Satan are confused and difficult to follow. By a typical cubist twist, Matorel minimizes Satan's omnipotence, confusing *him* with the marionette when, in reality, it is *man* who finds himself scaled down to marionette size by giving in and becoming a slave to sensual desire in the form of, for instance, *un énorme paquet de tabac*. This turnabout constitutes a patent evasion on Jacob's part, though it is impossible to doubt his awareness of the original premises of the theme.

Matorel further confuses the issue by accusing the *chapeau jésuitique* of inducing him into error! Then backtracking, he says: *Calomniez!*

calomniez! il en reste toujours quelque chose! seemingly accusing *himself* of calumny and affirming the continuing redemptive power of *jésuitisme;* while the final clause *c'est le chapeau qui tient les fils* would seem to re-assert the merging of devil and Jesuit.

The supreme inconsistency lies in the final contradiction: at the end, Matorel's "error" is favorable, desirable, inevitable! Matorel is caught in the strings of the Jesuitical hat just as helplessly as he was caught in Satan's snares, and just as helplessly and inevitably as he was on his way to being damned, he will now be saved. Jacob's reasoning has come full circle. He comes to rest, however, on a higher level; thus, he has described a spiral, a figure, incidentally, which smacks of high cubism and one which he repeats many times.

We have just seen an example of spiral reasoning in the passage from "L'Enfer." The predominant tone is penitential; Jacob willingly accepts the chastisements of hell in the *chambre infernale,* administered by the *ombre infernale,* justifying them all the while by his concomitant rem-iniscences of sensual pleasure. Twice in the first paragraph he comes full circle (or full spiral) again: *nous craignons les puissances infernales mais . . . quelles jouissances,* and *je ne sors de ta chambre . . . qu'épié par tes gens, mais sur le lit, quelles voluptés!*

At this point the harrowing cry of blasphemy breaks into the smug-ness of the *volupté* after which the *saints du Paradis qui m'ont fait regretter l'enfer* are difficult to explain on any logical basis whatever. The implication here is either that he prefers hell and fulfilled desire or that his taken-for-granted saintliness bores him and he yearns after his earlier sinful existence with both its infernal pleasures and its infernal punishments. It may be that the pleasure and punishment are simply one and the same. And he continues to take one with the other until eventually, near the end of his life, the temptation lessens, allowing him to break out of the vicious circle.

So much for the differences between Jacob and Baudelaire, differ-ences which will prove relatively minor in view of the many similarities. We have observed an obsession on the part of both poets with the images of Satan, marionettes, and ever present cords. In the hope of finding other common elements, we will make an extensive comparison of Jacob's poetry with Baudelaire's poetry, principally his *Fleurs du mal, Petits poèmes en prose,* and *L'Art romantique.*

Fleurs du mal has a ninety-page introduction by Baudelaire's friend and literary mentor, Theophile Gautier. Reading it we realize that we are not dealing exclusively with Baudelaire but with an entire "school." Gautier reports one of Baudelaire's *axiomes favoris* as follows:

"Tout dans un poème comme dans un roman, dans un sonnet comme dans une nouvelle, doit concourir au dénoûment. Un bon auteur a déjà sa dernière ligne en vue lorsqu'il écrit la première." Grâce à cette admirable méthode, le compositeur peut commencer son oeuvre par la fin et travailler, quand il lui plaît, à n'importe quelle partie.

["Everything in a poem as in a novel, in a sonnet as in a short story, must converge toward the resolution. A good writer already has his last line in mind when he writes the first." Thanks to that admirable method, the writer can begin his work at the end and work, when it pleases him, on any part.]

The quote within the quote, from Edgar Allan Poe's "Philosophy of Composition" (entitled in Baudelaire's own translation "La Genèse d'un poème") treats of Poe's compositional methods and purportedly describes in detail how Poe came to write "The Raven." Baudelaire-Poe elaborates:

S'il est une chose évidente, c'est qu'un plan quelconque, digne du nom de plan, doit avoir été soigneusement élaboré en vue du denoû-ment, avant que la plume attaque le papier. (*L'Art rom.*, p. 87)

[If one thing is obvious, it is that some outline or other, worthy of the name of outline, must carefully have been worked out toward a final resolution before the pen attacks the paper.]

This concept is, of course, already explicit in Aristotle's *Poetics* as well as in French classical doctrine, the very one, in fact, expressed by Buffon in the "Discours sur le style" *que Baudelaire comme Flaubert estimait assez.*[6] Jacob knew Buffon as evidenced in the second paragraph of the "Préface de 1916": *Buffon a dit: "Le style, c'est l'homme même."* and then Jacob goes on to amend: *On confond généralement comme Buffon langue et style* (p. 13). In any case, what is significant for Jacob in this well-worn notion of a pre-established plan is that it fits perfectly

[6] *Baudelaire*, Classiques Larousse, ed. Adrien Cart (Paris, 1947), p. 87 n.

with the above-quoted (p. 65) speculation about the proper placing of the "Prologue."

In the light of this idea as expressed through Poe-Baudelaire-Gautier, that which at first appeared disconnected, specious, and obscurantist suddenly finds itself shriven of all mystery and reduced to the level of a simple mechanistic description. Jacob's phraseology, moreover, shows more than a passing acquaintance with the leading literary theoreticians of the late nineteenth century, including Flaubert. Jacob's *nous sommes dans nos oeuvres comme Jéhovah dans les siennes* can be taken as a parodic restatement of *l'artiste doit être dans son oeuvre comme Dieu dans la Création.*[7]

At another point in the introduction to *Fleurs du mal*, Gautier chides the *jeune école* for choosing so rigid a form as the sonnet for their metrical experimentation, characterizing this as *l'irrégulier dans le régulier* (p. 52). Have we not just encountered an otherwise inexplicable echo of this too in Matorel's perplexity, *l'irrégulier ou le régulier, je ne sais?* Jacob loved to consternate his readers with just such paradoxical references but, interpreted in the light of Gautier, the mysterious "Octogonal" becomes nothing more than a verse of eight feet.

In addition to the Satan-marionette-cords image common to both Jacob and Baudelaire, the themes of the intemporality of artistic vision, the irregular in the regular, and the arcane "Octogonal," the latter two bearing on versification, other Baudelairean echoes appear in Jacob's writings in the detail as well as in the larger pattern. Might not that cryptic reference from the "Premier Partie": *on l'enverrait à Saint-Maurice se faire faire un complet blanc* contain an oblique allusion to the Ile Maurice where Baudelaire made a short visit that was later to become historic for French letters?[8] Even Dalilah's dahlia seems to have been foreshadowed by Baudelaire's *moi, j'ai trouvé ma tulipe noire et mon dahlia bleu! Fleur incomparable, tulipe retrouvée, allégorique dahlia.* (*Pet. po. en pr.*, p. 74)

Baudelaire's "A une Mendiante rousse" (*F. du m.*, p. 235) finds its

[7] Gustave Flaubert, in a letter to Mlle Leroyer de Chantepie, 18 March 1857, from the *Correspondance*, IIIe série (Paris, 1910), III, 113.

[8] I am indebted to Professor Nat Wing (of the University of Pennsylvania) for reminding me that St.-Maurice is the other name of Charenton, a mental institution in Paris and the "white suit" could well be the inmates' uniform or that of the guards.

title mirrored in Jacob's "Mendiante de Naples" (*C. à d.*, p. 142), while the first strophe of that Baudelaire poem:

> Blanche fille aux cheveux roux,
> Dont la robe par ses trous
> Laisse voir la pauvreté
>> Et la beauté (*F. du m.*, p. 235)

> [White maiden with red hair
> Whose dress, through its holes
> Lets us see your poverty
>> And your beauty.]

reminds us of Jacob's "Kaleidoscope": *la petite princesse en robe noire, on ne savait pas si sa robe avait des soleils verts ou si on la voyait par des trous de haillons.* (*C. à d.*, p. 161)

An even more striking parallel is offered by "Amour du prochain" (quoted, p. 56) and Baudelaire's "Les sept vieillards."

LES SEPT VIEILLARDS

> Il n'était pas voûté, mais cassé, son échine
> Faisant avec sa jambe un parfait angle droit,
> Si bien que son bâton, parachevant sa mine,
> Lui donnait la tournure et le pas maladroit
>
> D'un quadrupède infirme ou d'un juif à trois pattes.
> Dans la neige et la boue il allait s'empêtrant,
> Comme s'il écrasait des morts sous ses savates,
> Hostile à l'univers plutôt qu'indifférent.
>
> Son pareil le suivait: barbe, oeil, dos, bâton, loques,
> Nul trait ne distinguait, du même enfer venu,
> Ce jumeau centenaire; et ces spectres baroques
> Marchaient du même pas vers un but inconnu. (*F. du m.*, p. 241)

[THE SEVEN ELDERLY MEN

> He was not bent but broken, his spine
> Forming with his leg a perfect right angle
> So that his walking stick, completing his appearance,
> Gave him the clumsy look and gait

Of a crippled quadruped or of a three-legged Jew.
In the snow and the mud he went along sinking deeper,
As if he were crushing dead bodies under his old shoes,
Hostile to the universe rather than indifferent.

His double was following him: beard, eye, back, stick, rags;
No trait distinguished this hundred-year-old twin
Come from the same Hell; and these baroque spectres
Were walking at the same pace toward an unknown goal.]

This poem immediately places before the reader's eyes so large a number
of common elements that it would be tempting to conclude that *Amour
du prochain* is directly inspired from *Les sept vieillards.*

Our evidence of preoccupations, key words and phrases, images,
topoi, and above all a pervasive atmosphere of *poète maudit* common to
the two men indicates a strong connecting link between Jacob and the
Baudelaire-Gautier esthetic. This is not to accuse Jacob of being deriva-
tive; he was, as we have seen, a surpassingly original poet but he did
have roots and they go back principally to Baudelaire. So as to turn some
of these points of resemblance into interpretive techniques and bring
them to bear on poetic problems, we shall relegate the further detective
work to a note and proceed to those problems immediately.

"Les Veuves Solitaires"

The Satan-marionette-cords image has already been commented on.
Its muddled and fragmented appearance in Jacob, was clarified by the
examination of a parallel development, clearer and more logically pur-
sued, in Baudelaire. The marionette element, incidentally, was also
present in the *pantin* image which the reader had been asked to retain
for future reference. Variations on this Satan-marionette-cords image
make their appearance in Jacob's "Amour du prochain" and in its
Baudelairean counterpart, "Les sept vieillards." They include *crapaud,
tout petit homme, rhumatisant, poupée, clown,* for Jacob; and *quad-
rupède, juif, centenaire, (voûté), cassé, maladroit, spectre baroque,* for
Baudelaire.

Another persistent image common to Baudelaire and Jacob is that
of the elderly lady, the *vieille.* We shall attempt to trace the manner in
which the two images, the marionette and the *vieille,* distinct but related

in Baudelaire, fuse in Jacob's poetry to form a single, intertwined complex. Elucidation of the Baudelairean source is essential to the complete understanding of Jacob's oblique use of the complex. This image-complex unites the formerly independent factors of the two original images. No reader, encountering Jacob's lightning-like and oblique allusions to it, and not supplied with the key from Baudelaire, could penetrate it entirely.

The first section of the first chapter of the *Matorel,* "Un employé du Métropolitain" ends on a *procession de velours* proceeding slowly through Matorel's bowels. The *velours* reminds us of the *chaussettes de velours noir* of the "Prologue." Jacob specifies that this procession is a *pèlerinage des faces de vieilles dames* become a vision seen in the shop window of *deux chères ombres absentes . . . tenant des accessoires de cotillon.* Throughout this tracing of an image, all related elements will be italicized in order to simplify their identification and comparison.

LES "PETITES VIEILLES"

Dans les plis sinueux des vieilles capitales,
Où tout même l'horreur, tourne aux enchantements,
Je guette, obéissant à mes humeurs fatales,
Des *êtres singuliers, décrépits et charmants.*

Ces *monstres disloqués furent jadis des femmes,*
Eponine ou Laïs!—*Monstres brisés, bossus*
Ou tordus, aimons-les! ce sont encore des âmes.
Sous des *jupons troués* et sous de froids tissus

Ils rampent, flagellés par les bises iniques,
Frémissant au fracas roulant des omnibus,
Et serrant sur leur flanc, ainsi que des reliques,
Un petit sac brodé de fleurs ou de rébus;

Ils trottent, tout pareils à des marionnettes;
Se traînent, comme font les *animaux blessés,*
Ou dansent, sans vouloir danser, pauvres sonnettes
Où se pend un Démon sans pitié! Tout *cassés*

Qu'ils sont . . .

—Avez-vous observé que maints cercueils de *vieilles*
Sont presque aussi petits que celui d'un *enfant?*
La mort savante met dans ces bières pareilles
Un symbole d'un goût bizarre et captivant,

Et lorsque j'entrevois *un fantôme débile*
Traversant de Paris le fourmillant tableau
Il me semble toujours que cet *être fragile*
S'en va tout doucement vers un nouveau berceau,

Ah! que j'en ai suivi, de ces *petites vieilles!*

Telles *vous cheminez,* stoïques et sans plaintes,
A travers le chaos de vivantes cités
Mères au coeur saignant, courtisanes ou saintes,
Dont autrefois les noms par tous étaient cités.

Vous qui fûtes la grâce ou qui fûtes la gloire,
Nul ne vous reconnaît! un ivrogne incivil
Vous insulte en passant d'un amour dérisoire;
Sur vos talons gambade un enfant lâche et vil.

Honteuses d'exister, ombres ratatinées,
Peureuses, le dos bas, vous côtoyez les murs;
Et nul ne vous salue, étranges destinées!
Débris d'humanité pour l'éternité mûrs!

Ruines! ma famille! ô cerveaux congénères!
Je vous fais chaque soir un solennel adieu!
Où serez-vous demain, *Eves octogénaires,*
Sur qui pèse la griffe effroyable de Dieu? (*F. du m.,* pp. 244–48)

[The Little Old Ladies

In the sinuous folds of old capitals,
Where everything even horror turns into an enchantment,
Obeying my fatal penchant, I spy upon,
Singular creatures, decrepit and charming.

These dismembered monsters were formerly women:
Eponine or Laïs! Broken, hunchbacked, twisted
Monsters, love them still; they are living souls.
Under their tattered skirts, under the icy cloth

They squirm, whipped by frozen winds
Shuddering at the rumbling din of the omnibuses
And clutching to their sides, as if they were relics,
A little handbag embroidered with flowers or mottoes.

They jerk past, just as if they were marionettes;
Dragging themselves along as wounded animals do,
Or dance without meaning to, poor jingling bell
Upon whose cord a pitiless Demon hangs. All broken

They are . . .

Have you noticed that many coffins of old ladies
Are almost as small as those of children?
Death, all-knowing, places in such biers
The symbol of a bizarre and captivating taste.

And when I catch a glimpse of a feeble phantom
Amid the teeming tableau of Paris
It always seems to me that that creature
Is going slowly off toward another cradle.

Ah! How many of these little old ladies have I followed?

This is how you make your way, stoical and without protest,
Across the chaos of living cities;
Mothers with bleeding hearts, courtesans or saints
Whose names were once on everyone's lips.

You who were once the grace or once the glory,
No one recognizes you now. An uncivil drunk
Insults you with crude derision as you pass;
At your heels skips a sickly, ungainly child.

Ashamed to exist, withered shadows,
Fearful, your backs bent, you skim along the walls
No one greets you; what a strange destiny!
Debris of humanity, ripe for eternity!

Ruins! my family! Oh spirits just like my own!
I salute you each evening with a solemn Adieu!
Where will you be tomorrow, octogenarian Eves
Upon whom weighs the fearful talon of God?]

Plis sineux suggest the tortuous path of Matorel's entrails through
which *se traînent, s'en va, vous cheminez,* all parallel in movement to the
s'y délace, indicate the incessant wandering of these lost souls. The
italicized words reveal the figure in the process of materializing. Com-

pressing the two poets' words to construct a composite picture of this figure, one finds: *petites vieilles dames brisées et ratatinées, qui furent jadis des femmes, tenant des accessoires de cotillon et un petit sac brodé de fleurs, chères ombres absentes, êtres singuliers, décrépits, bizarres, captivants, et charmants, tout pareils à des marionnettes.*

These elements indicate a master pattern, originally Baudelairean, from which Jacob works, whether consciously or unconsciously. The marionette and the *vieille* have expanded to complement and augment each other. They both designate an essentially helpless, sexless, and solitary creature, much the same, in fact, as that we had encountered earlier in "Equatoriales solitaires" (p. 37). The theme of solitude also fits in well with the complex, being as indispensable an ingredient to these *êtres singuliers* as it is, for example, to the *poète maudit.*

Another simple and straightforward description of the *vieilles* produced in Jacob is the following:

> Il était deux heures du matin: elles étaient *élégantes les trois vieilles,* comme on l'eût été il y a cinquante ans; *châles de dentelles noires,* bonnets à brides, camées, robes de soie *noire* marquant les plis de l'étoffe fabriquée. *Le trottoir était désert* et leurs yeux gros de larmes se levaient vers une fenêtre dont le rideau était faiblement éclairé. (*C. à d.*, p. 52, italics added)

> [It was two o'clock in the morning. The three elderly ladies were elegant as one would have been fifty years earlier: shawls of black lace, bonnets with ribbons, cameos, black silk dresses with creases showing the mark of the manufacture. The sidewalk was deserted and their eyes, heavy with tears, were raised toward a window whose curtain was dimly lighted.]

Again the italicized details conform to the original pattern. Let us sum up: *trois vieilles élégantes, dentelles noires, soie noire, leurs yeux gros de larmes, trottoir désert.* In this poem, the graphic portrayal is closer to the Baudelairean model than is the brief image in the *Matorel.*

In the *Fleurs du mal,* the poem immediately following the "Petites vieilles" bids us contemplate "Les Aveugles":

Contemple-les, mon âme; il sont vraiment affreux!
Pareils aux mannequins; vaguement *ridicules;*
Terribles, *singuliers* comme des somnambules;
Dardant on ne sait où leurs globes ténébreux. (*F. du m.*, p. 249)

[Contemplate them my soul; they are truly hideous!
Like mannequins, they are vaguely ridiculous;
Horrible, peculiar, like sleepwalkers;
Turning this way and that their shadowy globes.]

Here the figure of the *mannequin* adds its weight to the sum of marionette images while the infirm blind people reinforce the *vieilles*. The *singulier* reminds us of *êtres singuliers* and the *ridicule* takes us back again to Matorel, who *sous l'uniforme était moins ridicule.*

There exist other and more explicit references in Baudelaire to the figure of the decrepit but still elegant old lady. In the *poème en prose,* "Les Veuves," one finds:

Avez-vous quelquefois aperçu des *veuves* sur ces bancs *solitaires, des veuves pauvres?* Qu'elles soient *on deuil* ou non, il est facile de les reconnaître. (*Pet. po. en pr.,* p. 68)

[Have you sometimes perceived widows on a lonely bench, poor widows? Whether they are in mourning or not it is easy to recognize them.]

and at the end of the same poem:

La grande veuve tenait par la main un enfant *comme elle vêtu de noir.* (*Pet. po. en pr.,* p. 70)

[The tall widow held a child by the hand. He was dressed in black as she was.]

From these latter two examples, it becomes abundantly clear that Baudelaire also saw these figures dressed in black.

The fullest and most graphic description of the *vieilles* is in Gautier's introduction to the *Fleurs du mal* in *quelques mots sur cette pièce des "Petites vieilles" qui a étonné Victor Hugo* (all relevant expressions will continue to be italicized) :

Le poète, se promenant dans les rues de Paris, voit passer de *petites vieilles à l'allure humble et triste,* et il les suit comme on ferait de jolies femmes, reconnaissant, d'après *ce vieux cachemire usé,* élimé, repris mille fois, d'un ton éteint, qui moule *pauvrement* de maigres épaules, d'après ce bout de *dentelle éraillée et jaunie,* cette bague, souvenir péniblement disputé au mont-de-piété et prête à quitter le doit effilé d'une main pâle, *un passé de bonheur et d'élégance, une vie*

d'amour et de dévouement peut-être, un reste de beauté sensible encore
sous le délabrement de la misère et les dévastations de l'âge. Il ranime
tous ces *spectres tremblotants,* il les redresse, il remet la chair de la
jeunesse sur ces minces squelettes, et il ressuscite dans *ces pauvres
coeurs flétris les illusions d'autrefois.* Rien de plus *ridicule* et de plus
touchant que ces Vénus du Père-Lachaise et ces Ninons des Petits-
Ménages *qui défilent lamentablement* sous l'évocation du maître,
comme *une procession de spectres* surpris par la lumière. (*F. du m.,*
p. 48)

[The poet, walking through the streets of Paris, sees *little old
ladies passing by looking humble and sad* and he follows them as one
would pretty women. He realizes from *the worn old cashmere,* thread-
bare, mended a thousand times over, faded and barely clinging to the
thin shoulders, and he recognizes from that wisp of *partly unravelled
yellow lace,* from that ring, a memento pathetically fought over at
the pawnshop and ready to leave the tapered finger of a pale hand, he
recognizes from all these a *past of happiness and of elegance, a life
of love and perhaps of devotion, the remains of beauty still perceptible*
under *the dilapidation of misery and the devastation of age.* He ani-
mates once more all these *trembling specters,* he makes them stand
up again, he puts back the flesh of youth on their scrawny skeletons,
and he resuscitates in these poor, *withered hearts the illusion of
happier days.* Nothing is more ridiculous or touching than these
Venuses of the Père Lachaise or these Ninons of the Petits Ménages
who file by lamentably under the evocation of the master *like a pro-
cession of specters* caught by surprise in the light.]

The full significance of the image is here made explicit by Gautier, where
previously it had only filtered through Baudelaire's poetic evocations
and Jacob's disconnected allusions.[9] The pathos of the "chères ombres
absentes tenant des accessoires de cotillon" is detailed here, and as we
follow the progression of this image through Baudelaire and all the way
back to Gautier, we realize that, insofar as poetic sensibility is concerned,
Jacob will have to take his place among the late, decadent romantics.

[9] It is not intended here to imply that Gautier used these themes only theo-
retically in discussions of Baudelaire's work. On the contrary, *Emaux et Camées* is
full of such themes as the elderly lady and gentleman, the specter, the grotesque, the
danse macabre, the blind, and the marionette. For the elderly and the specter, see
"Vieux de la Vieille" (p. 39) ; for the grotesque and the danse macabre, "Bûchers et
Tombeaux" (p. 41) ; for the blind, "L'Aveugle" (p. 42) ; for the marionette (in this
case, the *pantin*), "Les Joujoux de la morte" (p. 52).

VI. Who Is the "Vieille"?

T HE QUESTION THEN comes to mind: who are these *petites vieilles*, what do they signify, and why do they constitute a virtually obsessive preoccupation for Baudelaire as well as for Jacob? To abstract some of their fundamental attributes, we find that they are tiny, elderly, solitary, often infirm, usually feminine creatures, a prey to sadness and to genteel poverty, beings whom life has passed by and who continue to live on the edge of society, nourished by nostalgia for a bygone era, dressed soberly in black in superannuated elegance, and utterly helpless to ameliorate their situation in any way.

This figure is frequently encountered in the literature of the late nineteenth century. Various manifestations, subtly altered in both male and female incarnations, abound in Balzac, Flaubert, and Maupassant. The Père Goriot and the Abbé Birotteau are two of the most notable examples from Balzac; one thinks also of Flaubert's Félicité from *Un Coeur simple*, and of the elderly couple from Maupassant's "Menuet." The *vieilles* are not far from a curious *mélange* of Verlaine's *femme inconnue* whose name is *doux et sonore comme ceux des aimés que la Vie exila*[1] and whose voice has *l'inflexion des voix chères qui se sont*

[1] Paul Verlaine, "Melancholia," from *Poèmes saturniens.*

100

tues, and the petulant *spectre* (that word used by Jacob, Baudelaire, and Gautier) of "Colloque sentimental."[2]

It is easy enough to characterize the *vieilles* and to point out their occurrences in various literary disguises. More difficult is to establish a fundamental identification for them, not outwardly but inwardly, that is, as they exist symbolically in the poet's mind. If the *vieille* is one of the favorite subjects of writers of the last century, another major subject is the artist's detachment from society. Romantic literature, prose and poetry, is teeming with geniuses dying misunderstood, penniless, and forgotten in a garret, for example, *Chatterton.*

The progressive alienation of the artist from his society had left him (in spite of any arguments he could offer in rebuttal) smarting mightily under a deep sense of resentment, frustration, and regret. If the romantic and post-romantic artist had really despised the social values of the bourgeoisie with its enshrinement of material considerations, then there would have been no need for his continuous and bitter diatribes against that society and, above all, no need for that extravagant self-pity that is one of the marks of romanticism. On the contrary, he would have welcomed social ostracism as a desirable separation from a society he claimed to despise.

But the romantic found himself sorely tempted by the glitter and glamor as well as by the security of the bourgeois social milieu and consequently acutely resentful of its rejection of him. And since the nineteenth-century artist tended often to express his personal feelings indirectly, via elaborate allegory or by means of a suitable intermediary, to symbolize his own lot, he chose the pathetic figure of the helpless elderly lady. This tiny creature, dressed in an outmoded and even outlandish finery, signifies obvious, if outdated, social pretension but equally reveals an obvious indigence, a failure to live up to standards of an affluent bourgeoisie.

Although the *vieille* may not be appreciated by the world at large, she nevertheless possesses an innate fineness and a martyred personal nobility which, were the bourgeois less hard-hearted, would bring him to his knees in admiration, for example, *Père Goriot.* Thus she furnishes a convenient symbol in that she concentrates within herself the maximum of both

2 From *Fêtes galantes.*

pathos and worthiness, emotions which the poet feels he possesses to a supreme degree. From the standpoint then of personal worthiness, he has no qualms about identifying with her.

From another standpoint, too, the *vieille* proves a convenient symbol. By her advanced age, her general debility, her attachment to the past and detachment from the present, and by her symbolically black garb, she is a figuration of death (one more major preoccupation of the past century's literature). But the death she represents is not total, final, irrevocable, and horrible as death really is. She represents rather the late romantic blending of death with life, a concept like Wagner's *Liebestod*.

Love, which should ideally produce life, finds its apotheosis in the death of the lovers (at least according to the romantic sensibility). From the theme of the death of lovers, it is only a short step to those decadent themes mixing life and death on many planes and manifesting a fascination with—even a delectation for—ghouls, ghosts, and specters. And a specter is what the *vieille* appears to be when she is encountered in the middle of the night on the deserted city streets, a setting temporarily simulating the death of the city's life.

One more element in the synthesis of the *vieille* and of the post-romantic artist imposes itself: helplessness. Both are afflicted by an incapacity to participate in socially approved activities and thereby to alter or improve their human condition. It is this impotence which obviously prevents them from getting in step with their times. Nor does the deep imprint of helplessness that they carry come exclusively from bending limply before societal sanctions; it comes from bending before the pressures of sickness, death, love, temptation, and esthetic creation—of life itself. Indeed, for the young cubists, romantic and late romantic literary expression often appeared to be one protracted wail of self-pity.

Baudelaire identified the *petites vieilles* as *êtres, tout pareils à des marionnettes* and made a parallel identification of the *aveugles* as *pareils à des mannequins*. There is no doubting his intention here for he is perfectly explicit about it. Both the *vieilles* and the *marionnettes* participate in that utter helplessness, that being endlessly a victim, the mark of the decadent *littérateur*. Jacob too relates the two images but initially in a more indirect manner. For him, the *fils* symbolize the marionette (and we have had a demonstration of how often he exploited this detail) while *velours noir* evokes the finery of the *vieilles*.

Actually the dual image stands for two aspects of helplessness. The composite figure of the *vieilles-veuves-aveugles* represents *external* helplessness in the face of a hostile or oppressive (or at best indifferent) social order. The marionette, on the other hand, dancing hither and thither on the strings of its paltry desires, represents *internal* helplessness in the face of infernal temptation, a weakness of the will for which the sinner envisages paying dearly.

Both Baudelaire and Jacob were acutely conscious of these implications, emphasizing now one, now another of them, and combining them occasionally. But while Baudelaire alternates between two well-formed equal images, Jacob's cubist optic darts back and forth between two half-formed ones, concentrating usually on only the most elusive of symbolic details, for example, *fils* or *velours*, thus remaining always close to the very outer edge of intelligibility. From Baudelaire's *vieilles-veuves en deuil*, however, and from his Satan-marionette, through Jacob's *procession en velours des faces de vieilles dames*, back to the *chaussettes de marionnettes de velours noir au bout de tes fils* of the "Prologue," the elements of the dual image of Baudelaire have finally coalesced to form a single tone and texture in Jacob.

A third dimension of the marionette-*vieilles* image-complex is defined by its use in both Baudelaire and Jacob to designate an ultimate degree of degradation, moral, social, or economic: *poupée, monstre, saltimbanque, clown, quadrupède, crapaud.* And may well be added to this list *juif* both in the objective sense that Baudelaire gives to it and in the subjective one that Jacob does. For in Jacob's particular case, the weight of his degradation, social, economic, and moral, must have been increased by the cruel and gratuitous anti-Semitism prevalent at the time of the Dreyfus affair.

In any of Jacob's poetry and prose dealing with Judaism, anti-Semitism, the tribulations of a Jew trying to obtain baptism, or of a Jew whose brother-in-law and sister were arrested and deported to Germany, or of a Jew who was finally to be arrested by the Gestapo himself, the accents of anguish are unmistakable. Witness the above-quoted meditation in which he refers to himself as a *pauvre Juif vieux et stupide,* or the "Amour du prochain" with its bitterly ironic title and its unforgettable last line: *Heureux crapaud, tu n'as pas d'étoile jaune.*

The previously noted similarity between the "Amour du prochain"

and "Les Sept vieillards" further cements the relationship between the themes we have been examining. Baudelaire, by subtly manipulating the figures, substituting *vieillards* for *vieilles* and transforming the pariah into a *juif* with beard and cane, and retaining the overall humility, the bent posture, the advanced age, and the general wandering movement, affords Jacob the transition he needs to visualize the *juif-crapaud* image.

Jacob thus adds one more designation to the now long list of attributes that compose the various *nuances* of this complex. *Juif*, in the sense that Jacob means it—helpless butt of an unfair prejudice—extends the dimension of the overall marionette-*vieille* complex downward. To sum up then, the image is made up of these overlapping elements: *vieille dame* and also *vieillard, veuve, aveugle; ombre, spectre, être; marionette, mannequin, pantin, poupée; clown, saltimbanque, crapaud, juif.*

These elements tend to fall naturally into four groups according to the kind of force that has subjugated them. The first four have been subjugated by adversity, that is, age, widowhood, or infirmity; the next three by death itself; the next four by sinful desire and weakness of will; and the last four by societal pressures of various types.

Even without many specific references to Jacob's biography, most readers of Jacob suspect a possible parallel between Max Jacob and his literary creation, Victor Matorel. They are both tiny, feeble, often infirm, desperately poor, morally helpless, both converts to Catholicism, both pederasts, and though Jacob never says that Matorel is a Jew, his baptismal name, Frère Manassé, is that of one of the twelve tribes of Israel.

Furthermore, the traits under which Victor Matorel are painted are precisely those of Jacob himself; the events which befall the protagonist are an accurate account of many episodes from the author's life. And the pathos of the anti-hero remains constantly in rapport with the pitiable aspects of the *anti-littérateur*. The reader, moreover, has already suspected that the elevated tone of the urbane interlocutor represents still another side of Jacob's personality, and indeed this suspicion is confirmed when, in "Chapitre III," Mlle Léonie actually refers to him by his soubriquet of the period, *Monsieur Max* (*St. Mat.*, p. 22).

Besides the pathetic, there is much that is deliberately abject. Matorel is a humble, half-crazy, garrulous subway guard; the urbane chronicler, despite all his eighteenth-century elevation of style, is himself no more

than a floor-sweeper at the Maison Chieret (name suggesting the verb *chier*) meant to be the Entrepôt Voltaire where Jacob really worked. This took place in the depressed and depressing *quartier* St.-Antoine where Jacob lived; Matorel is a timid *faubourien* with the squalor and vulgarity that that term implies.

The beauties of Matorel's soul, moreover, are *tristes beautés*, this being perhaps one more significant Baudelairean echo from "Une nuit que j'étais près d'une affreuse *Juive*":

Je me pris à songer près de ce corps vendu
A la *triste beauté* dont mon désir se prive. (*F. du m.*, p. 148)

[I began to meditate next to this pandered body
On the sad beauty which my desire was depriving me of.]

He is mocked at and openly told he is grotesque by his section chief, and finally his own discourse delivers him up unto the reader for what he is: a pitiable fool babbling an endless stream of poor puns and astrological lore interspersed with subway stops and cheap neighborhood gossip, hallucinations, and complaints of illness.

If Matorel was less "ridicule" in his subway guard's uniform, Jacob affected the sartorial splendor of *un monocle, une redingote grise, un chapeau claque, et des cravates de diverses couleurs qu'il variait cabalistiquement selon les jours de la semaine ou des signes du Zodiaque* [a monocle, a gray morning coat, a high hat, and ties of different colors that he varied cabalistically according to the days of the week or the signs of the Zodiac], as Billy tells us. And he adds: *Sous ce dandysme de music-hall, quelle tristesse! Quelle misère! Quels tourments!*[3] [Under this vaudeville foppishness, what sadness! What misery! What torments!] To see in Jacob both the *vieille* and the marionette, and not only both separately but both together, is certainly not implausible.

Aside from symbolic manifestations of the *vieille* and the marionette in *Matorel* and in Jacob's self-image, the language of the *Matorel* presents more than one point of direct similarity with Baudelaire. At the end of the passage from "Chapitre Premier," the urbane narrator says of Matorel: *"Je ne puis m'empêcher de l'aimer et de la plaindre."* ["I cannot keep myself from loving him and pitying him."] And Baudelaire, in "Les

[3] André Billy, *Max Jacob* (Paris, 1946), pp. 31–32.

Veuves," describes a public concert which invariably attracts lonely old people and says of them: *"Je ne puis jamais m'empêcher de jeter un regard, sinon universellement sympathique, au moins curieux sur la foule de parias"* (emphasis added). ["I can never keep myself from hazarding a glance, if not entirely sympathetic, at least curious, at the mob of pariahs"] (*Pet. po. en pr.*, p. 69).

Jacob regards Matorel in much the same way that Baudelaire regarded the pariahs, that is, with a combination of indulgent amusement, curiosity, and pity. There is good reason to believe too that Jacob identifies Matorel with these *parias,* singular, decrepit, charming, frail, and helpless, elderly ladies, *honteuses d'exister.* And not only Matorel, but Jacob *himself* emerges as a grotesque and ridiculous figure, old-fashioned by his rhetoric, by his outmoded clothing, by his romantic sensibilities, and effeminate by his pederasty.

The extent and penetration of the marionette-*vieille* image in twentieth-century French literature is readily documented.[4] Marcel Proust simply presents the image in its literal framework, using it to point up the differences in psychic size between the manipulator and the manipulated in a social situation.

> M. Legrandin avait à peine répondu, d'un air étonné, comme s'il ne nous reconnaissait pas, et avec cette perspective du regard par-

[4] It is not intended to be implied here, incidentally, that the marionette image dates *only* from the nineteenth century. Notable examples of it are to be found in Diderot and Rousseau, and the sense they give to it is in no wise ambiguous. For the former, see *Jacques le fataliste* (Paris, 1959):

> JACQUES. "-N'est-il pas évidemment démontré que nous agissons la plupart du temps sans le vouloir? Là, mettez la main sur la conscience: de tout ce que vous avez dit ou fait depuis une demi-heure, en avez-vous rien voulu? N'avez-vous pas été ma marionnette, et n'auriez-vous pas continué d'être mon polichinelle pendant un mois, si je me l'étais proposé?" (p. 280)
> [JACQUES. Isn't it evidently demonstrated that we act most of the time without wanting to? There, put your hand on your conscience: did you want to do all that you have said or done in the last half hour? Are you not my marionette, and wouldn't you have continued to be my puppet for a month if I had decided it?]

For the latter, see *La Nouvelle Héloise*, Lettre XVII, "Le Souper prié" (Paris, 1937): "Tout le monde y fait à la fois la même chose dans la même circonstance; tout va par temps comme les mouvements d'un régiment en bataille: vous diriez que ce sont autant de marionnettes clouées sur la même planche, ou tirées par le même fil." (p. 52) [Everybody there does the same thing in the same circumstances; everything goes by the numbers as with a regiment in battle: you would say that they are so many marionettes nailed to the same plank or drawn by the same string.]

ticulière aux personnes qui ne veulent pas être aimables et qui, du fond subitement prolongé de leurs yeux, ont l'air de vous apercevoir comme au bout d'une route interminable et à une si grande distance qu'elles se contentent de vous adresser un signe de tête minuscule pour le proportionner à *vos dimensions de marionnette.*[5]

[Monsieur Legrandin had hardly answered; but he did so with an astonished look as if he hadn't recognized us and also with that perspective peculiar to persons who don't want to be friendly and who, from a plane at the very back of their eyes—a plane that they suddenly project outward toward you—seem to perceive you as if you were at the end of an interminable road and at such a great distance that they are content to nod their head to you almost imperceptibly in order to proportion their greeting to your marionette dimensions.]

The marionette here may be said to partake of the humility and helplessness of the *vieille* when seen as the weaker of two personalities, dominated and reduced by the more powerful one. The marionette image, as transposed by Proust on a human plane and dominated here by Legrandin, gives rise to the existentialist *Autre.* In the second of these texts (from Gide), La Pérouse speaks of his abortive suicide attempt:

Quelque chose de complètement étranger à ma volonté, de plus fort que ma volonté, me retenait. . . . Comme si Dieu ne voulait pas me laisser partir. Imaginez une *marionnette* qui voudrait quitter la scène avant la fin de la pièce . . . Halte-là! On a encore besoin de vous pour le finale. Ah! vous croyiez que vous pouviez partir quand vous vouliez! J'ai compris que ce que nous appelons notre volonté, ce sont *les fils qui font marcher la marionnette, et que Dieu tire.*[6]

[Something completely outside of my will, stronger than my will, held me back. As if God didn't want me to depart. Imagine a marionette who wanted to walk off the stage before the end of the play. "Hold it there! We still need you for the finale. Ah! you thought you could leave when you wished." I understand that what we call our will is only the strings that make the marionette dance and that God pulls.]

This image, which was to become extremely wide-spread in twentieth century prose and poetry, is all-pervasive in Max Jacob and helps the reader to peer more deeply into the obscured meanings of another text from the *Matorel.*

[5] *A la recherche du temps perdu* (Paris, 1919), p. 164.
[6] André Gide, *Les Faux-Monnayeurs* (Paris, 1925), p. 318.

VII. "L'Automate"

I N THE EIGHTH CHAPTER of *Saint Matorel,* "Chapitre des remords,"
Jacob presents the first of his published *poèmes en prose.* He intro-
duces it in the following manner:

Voici quelques notes trouvées dans les papiers du frère Manassé,
mort au couvent des Lazaristes, à Barcelone, et qui jettent un peu de
sympathie sur ce malheureux.

Ces notes que mes amis d'à présent nommeraient "Proses" ou
"Poèmes en prose," et qui figureraient honorablement dans nos
Gothas littéraires, le futur moine s'en servait boulevard Barbès pour
allumer le feu. . . . (*St. Mat.,* p. 51)

[Here are some notes which were found among the papers of Brother
Manasse, who died at the convent of the Lazarists in Barcelona, and
which cast a little sympathy on that unhappy man.

My friends of the moment would call these notes *"Proses"* or
"Poèmes en prose" and they would figure honorably in our literary
anthologies. The future monk used them, when he lived on the boule-
vard Barbès, to light the fire.]

This critical acumen and foresight shows that Jacob was a fully conscious
artist and entirely aware of the ramifications his work would have.

108

L'Automate

Il était assis dans le fauteuil du trône, avec sa crinoline de poussière, l'automate! Et ses bras poudrés de riz. . . . Le prince, coiffé du chapeau rond des voyous, regardait les cils peints sur la porcelaine et les yeux bleus fixes. La poupée se leva, pleine de dignité et de ses doigts poudrés, elle joua, la poupée, sur le clavier du piano, le leitmotiv du remords. (*St. Mat.*, p. 51)

[The Automaton

It was seated in the armchair of the throne, with its crinoline of dust, the automaton! And its arms powdered with rice powder. . . . The prince, wearing the round hat of the hoodlums, looked at its eyelashes painted on the porcelain and at its fixed blue eyes. The doll arose, full of dignity and, with its powdered fingers, it played, the doll, on the keyboard of the piano, the leitmotif of remorse.]

The poem begins with *il était assis,* a construction in which the imperfect tense and past participle prolong the inaction of the sitting figure and thus set a scene of oneiric immobility. The redundancy, *fauteuil du trône,* sharpens the focus of attention on the throne, emphasizing its function as a seat, and consigning the *automate* more profoundly to it. *Trône,* aside from recalling the name of a poor wrestling arena, *La foire du trône,* of which there was some mention in "Chapitre VII," both by the word *foire* (in the sense of *foireux,* 'diarrheic') and by the word *trône* (which can also mean a child's toilet seat) suggests a childlike, and insofar as infantile fantasy reconstructions are often dreams, an oneiric mood.

The first part of the first sentence, *il était assis dans le fauteuil du trône,* offers no particular difficulty of meaning. But the *crinoline* with its qualifying *de poussière* introduces a puzzling note and sends the reader back to wonder what *avec* can mean here, whether "dressed in" or simply "holding," and whether the material itself is actually dusty or whether its rough texture resembles a coating of dust. Then the gratuitous repetition of the title word plus an exclamation point closes the sentence with great finality.

The next truncated phrase, beginning with the nonsequential conjunction *et,* rather than elucidating what has already preceded, only increases the confusion since it informs us that the *automate* seated on the

throne in dusty crinoline has its arms powdered with rice powder. The *automate* sits regally on the throne while the prince, wearing the "round hat of the toughs" (perhaps the cap of the Parisian *Apache*), stands staring intently into the fixed and painted eyes of the porcelain face as if marvelling.

The *automate*, referred to now as a *poupée*, arises full of dignity, and therefore slowly, this lack of animation extending from the original suspension of movement suggested by *était assis* and continuing through the dreamlike scene and the fixity of the gaze. The mention of the powdered fingers brings the figure into even closer focus than the *bras poudrés* had done, and the repetition of *la poupée* acts as a stop to retard further what little action there has been.

The powdered fingers then play, not just on the piano but on the keyboard, constituting a double synecdoche: fingers subtracted from hand, arm, and person; and keyboard subtracted from piano, a construction which parallels somewhat the *fauteuil du trône*. The successive phrases of the last sentence, if arranged like the verses of a more conventional poem:

La poupée se leva,
pleine de dignité
et de ses doigts poudrés
elle joua, la poupée
sur le clavier du piano
le leitmotiv du remords.

produce the effect of musical chords or arpeggios, the first four ranging upward, the last two downward to a sort of tonic resolution.

The setting has been, thus far, one of static immobility. Now silence is, in the aural realm, the counterpart of immobility in the realm of motion. If, by that synecdochic subtraction of keyboard from piano, the dummy were to produce silence instead of sound, this would establish an equilibrium between the two elements of the dreamlike scene. Keats has implied that music can be silent, for example:

Heard melodies are sweet, but those unheard
Are sweeter....

Nor is the notion unknown to twentieth-century writers: *Les oreilles ne*

peuvent plus écouter de musique que celle que joue le clair de lune sur la flûte du silence.[1]

Some features of this poem are traceable elsewhere in Jacob. By their differing applications, they may cast some light on the *automate.* In the "Préface de 1916," Jacob berates those nineteenth-century writers who *n'ont pas osé descendre du trône que leur désir de pureté avait bâti.* (*C. à d.*, p. 14) *Trône* is equated to a *désir de pureté* but may be also a playful jibe at that purity, in the double sense in which *trône* is used in "L'Automate" and which accords itself well, as we shall see, with certain other elements of the poem.

Another poem in the *Cornet à dés* presents a related tableau:

> La flamme de sa main veut rejoindre son profil. Son corps est un dossier de chaise; ses genoux sont les pieds de son maigre trône. Son sceptre que heurte de sa flûte immobile un autre arlequin en dansant s'appuie à l'épaule négligemment. (*C. à d.*, p. 60)

> [The flame of her hand wishes to join her profile. Her body is the back of a chair; her knees are the feet of her meager throne. Her scepter, that another harlequin bumps with his immobile flute while he dances by, leans negligently against her shoulder.]

Many of the same images, fleeting and fragmented, sweep past the reader. Comparing the hand and fingers to tongues of flame touching the profile shows us a tired harlequin resting her head on her hand. The body of the harlequin and her "throne" seem, moreover, to have achieved a substantial interpenetration à la Picasso, a source the painter was exploiting as early as 1913 (in *Femme en chemise assise dans un fauteuil*) and as late as 1948 (in *Portrait d'une femme*).

An overpowering lassitude pervades the scene. The first harlequin seems to be sitting on her "throne" and dancing at the same time with her scepter leaning "negligently" against her shoulder, a touch which imparts a quasi-immobility to the exhausted dancers. There is also that inverse regal quality expressed by scepter and throne but associated here with harlequins who, along with Baudelaire's celebrated *saltimbanques,* constitute one of the lowest levels of society. Aside from the dynamic chair-body penetration, the scene is nowhere better depicted than in the canvases of Picasso's blue period.

[1] Marcel Proust, *A la recherche du temps perdu* (Paris, 1919), p. 174.

As regards powder, crinoline, painted eyebrows, and the like, cosmetics and makeup were dear to Baudelaire's heart. He wrote a well-known "Eloge du maquillage" (from *L'Art romantique*). Gautier says of Baudelaire:

> . . . une fleur de *poudre de riz sur la gorge et les épaules* ne lui déplaisait en aucune manière. . . . Ce n'est pas lui eût écrit de vertueuses tirades contre le *maquillage* et la *crinoline*. (*F. du m.*, p. 31, emphasis added).

> [. . . a sprinkling of rice powder on the throat and the shoulders did not displease him in any way. . . . You would never see him writing virtuous tirades against makeup and crinoline.]

Baudelaire was fond of extending this comparison to literary problems. In "La Genèse d'un poème," he opines,

> Après tout, un peu de charlatanerie est toujours permis au génie, et même ne lui messied pas. C'est comme le fard sur les pommettes d'une femme naturellement belle, un assaisonnement nouveau pour l'esprit. ("La Gen.," p. 87)

> [After all, a little charlatanism is always allowed geniuses and isn't even unbecoming to them. It is like rouge on the cheeks of a naturally beautiful woman, a slightly different seasoning for the mind.]

and at the end of the same essay, à propos of literary composition he speaks of

> les plumes de coq, le rouge, les mouches et tout le maquillage qui . . . constituent l'apanage et le naturel de l'histrion littéraire. ("La Gen.," p. 89)

> [rooster feathers, rouge, artificial beauty marks, and all the makeup that constitute the prerogatives and the disposition of the literary histrion.]

It is plausible, moreover, that the poem places before us once more a variation on the combined *vieille-marionnette* figure since the *automate* is obviously a type of marionette too, and also, because of the crinoline

and the powder, something of a *vieille*. In addition, the *automate* effects the synthesis of these two elements which is that of being a harlequin, as the earlier Jacob poem demonstrates. Aside from the fact that the Gautier passage, by its very vocabulary, could have set off the entire train of fantasy in Jacob's mind resulting in the composition of this poem, Baudelaire's application of these ideas to literary creation points to the possibility that Jacob meant to write a *charlatanerie* which would be *un assaisonnement nouveau pour l'esprit* on the part of the literary *histrion* that he was.

In the "Pièces burlesques" of the *Matorel,* there are several poems which develop some of the very themes of "L'Automate":

DECOR DE PORCELAINE

Marie se remarie, la Reine des pianos!
Sous le poirier d'argent cousent trois chambrières
L'organdi d'un trousseau tout brodé de chimères. . . .
(*St. Mat.,* p. 239, emphasis added)

[PORCELAIN DECOR

Marie is getting married again, the Queen of pianos!
Under the silver pear tree three chambermaids are sewing
The organdy of a trousseau all embroidered with illusions. . . .]

Here the reference to the Virgin Mary is unmistakable though Jacob never explains why she is *la Reine des pianos.*[2] The organdy of her trousseau, *tout brodé de chimères* would seem to suggest crinoline, another echo perhaps of the *accessoires de cotillon.* Jacob himself comments on this poem, saying:

Pourquoi ce titre "Décor de porcelaine"? Matorel se moque-t-il de lui-même? (*St. Mat.,* p. 239)

[2] Among the many similarities between Jacob's work and that of Rimbaud, one finds: "Madame***établit *un piano* dans le Alpes. . . . et *la Reine*, la Sorcière qui allume sa braise dans le pot de terre, ne voudra jamais nous raconter ce qu'elle sait, et que nous ignorons." ("Après le déluge") And in the very next *poème en prose*, it is a question of "*Cette idole, yeux noirs et crin jaune*, sans parents ni cour, plus noble que la fable, mexicaine et flamande." ("Enfance") The third begins: "Un *prince* était vexé . . ." ("Conte," in *Les Illuminations*, emphasis added)

Immediately following this, another poem is more explicit about the theme of powder:

—Comme il est pâle, se dit-elle, il doit se poudrer . . . Pas possible. . . . (*St. Mat.*, p. 240)

["How pale he is," she said to herself, "he must use face powder. . . . Impossible. . . ."]

This appears to be a speculation on whether the man, a hospital intern in this case, uses face powder with the implication that if he does, he is a homosexual. The flouncy finery and the makeup might seem to indicate the effeminate more than the genuinely feminine. And in the curiously twisted psyche of the invert, homosexual relations assume a pure, disinterested, almost virginal quality in contrast to the heterosexual relations which may bear fruit and thus mark the persons who indulge in them.

In the "Troisième partie," Jacob tells us:

Le Dante cherche sur un piano l'inspiration du ciel. (*St. Mat.*, p. 290)

[Dante seeks on the piano the inspiration of Heaven.]

Here the piano, because of the association with Dante, leaves us with an *automate* that is a kind of mechanical Beatrice. This *poupée* would seem to incarnate a perfection and a purity somewhere between that of man and that of the angels. In its inhuman manner, it attains to the highest distillation of the feminine ideal, absolutely pure and yet compassionate, a personage embodied most perfectly in the Virgin Mary beside whom even a prince appears a *voyou*.

The poem in which Jacob speaks of *Marie . . . la Reine des pianos* and the one in which Dante *cherche sur un piano l'inspiration du ciel* indicate that the piano symbolizes heavenly, therefore superhuman or supernatural, aspirations and acts as a kind of divine *ouija* board for poetic inspiration as well. But the superhuman might also symbolize, for the notorious invert that Jacob was, simply extra-heterosexual or homosexual sensitivity, placing the invert above the level of mortal man as if he were somehow capable of perceiving higher truth.

The prince stares in evident fascinated submission at the figure (presumably occupying his own throne) while the eyes painted on the porcelain face stare fixedly, in turn, at some far-away and immutable truth, and it is as if the truth glimpsed by the *automate* were in some mysterious way transmitted to the prince. The *chapeau rond des voyous* suggests that the prince has been an evil-doer, and we know from several confessions in the *Matorel* that Jacob, who often identifies himself with Matorel, was a tormented kleptomaniac:

> . . . l'argent était là sur le tapis.[3] Et Matorel . . . eut un grande feu dans la poitrine, une envie de piraterie.
> Il ne souriait plus sous son gros front, il ne regardait plus derrière ses yeux le livre d'images de ses pensées; il n'y avait qu'un fait au monde: cet argent mêlé d'or et sa poitrine rouge en dedans. Alors une voix dit au fond de son oreille: "Voleur! Voleur!"; une voix chanta sur un rythme badin, une voix claire: "Voleur! Voleur! Voleur!"
> (*St. Mat.*, pp. 41–42)

> [. . . the money was there on the gaming table. And Matorel . . . had a great fire in his breast, a desire for piracy.
> He was no longer smiling under his massive forehead, he was no longer looking at the picturebook of his thoughts behind his eyes; there was only one fact in the world: that silver mixed with gold and his red breast in the midst of it all. Then a voice said deep in his ear: "Robber! robber!" A voice sang on a childish rhythm, a piping voice: "Robber! Robber! Robber!"]

This is about as graphic a description of the temptation to larceny as one could hope to find in literature, and not only a description of desire but of a veritable compulsion. The presence of money constitutes temptation; and the voice of conscience punishes even before the act has been committed, so that the theft, when it takes place, is the inevitable completion of an interior drama.

The *automate*, invested with a cluster of significations derived from the *vieilles*-marionette-harlequin complex, represents the remorseful or virtuous stage of the temptation-sin-remorse cycle. The *automate* represents a *désir de pureté*, while the prince-*voyou* represents man's baser

[3] The reader will now understand the full significance of the title of the *poème en prose* from *Le Cornet à dés* first mentioned on p. 47, "Capital: Tapis de Table."

instincts held in thrall for a moment. The silence and immobility contribute an atmosphere of peace (or *recueillement*) so that, when the *automate* glides noiselessly to the piano to sound the silent call of remorse, the rapt prince listens, touched to the very depths of his being.

It is possible to interpret this poem from another and opposed point of view. The presumedly angelic *poupée* can as well represent an ancient *courtisane* as the dusty crinoline, the painted eyes and face, and the powdered arms suggest, the prince being in this case her client or panderer. Her song may sing of what remains after the passions have fled, those imperious but fugitive desires that make of man a puppet and leave the heart heavy and the mind saddened. The overwhelming sensation of lassitude that this produces is not unlike the one we have discovered in the harlequin in a related *poème en prose* of Jacob, nor is it unlike the ultimate fate of a resigned Léonie become a bogus Greek *danseuse de charme* in the poorest of cabarets (*St. Mat.*, p. 24).

Nor is it unreasonable to assume that Jacob could have imagined this fantasy in either of its opposed aspects, or alternately in both or, for that matter, in both at once. For him, remorse returns like a leitmotif. Who can guess the number of times he saw the cycle complete itself? In his *désir de pureté*, he would have liked to arrest it permanently at the stage of remorse but inexorably it continued to turn just a little too far and, to get out of hand, to proceed toward new temptation. This combination of superhuman perfection and/or all-too-much frailty implies an ascertainable and absolute moral standard which the frivolous Jacob failed to live up to. Having charted his deviation from this code of conduct, he hears once again the sad call of remorse.

VIII. Explication de Texte: "Jouer du bugle"

C HAPTERS IV THROUGH VII have concentrated on the *Saint Matorel*. The confrontation with Baudelaire has been useful in exploring Jacob's knotty-imaged poetry in the *Matorel* and his other early books. As Jacob continued to write, he grew bolder and more self-assured, though without abandoning the favored preoccupations, so that by applying the same Baudelaire-slanted approach one finds it possible to delve deeper into what at first appears a nearly impenetrable poetic surface. "Jouer du bugle," for example, a poem from the *Le Laboratoire central* (1921), prompted Marcel Raymond to say: *Max Jacob use d'un matérial d'illusionniste, et ménage des effects de miroir qui rendent sa retraite impénétrable.*[1] [Max Jacob uses illusionistic material and he operates mirror-effects which render his retreat impenetrable.]

JOUER DU BUGLE

Les trois dames qui jouent du bugle
Tard dans leur salle de bains
Ont pour maître un certain mufle
Qui n'est là que le matin.

[1] *De Baudelaire* (Paris, 1947), p. 253.

117

L'enfant blond qui prend les crabes
Des crabes avec la main
Ne dit pas une syllabe.
C'est un fils aldutérin. [sic]

Trois mères pour cet enfant chauve
Une seule suffirait bien.
Le père est nabab mais pauvre
Il le traite comme un chien.

> Coeur des Muses, tu m'aveugles
> C'est moi qu'on voit jouer du bugle
> Au pont d'Iéna, le dimanche
> Un écriteau sur la manche. (*Lab.
> cent.*, p. 22)

[PLAYING THE FLÜGELHORN

The three ladies who play the Flügelhorn
Late in their bathroom
Have for a master a certain cad
Who is only there in the morning.

The blond child who catches crabs
Crabs with his hand
Doesn't utter a syllable.
He's illegitimate.

Three mothers for that bald child
One would be more than enough.
The father's a nabob but poor withal
And he treats him like a dog.

> Heart of the Muses, you blind me
> It is I whom you see playing the Flügelhorn
> On the Iéna Bridge on Sunday
> With a sign on my sleeve.]

This quaint and out-of-date brass instrument evokes a Salvation Army band. *Bugle désignait d'abord un instrument en corne de buffle (relevé dans un texte du XIIIe siècle, rédigé en Angleterre)*,[2] and originally came

[2] Oscar Bloch and W. von Wartburg, *Dictionnaire étymologique de la langue française* (Paris, 1950), p. 90.

from the Old French verb *beugler*. (Despite Jacob's irrepressible penchant for allowing sound to run away with sense, nowhere in the poem does the verb *beugler* occur, though it must inevitably have suggested itself to the poet from its association with both *bugle* and *buffle*, and he does use this very word in a related context.)

Dame, from the Latin *domina*, still retains a vestige of that ancient title of respect in spite of the fact that *dame* has more and more come to replace *femme* in uneducated speech (who has not heard *votre dame* used for *votre femme?*). For this reason, *les trois dames*, sounds formal but at the same time has the ring of a solecism. *"Les trois dames qui jouent du bugle* presents an inexplicable and disturbing tableau, again à la Picasso of the *Demoiselles d'Avignon* canvas, wherein three central female figures dispose themselves in nightmarish postures, none stranger, however, than playing the Flügelhorn in the bathroom.

Tard dans leur salle de bains further displaces the logic of the programmatic content. *Tard*, on the dramatic plane, implies an application to master some difficult skill, a burning of the midnight oil, a willingness to forgo rest. Phonetically *tard* imitates the blare of a hunting horn (represented by *tara-tara* in French). By means of the A plus the liquid, present in both phonemic units, the [ar] in *tard* suggests somewhat the [al] in *salle*. *Salle*, in turn, seems to pull along with it *de bains* both because of the frequent association of these two words and because, together, the mute E of *de* being briefer and less distinct, they create something of an iambic pattern suggestive of the horn blast (though not to be confused with the strong iamb of the English verse foot).

The verse then, with its open vowels and nasals, would seem to blast out a fanfare. In addition, each word (or note) remains on a constant pitch except *leur* which sounds a fifth lower. If we were to submit the verse to a kind of *Schallanalyse*, it would come out:

| tard | dans | leur | salle | de-bains |

the lower note being like one obtained by pressing down on one of the

pistons. The rythmic elasticity of the *de bains,* suggesting an iamb, also contributes to the bugle-call quality of the verse by its *ta-taaaa.* The sound as well as the sense of these verses depicting a trio of lady Flügel-horn players trumpeting to the reverberating acoustics of a tiled bath-room, brings us near to the outer limits of both verbal intelligibility and poetic suggestibility.

The clause, *ont pour maître,* by the nasal *ont* and by the braying tone imparted by the length of *maître* [mɛ:tre] continues the infernal brass concert. It also introduces, because the sense of *maître* suggests the panderer, a hint of the sordid. *Mufle* (possibly the result in Jacob's mind of a cross between *maître-bugle* and *buffle*), current slang for a common, selfish, mean, and brutal person, reinforces this idea of the *maître* being a panderer. The primary sense of *mufle* is, incidentally, *extrémité du museau,* obviously of an animal whose characteristic cry is a *beuglement,* which sense would further suggest bestiality, and the connotations of meanness surrounding the word *vache* in French will escape no one.

If we subtract the jarring note of the Flügelhorns, there is nothing bizarre in the phrase *trois dames ont pour maître un certain mufle qui n'est là que le matin.* The mysterious absence day and night might be more than neglect, however; is it the classic effacement of the panderer to give privacy to his clients? The ominous morning presence, plausibly to collect the receipts of the previous night's activity, also attests to the occupation of the *mufle* and gives the measure of his *muflerie.* This part of the poem makes perfect sense.

But the introduction into the texture of the poem of a Flügelhorn trio playing in the bathroom produces a hallucinatory or oneiric quality. *Il y a toujours eu dans l'esprit des hommes un lien étroit entre les bains et la volupté,*[3] Aragon tells us and seen in this light the Flügelhorn be-comes a phallus. Thus the first rather undistinguished setting suddenly comes alive, illuminated by a volatile new light source, new but still in keeping with the original sense framework. One might interpret this polarity between the three soggy ladies of easy virtue and the incandescent blaring of the horns as just that opposition between two of the stages in Jacob's temptation-sin-remorse cycle, the remorse being symbolized by the persons of the three degraded women, cf. the *vieille,* the flamboyant

[3] *Le Paysan de Paris* (Paris, 1926), p. 63.

new temptation being adumbrated in the guise of nightmarish music.

From the standpoint of intelligibility, *les trois dames jouent du bugle tard dans leur salle de bains* constitutes a perfect sense unit, while *les trois dames ont pour maître un certain mufle qui n'est là que le matin* constitutes another. The two blocks of meaning branch off from their common point of departure which is *les trois dames* in both cases. *Les trois dames ont* is a primary sense unit, however, but *jouent du bugle*, preceded as it is by the relative pronoun *qui*, draws after it the subordinate clause full of the preposterous Flügelhorn music.

In other words, the meaning bifurcates and the ridiculousness of the Flügelhorns is *inserted* into the primary element of the sentence rather than having constituted a basic part of it from the beginning. That is, the essential element here is decidedly not *bugle* but *mufle*. The Flügelhorns are a "touch" added to destroy the continuity of sense unity, seemingly gratuitous at this point in the poetic narrative but whose logical presence will be justified when the reader will have arrived at the *envoi* and the poem itself will have come full circle.

The second stanza begins *l'enfant blond qui prend les crabes.* Aside from the continuation of the obvious verbal music in the play of the nasals and in the liquid plus the A of *prend* [prã] and *crabes* [krab], it introduces a third actor into the sordid little piece in addition to the already encountered, collective *dames* and the *maître-mufle*. At first, the child is simply *blond*. Both by sound and by sense, [blɔ] suggests *blanc* [blã], therefore candor, purity, even perhaps the too perfect innocence of the "sacred" idiot of traditional folk culture.

One imagines a tow-headed child, obedient and silent, bent over his humble chore, a chore not only disagreeable but a little dangerous as well. The change from *les crabes* to the partitive *des crabes* and, in the second instance, the reinforcing of the *des* by *avec la main* which focuses on the boy's hand instead of on the crabs, might possibly suggest repugnance or at least caution on the boy's part to avoid being bitten and also plays up the difficulty of catching the crabs.

Jacob mixes sound and sense, now the sense drawing the sound, now the sound the sense, until he has built a verse. *Blond-prend-crabes* constitute a phonetic progression which may be analyzed as follows: *blond* consists of an initial voiced bilabial stop followed by a liquid followed, in turn, by a nasal, [blɔ]; *prend*, of a similar construction, consists of

the same initial bilabial stop but unvoiced in this instance plus a liquid plus another nasal, [prɑ̃].

With the word *crabes,* however, the pattern is broken. What had been an initial bilabial stop has now become the velar stop [k] (P to K is not infrequent in the Romance languages), while the nasal [ɑ̃] of *prend* has denasalized to an anterior A [a], and the originally initial bilabial now appears tacked on at the end.

On the purely phonetic plane, *crabes* represents something of a breakdown of the original pattern, [blɔ-prɑ̃], while *prend* manages to suggest *crabes* not so much by sound as by a prehensility common both to its etymon and to the crab it is describing. The boy reaches out two fingers of his hand to take the crab much as the crab reaches out its two-pointed claws to take the boy.

Ne dit pas une syllabe plays up the passive and docile nature of the child. This innocuousness is presumably accounted for in the next verse by what seems to be an aside: *c'est un fils aldutérin* (with that startling error). Whether this is a typographical error or a deliberate metathesis such as Jacob occasionally employs to mock popular speakers who habitually speak this way is of no consequence to the ultimate interpretation of the poem. *Aldutérin* for *adultérin* would only add one tiny brush stroke as it were to the slightly vulgar tableau before us in the poem and a possible error could hardly change anything.

Aldutérin, or *adultérin* as it is properly, both carry traces perhaps of the expression *frère utérin,* the syllables [ytɛr] being common to all these words. They also participate in the ecclesiastico-legal jargon of the French *notaire;* one thinks of such terms as *dogme, casuistique, dispensations, remariages, veuvages, viduités,* and so on. Nor is this the sole occurrence of the theme of bastardy in Jacob's works.

Let us note the intensity of the child's silence. Not only does he not speak, does he not say a word, but he does not even utter a syllable! And the synecdoche here is probably the most emphatic manner of insisting on this point, especially since the word "syllable" does not exclude the possibility of the child's making grunting noises in an effort to speak as an idiot or a mute will do. Moreover, the fruit of an adulterous union of whom one would rather not speak, by a foreshortening of cause and effect, refuses to speak himself.

The descriptive elements of the second quatrain can be summed up

as *l'enfant blond ne dit pas une syllable, c'est un fils aldutérin.* The action of the child's catching crabs erupts into these verses within a relative clause just as playing the Flügelhorn had erupted into the earlier ones. Stylistically the first two verses of this quatrain repeat each other with only a slight advance in the unfolding of the sense content, somewhat like the repetitious verses of Péguy. But this repetition facilitates the banal rhymes, at the same time, prolonging the bleating music of the *bugle.*

The third stanza places before us the difficult problem of metrical analysis of this poem. In spite of the centuries-old controversy over quantitative metrics in French verse and many well-founded doubts as to its validity, the rollicking rhythms and banal rhymes and half-rhymes impose a method of analysis quite different from that applicable to classical French versification. Everywhere but in the second verse of the first stanza, scansion reveals a line of seven (or occasionally eight) syllables divided into halves. The model for this is

```
        /                        /
les trois dam's qui / jouent du bugle
 1    2    3      4   1    2   3  4
```

The sense of the words puts an ictus on the next to last syllable of each group, /dam's/ and /bu-/, as indicated by the slashes over the line. The /-gle/ of *bugle* is a dead syllable exactly like the vowel, or consonant plus vowel, or consonant plus liquid plus vowel, which add an extra syllable to the end of a feminine rhyme in classical French poetry. Since this phenomenon occurs at the end of ten of the fourteen verses in the poem, its persistence tends to set up a pattern in the reader's mind.

Qui, which, in the first group, parallels /-gle/, because it occupies the same numbered syllable in the verse, thereby takes on the quality of an extra, unstressed syllable too. The group, considered in this manner, resembles an irregular anapest consisting of two unstressed syllables, /les/ and /trois/, or /jouent/ and /du/, followed by a stressed syllable, /dam's/ or /bu-/, followed in turn by an extra, unstressed syllable, /qui/ or /-gle/. In some verses, especially the second and fourth of each stanza, the last syllable of the second half of the pair, which we have designated as resembling a feminine rhyme, is lacking.

If one were to letter the four stanzas, A, B, C, and D, and number the

four verses of each stanza, 1, 2, 3, and 4, the other nine verses conforming
to the pattern set up by the first verse would appear thus:

	1	2	3		1	2	3	
A1	les	trois	dam's	(qui)	jouent	du	bu-	(gle)
A3	ont	pour	maî-	(tr'un)	cer-	tain	mu-	(fle)
A4	qui	n'est	là	(que)	le	ma-	tin	——
B1	l'en-	fant	blond	(qui)	prend	les	cra-	(bes)
B3	ne	dit	pa-	(s-u-)	ne	syl-	la-	(be)
B4	c'est	un	fils	(al-)	du-	té-	rin	——
C2	u-	ne	seul'	(su'-)	fi-	rait	bien	——
C3	le	pè	r'est	(na-)	bab	mais	pau-	(vre)
C4	il	le	trai-	(te)	co'-	m'un	chien	——
D1	coeur	des	Mu-	(ses)	tu	m'a-	veu-	(gles)

The six verses not conforming to this dominant pattern might be
placed before the reader in much the same manner:

A2	tard	dans	leur	——	sall'	de	bains	——
B2	des	cra-	be-	(s-a-)	vec	la	main	——
C1	trois	mèr's	pour	(ce-)	t'en-	fant	chau-	(ve)
D2	c'est	moi	qu'on	(voit)	jouer	du	bu-	(gle)
D3	au	pont	d'Ié-	(na)	le	di-	man-	(che)
D4	u-	n-é-	cri-	(teau)	sur	la	man-	(che)

Now it is first of all necessary to explain certain techniques employed
in the analysis of these verses. Since all mute E's in terminal position
elide before a word beginning with a vowel, the last preceding consonant
or consonants fulfill the function of an initial consonant, for example,
maître un [mɛ:/trœ̃], which justifies its being junctured in the table as
/*maî-tr'un*/. *Père est* [pɛ/rɛ] has, for the same reason, been junctured
/*pè-r'est*/. In such words as *comme* and *suffirait*, the double consonant
has no phonetic value being simply an orthographic convention, so the
second element of it has been eliminated, the missing letter being indicated
by an apostrophe, and the words rendered as pronounced: *comme un*
[kɔ/mœ̃] as /*co'-m'un*/, and *suffirait* [sy/fi/rɛ] as /*su'fi-rait*/.

In *syllabe*, it is optional whether the two L's are doubled or not, so
they have been allowed to remain but are separated in accordance with
standard French usage. All liaison, again in keeping with standard usage,
is indicated thus: *pas une* [pɑ/zy/nə] is rendered /*pas-s-u-ne*/. In a few

cases, mute E's have been eliminated, as in the first verse, *les trois dam's*, and others which might ordinarily have been dropped in *style parlé* are retained. These choices were dictated by the sense and/or metrical exigencies of the verses themselves and will be explained presently.

As has already been noted, *les trois dames* and *jouent du bugle* of the first verse establish a suggestion of anapestic meter with stresses naturally falling on what practically amounts to a semantic opposition between *dames* and *bugles*. But immediately following this verse, and before the rhythm has been hammered into the reader's consciousness as it will be shortly by at least ten subsequent verses all following nearly the same pattern, the second verse abandons the original rhythmic pattern to become a kind of fanfare of four long and unstressed monosyllables resembling two spondees plus a final iamb: /*tard* / *dans* / *leur* / *salle* / *de-bains*/. The next three verses, however, unmistakably reinforce the initial rhythmic pattern.

But in verse B2, one encounters: *des crabes avec la main*. The disposition of the syllables makes it virtually impossible to put a stress on the usual third syllable, here a mute E. Now the full subtlety of Jacob's poetic technique begins to make itself felt. In normal conversation—and there can be no question but that this poem is written in *style parlé*—a phrase such as *l'enfant blond prend des crabes avec la main* would automatically eliminate the *liaison* between the S of *crabes* and A of *avec*.

By displacing the natural pairing of semantic value and ictus, Jacob makes the mute E fall on the third syllable where the ictus had fallen *twice* in each of the preceding four verses which conform to the original pattern. Jacob virtually forces the pronunciation of the S in *liaison*, so out of place in a poem of this sort, thus creating perhaps a suggestion of the hissing and bubbling of crabs in a basket.

From this, it also becomes evident that an overstrict and perhaps monotonous attachment to a given rhythmic pattern in the poem renders any deviation from that pattern immediately striking and even disturbing to the reader. The monotonous rhythm plus the jarring deviation constitute a conscious and deliberate device, a highlighting of the elements so set off from the rest.

There is another example of just such a device in verse C1. After having firmly established in the reader's mind the rhythmic pattern first

presented in verse A1, Jacob again makes it impossible to continue that pattern in verse C1 thus creating an unresolved tension:

A1	les	trois	dam's	qui	jouent	du	bu-	gle
C1	trois	mèr's	pour	cet	en-	fant	chau-	ve

It is impossible here for the stress, in conformity with the usual pattern, to fall on the third and sixth syllables coming as they do on two subordinate semantic units, /pour/ and /chau-/. Taken alone, however, verse C1 seems naturally to redispose itself into four trochee-like "feet":

/ trois mèr's / pour cet / en- fant / chau- ve/

The fact that the sense elements of the first half of verse C1 echo somewhat those of verse A1:

A1	les	trois	dames	qui	
C1	——	trois	mèr's	pour	cet

in the identical numeral *trois* and in the easily substituted *mères* for *dames,* renders the deplacement of these elements still more unsatisfactory to the ear. As the confrontation shows, only the absence of the initial plural article, *les,* produces the sense-ictus deplacement so that the dissimilarity from the pattern established in the first verse, resounding through five intervening verses, creates an out-of-phase feeling.

The verbal disorganization, moreover, leads directly into disorganization on other planes. The three "mothers," instead of taking care of the blond child, spend their time in the bathroom practicing the Flügelhorn. And not only do they neglect the child in favor of the insane music, but they are prostitutes as well. And while they neglect the child, the selfish and authoritarian father "treats him like a dog." It is as if the disintegration of the rhythmic pattern had announced a similar disintegration in the moral fiber, in much the same way that the sordid but realistic images had given way to nonsense images.

Verse C2 begins with the indefinite article, *une,* signifying both "any" and "*the* one" or "sole" and, of course, weighing in favor of the second of these possibilities, a combination most explicitly spelled out in Verlaine's rhapsodizing:

... une femme inconnue, et que j'aime, et qui m'aime,
Et qui n'est, chaque fois, ni tout à fait la même
Ni tout à fait une autre, et m'aime et me comprend.[4]

[... an unknown woman whom I love and who loves me,
And who is, each time, neither entirely the same
Nor entirely another, and who loves and understands me.]

uniting the most concrete and intimate with the most ethereal and im-
personal. This "sole" mother is not actually present, as the conditional
of the verb tells us, but if she *were,* she would only be "sufficient." And
it is the banality of the adjective "sufficient" that finally results in the
total breakdown of both the idea and the Ideal, with perhaps a tinge of
sentimental regret at "what might have been."

Le père est nabab mais pauvre further delineates the *maître-mufle*
figure. *Nabab,* originally an Indian potentate, then commonly applied to
the *nouveau riche* bourgeois, is used satirically since this *nabab* is not
only a *mufle,* he is *pauvre* as well. He is a nabob only insofar as he unites
in his person the authoritarian figures of a *père* who is both *maître* and
mufle, and who consequently dominates the fate of the four pathetic
beings in his charge on a physical as well as on a moral and psychological
plane. Even the word *nabab* sounds a little like a child's attempt (and
perhaps a retarded child's attempt) to speak or to pronounce the word
papa.

Pauvre is contaminated by its forced rhyme with *chauve,* encouraging
the reader to pronounce negligently *pauv'e,* a pronunciation which in-
fuses the line with a distinct lower-class quality quite in keeping with the
sordid surroundings and actors of the earlier stanzas. There takes place
here, too, a dual degeneration of sound and sense from *père* to *nabab* to
pauvre: on the plane of meaning, from fatherhood to a pretentiously-
named potentate to poverty; on the phonetic plane, from [pɛ] to [ba]
to [vo] (this last element present but reversed in [pov] with a cor-
responding lowering and "darkening" of the vowels).

The phenomenon of word contamination through the influence of
rhyme, that is, a word that does not properly possess a stop plus an R
rhyming with another word that *does* possess a stop plus an R, often

4 See "Melancholia," from *Poèmes saturniens.*

unpronounced in colloquial speech, has encouraged the reader to elim-
inate the R and say *pauv'e*. *Traite* too finds itself tangled in an earlier
verse. Since it is common practice for Jacob to manipulate internal
rhymes and assonances as in:

> les trois d*a*mes
> qui n'est l*a*
> ne dit p*a*s

or:

> trois m*è*res pour
> le p*è*re est

traite by its open E, the play of the initial T plus R and by its identical
position in a verse nine lines away (A3), echoes the word *maître* which
contains a codal T plus R. The word *traite*, moreover, suggests a number
of pejorative meanings in various ways connected with *maître*. There is
first the word *traitre* (which actually rhymes with *maître*), and then a
whole list of expressions such as *traiter quelqu'un en inférieur, la traite
des nègres, intraitable,* and so on.

In contrast to this, the last word of the preceding verse, *pauv'e*, and
the last work of this verse, *chien*, reinforced by five earlier occurrences of
the E nasal [ɛ̃] (*bain, matin, main, adultérin, bien, chien*), constitute
a plausible reason for hypothecating a *pauv'e chien*. So then we find a
kind of "house that Jack built" descending into total abjection, a nega-
tive piling up as it were: a degraded panderer, master of three unfor-
tunate ladies, who in turn neglect the blond child, who occupies the
ultimate abject rank of *pauv'e chien*.

The *envoi* begins on a vocative tone which likens it to that of a formal
ballade. *Coeur* is probably a pun on *choeur* since the entire poem imitates
a *choeur d'instruments à vent* in its exploiting of the effects of verbal
music. The phrase is unusually equilibrated on the phonetic level, the
vowels of the two halves of the verse creating a mirror effect:

> [koer / de / my / zə / ty / ma / voe / glə]
> 1　　2　　3　　　3　　2　　1

that is, the vowels in the pairs of syllables designated as 1 and 3 match.

Up to the *envoi*, the poem has carefully preserved the anonymity of

the speaker and the fiction of the *mufle* and his four unfortunate charges. But with the *me* of *tu m'aveugles*, immediately reinforced by an impassioned *c'est moi* here (parallel to *c'est un fils*, the only other instance of the *c'est* construction in this work), the poem suddenly takes on a distinctly personal note with the narrator's assuming the first person. *C'est moi*, moreover, combines the impersonality of *c'est* with the superpersonal *moi* while *on voit*, an expression which would be translated by a passive construction in English, further reinforces the impersonality. The addition of the hallucinatory *bugles* turns the *envoi* into a virtual cry of anguish.

All the tawdry appanage of the poem, the three ladies of easy virtue, the *maître-mufle* figure, the blond bastard child who is also probably an idiot, the Flügelhorn playing in the bathroom, in short the entire sordid phantasmagoria becomes identified with the speaker himself. It is *he* who, blinded (rather than illuminated) by the Muses, plays the Flügelhorn on Sunday mornings at the Pont d'Iéna. The last two verses, D3 and D4, serve simply to underline the final resolution of the images. At the end the tableau impresses itself on the reader's consciousness as one of utter abjection, the man of letters who finishes blind and alone, playing in the street for alms with a note pinned on his sleeve indicating his total abandonment.

As for the metrics, the first verse of the last quatrain conforms perfectly to the rhythmic pattern of the majority of the preceding verses. In the last three verses, D2, D3, and D4, however, because of the displacement of sense units from the ictus,

					´		´	
A1	les	trois	dam's	qui	jouent	du	bu-	gle
D1	coeur	des	Mu-	ses	tu	m'a-	veu-	gles
D2	c'est	moi	qu'on	voit	jouer	du	bu-	gle
D3	au	pont	d'Ié-	na	le	di-	man-	che
D4	un	é-	cri-	teau	sur	la	man-	che
	1	2	3		1	2	3	

the rhythm takes on a hesitant, almost limping quality. That is, given the unfeasibility of putting the stress on the habitual third syllable, in verse D2, /qu'on/, in verse D3, /d'Ié-/, in verse D4, /-cri-/, without deforming the sense of the words, once more the rhythm of the poem becomes

disturbingly altered. This completes the picture of madness and total dissolution.

One last technical observation imposes itself before we can proceed to a presentation of some assembled historical antecedents and to an eventual synthesis: an analysis, from the standpoint of classical French verse norms, of the rhymes. With only the exception of verses A1 and A3 and of D1 and D2, the rhymes are mostly *suffisantes* and crossed:

A1 bugle
A2 bains
A3 mufle
A4 matin

B1 crabes
B2 mains
B3 syllabe
B4 aldutérin

C1 chauve
C2 bien
C3 pauv'e
C4 chien

D1 aveugles
D2 bugle
D3 dimanche
D4 manche

that is, except for *bugle-mufle*, and the last quatrain where they are no longer crossed and where the first two are only half-rhymes.

The first three stanzas have an a b, a b scheme, the b b element always a masculine rhyme and always the *same* rhyme and a true rhyme even by classical standards, except *bains-matin*. The a a element is a feminine rhyme, and in stanza one is an assonance rather than a rhyme (this is possibly true in stanza three as well). In the *envoi* it becomes a a, b b. A a is a faint assonance. B b is a rich rhyme. All are feminine endings.

IX. Ultimates

THE THREE FLÜGELHORN-PLAYING *dames* are the three *vieilles* who appear in the *Matorel* and in the *Cornet à dés*. The *maître-mufle*, too, is familiar as a figuration of the devil, while the child is an extension downward of the marionette, at the level of the *poupée* or the *crapaud*.

There are correspondences in yet other passages from the *Matorel:*

> Voici la troisième femme! elle nous acceuillera dans sa maison. Est-ce moi qui suis moi, *le philosophe en méditation derrière cette porte?* Ah! ce rez-de-chaussée! Ici nous avons bu tant de vin. *Les trois femmes se déshabillent ou rhabillent leurs nudités asiatiques;* et *le philosophe en méditation derrière la porte est un nègre,* hélas! le philosophe n'était qu'un nègre. (*St. Mat.*, p. 258, emphasis added)

> [Here is the third woman! She will welcome us in her house. Is it I, the philosopher in meditation behind that door? Ah! this first floor. Here we have drunk so much wine. The three women undress and then dress again their asiatic nudity; and the philosopher in meditation behind the door is a Nigger, alas! the philosopher was only a Nigger.]

Here the dramatic situation is that of three Asiatic prostitutes busily

131

dressing and undressing perhaps in a *salle de bains.* The philosopher meditating "behind the door" reminds us of a child who has been punished and thus might correspond to the *enfant blond,* for as a philosopher, he is no more than a *nègre.*

Later in the *Matorel,* in the "Pièces burlesques," a most explicit poem takes up the themes:

Trois femmes, deux sur un lit: un dos sans graisse ni os, *la face d'une figure borgne! La misère. Dieu! as-tu permis cette plaie rouge sur ce bras! Et l'autre qui est borgne* regarde le Métropolitain en riant sans dents et avec des gencives terribles. La plus malade détourne la tête. Au fond, un autre lit avec une vieille. Toutes trois sont borgnes: c'est affreux! Et malgré toutes ces douleurs sur une table en acajou, un collet de soie orné de perles, comme en portent les bourgeoises le dimanche (*St. Mat.,* p. 286, emphasis added).

[Three women, two on a bed: a back without either fat on it or bones, a one-eyed face! Misery! God! Have you allowed that red sore on that arm? And the other who is one-eyed looks at the subway, laughing without teeth and with horrible gums. The sickest turns her head away. Behind, another bed with an elderly lady. All three are one-eyed: it's frightful! And in spite of these miseries, on a mahogany table, a silk collar embellished with pearls like those that middle-class women wear on Sunday.]

It is probable that Jacob has glimpsed this squalid scene in some broken-down hotel of Montmartre. He has woven a Flügelhorn and blond child into this original tableau too and then imagined himself as a composite of the protagonists, in the best *poète maudit* manner.

The *mufle* finds a clear descriptive treatment in the *Cornet à dés:*

L'homme à la blouse blanche tirait la vache par le naseau entre ciel et montagne. L'implacable odeur de *vache brûlée* va en diminuant.

La poitrine de femme ne se vend pas, car ce n'eût pas été *la vache qu'il eût tirée par le naseau.* Elle mugissait (*C. à d.,* p. 65, emphasis added).

[The man in the white smock was tugging at the cow by the nostril between the sky and the mountain; the implacable stench of burnt cow diminishes with the distance.

Breast of woman is not for sale because it would not have been the cow who would have tugged her by the nostril. She was lowing.]

L'homme à la blouse blanche represents a butcher, notorious in France for brutality, and a *maître-mufle* as well since he is obviously hurting the cow in the first *poème en prose*. In the second, he seems to be tugging at the woman's breast exactly as if he were pulling on the cow's muzzle, another instance of his brutality.

In just another such *poème en prose*, Jacob treats a different theme:

> Dans *la salle de bains* de votre amie, madame, pourquoi garder votre *ombrelle ouverte?* pendant que la vieille taille *les cors*, c'est pour la protéger du soleil derrière la *baignoire* en marbre blanc. (*C. à d.*, pp. 68–69; emphasis added)

> [In your lady friend's bathroom, Madame, why keep your parasol open? Is it to protect the old lady from the sun behind the white marble bathtub while she cuts her corns?]

The open umbrella might suggest the open bell of the Flügelhorn and *cors* could be a pun on horn.

In the same collection from which "Jouer du bugle" is taken, we find:

LA DAME AVEUGLE

La dame aveugle dont les yeux saignent choisit ses mots
Elle ne parle à personne de ses maux

Elle a des cheveux pareils à la mousse
Elle porte des bijoux et des pierreries rousses

Le dame grasse et *aveugle* dont les yeux saignent
Ecrit des lettres polies avec marges et interlignes

Elle prend garde *aux plis de sa robe de peluche*
Et s'efforce de faire quelque chose de plus

Et si je ne mentionne pas son beau-frère
C'est qu'ici ce jeune homme n'est pas en honneur

Car il s'enivre et fait s'enivrer *l'aveugle*
Qui rit, qui rit alors et *beugle* (*Lab. cent.*, p. 37, emphasis added)

[THE BLIND LADY

The blind lady whose eyes bleed chooses her words
She never speaks to anybody of her sicknesses

Her hair is like moss
She wears jewels and reddish stones

The fat, blind lady whose eyes bleed
Writes polite letters, leaves a margin and skips a line

She pays attention to the folds of her velvet dress
And tries to do even more

And if I don't mention her brother-in-law
It's because that young man is not in good odor

Since he gets drunk and makes the blind lady drunk
And she laughs and she laughs and then she bellows.]

Blindness is the chief concern of this poem, blindness and a kind of bourgeois correctness. Also present are a *dame* dressed in a *robe de peluche* (an echo of the *vieilles* and their *velours*), and twice repeated, the idea of refraining from speaking as found in the *enfant blond* who *ne dit pas une syllabe*, plus the rhyme *aveugle-beugle* which had been only a half-rhyme, *aveugle-bugle* in "Jouer du bugle," although one finds three *other* examples of half-rhymes in "La Dame aveugle."

The *fils adultérin* receives very comprehensive treatment in the following:

PLAIRE

L'enfant de l'adultère était profondément charitable,
égoïste et *dément*
La chambre devint si claire
qu'elle était vide comme l'éther
couleur de nacre, couleur d'huître blanc
si claire qu'elle éclata comme un éclair
Agé, âgé, faible et découragé
paré, pareil, paré désemparé
Hélas! quoi plaire? à combien d'exemplaires?[1]

[1] This poem is included in a *choix de poèmes* appended to the Billy biography. He attributes it to "Miroirs infidèles," but whether the title indicates a book of poems or a section from a book of poems it is impossible to determine since Billy gives no further information and the title is not to be found in any bibliography; André Billy, *Max Jacob* (Paris, 1946), p. 174.

[To Please

The child of the adulterous union was profoundly charitable
selfish and demented
The room became so light
That it was empty as ether
Color of mother-of-pearl, color of a white oyster
So light that it exploded like a lightning bolt
Aged, aged, feeble and discouraged
Dressed up, the same, dressed up and all at sea
Alas! How to please? And with how many copies?]

Just as the second stanza of "Jouer du bugle" had seemed to indicate, the *fils adultérin* was *charitable et dément,* or as it had been phrased, docile and retarded. The brightness and emptiness of the room, expressed in all the images of whiteness, is suggestive of the blond hair so light that it makes the child seem bald, all indicative of a perfect innocence, up to and including an emptiness of the head.

From blond to bald is a veritable *reductio ad absurdum* of innocence, presenting an imbecile child kept close-cropped for purposes of convenience and cleanliness though substantially neglected otherwise. We have learned from one of the biographies quoted in the Introduction that

Max . . . était insensible à tout, même aux coups qu'on ne lui épargnait guère. . . . Très battu, très battu par ses frères et par sa mère qui était nerveuse et impatiente. . . . Il reçut la dernière gifle de sa mère à 24 ans.[2]

So it is entirely likely that he thinks of himself as the disgraced child meditating behind the door after having been punished, treated *comme un chien.*

From an early age Jacob was nearly totally bald, and there is an interesting reminiscence of his still hirsute (though prematurely gray) youth:

Pourquoi la tondeuse à un âge où il est si légitime d'user de tous ses avantages? Je fus frappé par l'austérité que dénonçait déjà sa tête rase. Au Quartier Latin et dans le milieu littéraire régnait encore le

[2] Robert Guiette, "Vie de Max Jacob," N[ouvelle] R[evue] F[rançaise], CCL, CCLI (1934), p. 8. Translation given on p. xi of this book.

romantisme capillaire. Cette tête nue que piquetaient de courtes aiguilles d'argent avait quelque chose de monacal.[3]

[Why clippers at an age at which it is so legitimate to use all one's advantages? I was struck by the austerity that that shaved head denoted. In the Latin Quarter and in the literary milieu, long-haired romanticism was still the order of the day. That nude head with the short silver needles sticking up all over it had something monkish about it.]

This demonstrates again his tendency to confuse himself with the most abject and degraded personages of his poetry since he employs so many points of resemblance between the literary creation and the literary creator.

The child who handles the crabs with obvious aversion suggests the motif of the bitten fingers. In the *Matorel* we have seen:

Le tabac *me mordait les doigts* en ricanant, mon cher! (*St. Mat.*, p. 16, emphasis added)

and in the *Cornet à dés:*

on me pique avec une seringue: c'est un poison pour me tuer; une tête de squelette voilée de crêpe *me mord le doigt* (*C. à d.*, p. 24, emphasis added)

[They are sticking me with a hypodermic needle: it's a poison to kill me; a death's head draped with black bites my finger.]

These are only a few of many allusions to this motif in Jacob.[4] And as

[3] Billy, pp. 11–12.

[4] Another such obsessive image, perhaps a related one, is *mordre le bouton du sein*. We find, in the *Cornet à dés:* "Oui, il est tombé du bouton de mon sein et je ne m'en suis pas aperçu . . . , il est tombé de mon sein de Cybèle un poème nouveau et je ne m'en suis pas aperçu." (*C. à d.*, p. 70) [Yes, there fell from the nipple of my breast and I didn't notice it . . . , there fell from the nipple of my Cybel's breast a new poem and I didn't notice it.] And again in a poem entitled "Moeurs littéraires," one encounters: "Il paraît que j'ai écrit que tu avais mordu une femme au bouton du sein et qu'il a coulé du sang." (*C. à d.*, p. 101) [It appears that I wrote that you had bitten a woman on the nipple of her breast and that blood flowed.]

In another context, Jacob likes to play with the metamorphosing forms of what would seem to be a Biblical monster. For example, in the *Matorel*, he first presents

has been stated, this is one of the standard textbook symbols of the castration complex.

As for the word *nabab*, it is obviously employed in a pejorative sense in this poem, as the following quotation demonstrates:

> Je suis le *baobab* de la chair, *mon auréole est noire,* je suis le *rajah de la faiblesse* et le *nabab des scandales. (Méd. rel.,* p. 143)

> [I am the baobab of the flesh, my halo is black, I am the rajah of weakness and the nabob of scandals.]

this version of the monster: "Je suis en velours rouge, ma gueule est celle d'un porc épic, j'ai des dents de poisson, des yeux de cochon, une queue de vache en velours rouge et une béquille." (*St. Mat.,* p. 62) [I am of red velvet, my maw is that of a porcupine, I have the teeth of a fish, the eyes of a pig, a cow's tail of red velvet and a crutch.] It would seem likely that the monster with its red velvet trimmings is somehow related to the extensively-discussed marionette-*vieille* image. There is another such monster: "Barbazel était un serpent de velours rouge terminé par une tête de porc en velours rouge, il avait de petits yeux et cinq petites dents irrégulières et blanches." (*St. Mat.,* p. 95) [Barbazel was a serpent of red velvet who ended in a pig's head in red velvet, he had little eyes and five little teeth, white and irregular.] From this, it would appear safe to conclude that velvet is a symbol of evil for Jacob but that, at the same time, there is something compelling for him in small pointed teeth.

As for startling metamorphoses, we find on the same page: "La femme avait une tête de boeuf avec des bandes violettes autour des yeux, des cornes. Son corps était invisible." (*St. Mat.,* p. 95) [The woman had a steer's head with purple bands around the eyes and horns. Her body was invisible.] And near the end of the book: "La princesse dont on ne connaît que la bouche joue du violoncelle à genoux; celle qui est habillée d'une peau de crocodile parle ainsi: '—Je désire qu'un nègre vêtu comme d'une grande carte à jouer m'apporte: (1e) Le gland de chêne gros comme un oeuf; (2e) Un flocon de fumée brodé d'oeils et de lanières; (3e) Le serpent ichtyosaure qui danse la mattchiche avec des intentions de queue américaines; (4e) Une harpe terminée par la tête de Marat, celle sa mère ou de sa belle-mère; (5e) La soie rouge qui pleure.' " (*St. Mat.,* pp. 282–83). [The princess whose mouth we know plays the cello on her knees; she who is dressed in a crocodile skin speaks thus "I desire a Negro dressed like a large playing card to bring me: (1) an acorn the size of an egg; (2) a flake of smoke embroidered with peacocks 'eyes' and lanyards; (3) the ichthysaurus serpent who dances the *mattchiche* with American movements of the tail; (4) a harp with Marat's head on top of it, that of his mother or his mother-in-law; (5) red silk which runs."] A great many of the elements and themes we have been examining are either explicit or implicit in this passage: sexual and obviously homosexual symbols, symbols of the Absolute, monsters, and even red silk, reminiscent of the red and black velvet. One thinks inevitably of the monsters of the Old Testament, of Ovid's *Metamorphoses*, and of the repulsive metamorphoses in Dante's "Inferno," and indeed of all apocalyptic literature.

and Marcel Béalu has a letter from Jacob signed: *"Nabot-Jacob, dit Pauvre Jacob, dit le Pauvre sous l'escalier,"*[5] in which the morbid self-denigration assumes nightmarish proportions. The allusion to the *Roman d'Alexandre* also appears inescapable.

Nabab is a curious word, probably owing its popularity to Daudet's novel (1875); it is surrounded by all the connotations of the bourgeois who had enriched themselves at the *comptoirs de l'Inde* during the past century and represents for the social order something of what *bugle* represents in the domain of music, a heavy, outmoded, ridiculous thing. The last two examples reveal the negative twist that Jacob was wont to put on words of this sort, virtually transforming them into oxymora.

The *auréole noire*, probably an echo of Nerval's *soleil noir* and one more instance of that playing on the opposition between light and dark which is so much a part of religious poetry, is no more than a reciprocal intensification of polar opposites, a rhetorical device which had become practically a literary convention by the end of the nineteenth century. But the *rajah de la faiblesse* and the *nabab des scandales* is a highly original Jacobean touch combining some of his major preoccupations, *faiblesse* and *scandale*, with a decadent oriental opulence quite in keeping with *nudités asiatiques* and all the oriental trappings of the decadents in general.

Late in his life, Jacob shows himself still concerned with most of the same themes exploited in the earliest poems. A hint of the miserable child in meditation behind the door becomes for Jacob a description of *l'enfer:*

> *un escalier noir vers du noir. Une pauvre crécelle enfermée sous les cabinets d'aisance d'où une autre crécelle essaie de la faire sortir. Un tunnel très obscur*[6] (emphasis added).

> [A black stairway toward the blackness. A poor ratchet closed in under the toilet whence another ratchet tries to force it out. A very obscure tunnel.]

The *crécelle*, symbol of carefree and irresponsible childhood, remains closed in under the *cabinets d'aisance* which, though they are not abso-

[5] *Simoun* (Oran, n.d.), p. 31.
[6] From *Méditations religieuses*, quoted in *Simoun*, p. 72.

lutely synonymous in France with *salle de bains*, can nevertheless suggest *salle de bains* through the ideas of modesty and of privacy plus, of course, the more tenuous and subconscious though no less real associations between elimination and nudity. Most notable, perhaps, is the air of withdrawal from life as the child stays away from the world and its real problems to devote himself to another order, much like the romantic artist too, who withdraws into his art.

Some of these Jacobean motifs appear in this poem of Tristan Corbière:

LA RAPSODE FORAINE ET LE PARDON DE SAINTE-ANNE

Une forme humaine qui beugle
Contre le Calvaire se tient;
C'est comme *une moitié d'aveugle:*
Elle est borgne, et n'a pas de chien . . .

C'est une rapsode foraine
Qui donne aux gens pour un liard
L'Istoyre de la Magdalayne,
Du Juif Errant ou d'*Abaylar.*

Elle hâle comme une plainte,
Comme une plainte de la faim,
Et, longue comme un jour sans pain,
Lamentablement, sa complainte

—ça chante somme ça respire,
Triste oiseau sans plume et sans nid
Vaguant où son instinct l'attire:
Autour des Bon-Dieu de granit (emphasis added).[7]

[THE WANDERING SINGER AND THE PARDON OF SAINT ANNE

A human form which bawls
Stands against the Calvary;
It's sort of a half-blind person:
She is blind in one eye and has no dog . . .

[7] *Armor,* quoted in *La France à livre ouvert,* Pierre Seghers, ed. (Paris, 1954), p. 57.

She's a wandering singer
Who gives people for a penny
The story of Magdalen,
Of the Wandering Jew or of Abelard.

She shouts in a moan,
Like a groan of hunger
And, long as a day without bread,
Lamentable is her lament.

—That sings as it breathes
Sad bird without feathers and without nest
Wandering where its instinct draws it
Around granite shrines.]

One finds here poverty, total abjection, blindness, deformity, simple piety, and even an echo of Jacob's *Christ du village* with its *pieds de pierre* (see p. 12). This poem shares with the "Jouer du bugle" the short quatrains, a popular and unliterary tone, the displacement of units from line to line as in the third strophe, the very same rhymes as Jacob, *beugle-aveugle, chien-faim-pain,* and pairs of half-rhymes or assonances for a b rhymes, *plainte-faim, pain-complainte,* or *respire-nid, attire-granit.*

The full significance of "Jouer du bugle" cannot, however, be grasped from a piecing together of the isolated parts in Jacob's poetic puzzle. For the ultimate key, the reader must turn once more to a poem of Baudelaire we have already looked at. (The related elements will again be emphasized.)

LES AVEUGLES

Contemple-les, mon âme; *ils sont vraiment affreux!*
Pareils aux mannequins; vaguement ridicules;
Terribles, singuliers comme les somnambules;
Dardant on ne sait où leurs globes ténébreux.

Leurs yeux, d'où la divine étincelle est partie,
Comme s'ils regardaient au loin, restent levés
Au ciel; on ne les voit jamais vers les pavés
Pencher rêveusement leur tête appesantie.

Ils traversent ainsi le noir illimité,

Ce frère du silence éternel. O cité!
Pendant qu'autour de nous *tu chantes, ris et beugles,*

Eprise du plaisir jusqu'à l'atrocité,
Vois, je me traîne aussi! mais plus qu'eux hébété,
Je dis: *"Que cherchent-ils au Ciel, tous ces aveugles?"*
(*F. du m.*, p. 249)

[THE BLIND

Contemplate them, my soul; they are truly frightful!
Just like mannequins, vaguely ridiculous;
Horrible, peculiar as sleepwalkers;
Turning every which way their shadowy globes.

Their eyes from which the divine spark has departed,
As if they were looking off in the distance, remain raised
To the sky; we never see them lower dreamily their heavy heads
Toward the cobblestones.

Thus they cross the limitless blackness
This brother of eternal silence. Oh City!
While around us you sing, laugh, and bellow,

Enamored of pleasure to the point of atrocity
Look, I drag myself along as they do! But even more bewildered,
I say: "What are they seeking in the Heavens, all those blind
people?"]

This poem plays with many of the elements which Jacob was to utilize.

We find again the separate units from which Jacob weaves his hallu-
cination. The *vieilles* are here in their infirm incarnation as *aveugles.*
They are compared to *mannequins,* which suggests the marionette. They
possess that eccentricity that was the property of the romantic soul and
above all of the romantically esthetic soul. They are like sleepwalkers,
an image which unites the wandering ladies and hallucinatory dream
fantasies.

Certain elements from "Les Aveugles" may well be applied to
l'automate as well. For example, the *noir illimité* is the *frère du silence
éternel* and this accords us a table of equivalents: blackness is to light as
silence is to sound, as immobility is to motion, as blindness is to sight.
The blind who see nothing appear to look at something *far away,* indeed
beyond the range of a person with normal vision, much as the automaton,

who was after all a mechanical doll with eyes painted on her porcelain face, stared fixedly as if perceiving a higher truth, much as the pederast and kleptomaniac who prays desperately as if reaching for a higher morality.

The city, on the other hand, representing life and society, sings, laughs and bellows with pleasure, one supposes with the same tawdry pleasures that may be procured from the three pitiful prostitutes. The Flügelhorn music might symbolize this animal-like braying, but always with a pathetic overtone, always close to the pathos of the misfit and pariah. Because to participate in the city's life is to soil oneself, to begin that process of eventual degradation upon which the city's gayety feeds.

At the end, the poet suddenly focuses on himself, admitting that he too drags himself along as did all the *vieilles-vieillards* figures, as did the *crapaud*, admitting that he too is *hébété comme eux*. And this implied *hébétude* is what the *fils adultérin* is manifestly suffering from. We find then three stages of the complex: the *vieilles*, the marionette with its indispensable Satan to pull the strings, and the final degraded figure, variously a harlequin or *saltimbanque* or a *crapaud*, all delineated in this Baudelaire poem.

The inspiration for the rhymes in "Jouer du bugle" undoubtedly came from "Les Aveugles" who *beuglent* and, as we have seen, Jacob uses this very same rhyme in "La Dame aveugle." In Parisian popular speech, however, there takes place a slight opening of the [y] which tends to give it a hint of the [ø] sound, while what is properly the [ø] tends to veer toward the [y], a phenomenon that has been observed and commented on by linguists before.[8] So, from the [-œgle] to [-øgle] to

[8] Many cultivated Parisians joke about their own pronunciations of Eugène and Eustache which they tend to pronounce: [yǧɛn] and [ystaš] instead of the normal [øǧɛn] and [østaš], and Aristide Bruant transcribes a still lower-class phenomenon: a tendency to diphthong this sound. For example, he is quoted by Lacassagne and Devaux, *L'Argot du "milieu,"* (Paris: Albin Michel, 1950) : "Vrai, j'en ai les trip' à l'envers! Ça m'fait flasquer d'voir *eun' pétasse.*" (p. 142) [True, I got my bowels in an uproar because of it! It makes me crap to see a whore.] And again: "Ej' viens d'entende un coup d' sifflet. Mais non, c'est moi que j' lâche *eun'* perle." (p. 145) [I just heard a whistle blow. Oh no, it's me, I just farted.] And a third time: "Pour *eun'* thune a r'tir' son chapeau." (p. 148; emphasis added) [For a five-franc piece she takes off her hat.] This pronunciation may be clearly heard on "Germaine Montéro chante les chansons d'Aristide Bruant," Angel Record No. 64009 (New York, 1955).

[-ygle] is a tiny progression phonetically as from *aveugle* to *beugle* to *bugle* is an equally short step semantically, that is, a blind man howling or blowing a horn for alms. This seems to participate in a pattern that has been manifested again and again throughout these analyses: triplicity. The image-complex consists of three elements: elderly lady, marionette, toad. The *vieilles* are often three in number, both in Jacob and in Baudelaire. The *dames* too were three.

One wonders then if the three ladies are other than a figuration of the Holy Trinity, but a *negative* figuration. That is, *dames<dominae*, three in number, immoral, humiliated, assiduously practicing the Flügelhorn in a bathroom, represent a polar opposition to the true Trinity, consisting of three males, triumphant in Heaven, reigning over the universe. And the ridiculous *bugle* would be the reverse of the trumpets of glory announcing the coming of the Messiah.

The *enfant blond* too can be thought of as a kind of Christ figure. Christ too was something of a *fils adultérin* as well as a *fils utérin* and his candor, his mildness, his *mutisme*, his charity, all may appear to suggest madness or idiocy in confrontation with the everyday world (an aspect that Dostoevsky has exploited). He too is sexless as if castrated by the crabs as the bitten-fingers image might suggest.

It is possible that Jacob conceived this poem as a tableau with the three ladies looking like figures from a deck of cards, the exaggerated formality of "dames" which is at the same time vulgar, all mixed up with the bellowing Flügelhorns in a bathroom, with an idiot child fruit of an adulterous union which one would rather not discuss, with crabs, with a mean pimp—in short a kaleidoscopic vision of evil in which all the elements, without transitions between them, are thrown one alongside of the other to see what effect they produce. And *Le Laboratoire central* is indeed a most propitious place for this type of experiment.

When Jacob, in the *envoi*, invokes the Muses, he only invokes their heart, which is to say, their essence. Habitually Jacob seems to ignore the whole figure in favor of one central aspect paramount to him. We have seen how he chooses just a fleeting and fragmented symbol to portray a *vieille*, a Devil, a marionette, a toad, or a harlequin. And this is the controlling principle of his process of esthetic composition, a typically cubist procedure.

He refuses to write entire poems as he refuses to portray whole per-

sonages, preferring the scraps to the personages themselves and, to the poem, a kind of super-vibratory sound-meaning unit as it were, a kind of poetic essence. We *can* trace back to his source objects, words, emotions, aspirations, fears, temptations; but it is by the instantaneous leaping about, the slipping through the interstices of thought and language, that his poetry acquires its marvelous glitter and its anguished emotional content, again cubism in action.

The principal image to receive our attention in the third chapter, the *fils de velours noir*, led in two directions: upward toward Satan, and downward toward a helpless sinner, characterized as a marionette. At the level of the marionette, we encountered a related figure, the tiny, genteel, elderly lady, sometimes represented as infirm or blind, sometimes as an ancient *courtisane*. Whereas the marionette had embodied helplessness on a purely internal, that is, moral or volitional plane, the *vieille* embodied helplessness on an external, that is, social or societally imposed plane, the common factor being their inability to cope with forces stronger than they which make them victims.

The third and most abject face of this composite image was that of the *saltimbanque*, clown or toad, sometimes equated to the Jew. At this level, the image-complex assumes its final degradation. This degradation may be either internal or external but is always accompanied by a mental state of total resignation.

The scraps and tatters which build up to an obsessive pattern for Jacob we have discovered as whole images in certain poems of Baudelaire. Many themes preferred by Baudelaire were seen to be consistently present in Jacob though often so fragmented and with the fragments rearranged in such a manner as to render recognition a real problem. This problem appeared largely resolved, however, if the reader approached the Jacob texts with a specific Baudelaire model in mind. The resemblances then appeared patent and practically incontrovertible. In addition to Jacob's *method*, unmistakably cubist, we also discovered his *matter*, unquestionably Baudelairean.

Yet to say "Baudelairean" is not necessarily to mean deriving from Baudelaire alone. For gravitating toward Baudelaire—not only physically but rather ideologically—were a fair number of other late-romantic poets, all more or less decadent: Gautier, Nerval, Borel, and even in a sense, Poe. They constitute a school or *coterie*. By their use of hashish

and celebration of the black mass, by their drinking out of skulls, their promenades with a lobster on a leash, by their necrophilia and their ostentatious suicides, they were expanding the original anti-rationalistic tendencies of a waning romanticism into an exploitation of the irrational urges of what was later to be known as the unconscious.

We find Jacob adopting all of these same decadent trends, but carrying them beyond their accustomed limits. In other words, all these separate aspects of decadence find themselves fused into a constantly shifting mosaic pattern, and the turbulence and contradictions, the dynamism and iridescence of that pattern, constitute the central characteristics of cubism. An understanding of cubist method, as we have seen, rendered the dynamics of Jacob's poetry cogent, while the playing out of Baudelaire's original notions of topsy-turvyism in art to its logical or illogical conclusions results in negative figurations rather than positive ones.

Now that we have seen the background that produced Jacob, his poetic practice relating to cubist method, his models and predecessors in poetic subject matter, and his peculiar applications of these models and precepts, we may go on to examine the work of those artists who followed him and who, it may be shown, were significantly affected by his example. Having traced poetic influences from Jacob back to Baudelaire, we shall now trace them forward from Jacob up to the present moment.

X. "A La Manière de . . ."

THE HISTORY OF WESTERN ART since the Middle Ages reveals an artist usually deliberate and painstaking, even an "ulteriorly motivated" craftsman. Although he sometimes exhorted the Muses or whatever source of inspiration to provide him the initial spark—an essentially "classical" idea going back probably to Plato's Ion and reconstructed consistently only during the Renaissance—once the artist had that spark, he could then be expected to cultivate the recommended *genres,* to follow the rules (that is, to observe the unities and *bienséance*) —in short, to shape the inspiration into a finished work of art. He was primarily concerned then with control over both his material and his medium, the disciplined command of his technical means being the keynote of art for him. In fact, the greatest compliment one could pay an apprentice in one of the many painters' *ateliers* of the Renaissance was to mistake his work for that of his master.

The "objective" approach to art is typified by a creator such as Bach who once encouraged a student by saying: "I have had to work hard; anyone who works just as hard will get just as far."[1] Buffon said sim-

[1] Hans T. David and Arthur Mendel, *The Bach Reader* (New York, 1945), p. 37.

ilarly, "Le génie n'est autre chose qu'une aptitude à la patience,"[2] a notion that Flaubert paraphrases in cautioning Maupassant (who quotes it but then erroneously attributes it to Chateaubriand) that "Le talent—suivant le mot de Chateaubriand—n'est autre qu'une longue patience. Travaillez." [Talent—according to the words of Chateaubriand—is nothing more than abiding patience.][3] Add to this concept of art the dangers of offending the Church, the State, or some powerful nobleman and, above all, the task of pleasing a wealthy sponsor or the public, and it becomes evident that the artist created in an atmosphere charged by extra-artistic or *external* considerations.

Apollinaire to Duchamp

Concomitant with the objective tradition in art, there had always existed a subjective undercurrent of esthetic irresponsibility especially on the verbal plane. This involved the artist's giving in to sudden flashes of insight with irrational transitions, multiplication of chance effects, and encouragement of the unforeseen or the unexpected. Such an approach was often accused of leading to moral decadence and social destructiveness, while conversely in others, it was often extolled as the very essence of religious or philosophic mysticism. One thinks of the punning etymologies of certain Church Fathers, of the celebrated *bisticci* of Pulci, of the extravagant inventions of the Rhétoriqueurs, of the startling neologisms of Rabelais or of the hermetic language of the later symbolists. If throughout history this tendency had been largely kept in check, as the nineteenth century drew to a close the subjective undercurrents became more prominent. A predisposition toward anti-literary forms increased, probably as one element in the overall nihilistic atmosphere and also as part of the declared and deliberate nihilism with which the decadents belabored a dying romanticism.

The nihilism of anti-literature found a suitable means of expression in a virtual obsession with playing with the medium of language itself, with punning or playing on words. This had, as we have attempted to demonstrate in the foregoing chapters, the effect of fragmenting reality

[2] Buffon, in his inaugural speech to the Académie Française, quoted in David and Mendel, p. 37.

[3] From "Le Roman" which serves as a kind of preface to *Pierre et Jean*.

and of producing a constant shifting, metamorphosing, and transposition of images not explicable on any rational basis. Punning splays meaning outward, doubles and even triples it, and helps create thereby the glittering simultaneity that is the "iridescence" of the cubist poetic surface. It contributes powerfully to the general volatility of the medium but, multiplying and dispersing meaning, it also attenuates and weakens the rational structure, thereby serving the cubist strategy in two ways.

We remember many examples of word-play in Jacob: the low-class *gueux fou* being punned into an upper-sounding *fougueux*, and the wailing at the discomfort of indigestion *mal à, mal à la* transforming itself into a godly Valhalla. Sometimes Jacob uses one word or several words in combination having two or more meanings. At other times he uses what Rabelais called the *antistrophe* now commonly referred to in France as the *contrepetterie* or what *we* call the spoonerism, in which verbal elements are reversed or placed in a changed order to produce unexpectedly altered, usually vulgar meanings. At still other times, he allows the sounds to run away with themselves, to degenerate into words which are evocative but essentially devoid of rational significance. Sometimes it is the sound alone which effects a sense transition.

Max Jacob was among the first writers in the twentieth century to exploit fully the literary possibilities of the play on words. André Billy points this out: "La vogue du calembour date de Max et d'Apollinaire. Valéry et Cocteau l'ont repris ensuite à leur compte." [The vogue for punning dates from Max and Apollinaire; Valéry and Cocteau took it up afterward on their own account.][4] Jacob employs it, however, not as an end in itself, as was increasingly done by other practitioners of this device but he rather weaves it into the fiber of his poetic and prosodic diction to upset what starts out to be a unified tone in the discourse. Or else he uses it to reveal truths which no amount of rational exposition might make clear to the reader.

Apollinaire too used the pun to spice his lighter poetic creations. The following selection begins with a phonetic twist which is not really a pun.

Le Phoque

J'ai les yeux d'un vrai veau marin
Et de Madame Ygrec l'allure

[4] *Max Jacob* (Paris, 1946), p. 31.

On me voit dans tous nos meetings
Je fais de la littérature
Je suis phoque de mon état
Et comme il faut qu'on se marie
Un beau jour j'épouserai Lota
Du matin au soir l'otarie
 Papa Maman
Pipe et tabac crachoir caf'conc'
 Laï Tou[5]

[THE SEAL

My eyes are those of a true seal cub
And my walk that of Madame Y
They see me at all our meetings
I do literature
I am a seal by profession
And since everybody has to get married
One fine day I'll marry Lota
From morning to night Lota laughs
 Poppa Momma
Pipe and tobacco spittoon cafe concert
 That's all]

With the *phoque* in mind, Apollinaire allows the sound of *veau marin* to become confused with an expected *bleu marin*, and then, with *otarie* in mind, chooses a girl named Lota who laughs so that her name plus the verb constitutes a pun on *l'otarie*. Added to the foregoing is the characteristic French way of rendering the sound of yodeling which seems to say: *Là est tout.* This is very like Jacob's *dahlia que Dalila lia.* There are other verbal vagaries as well and, together, they indicate the humorously disrespectful intent of the new literature.

As the pun became more popular among the young cubists, it was taken up as a *genre.* This popularity led even academic critics and historians to appreciate and repeat the nonsense-rhyme effects of *Le Cornet à dés.* Max Jacob reports:

Je me souviens de la lettre d'Albert Thibaudet, alors soldat au Ministère de la Guerre: "Il me semble que tous les dossiers sont pêle-

[5] Guillaume Apollinaire, *Quelconqueries*, quoted by André Breton, *Anthologie de l'humour noir* (Paris, 1950), p. 250.

mêle tombés sur mon bureau." Laurent Tailhade, alerté par un copain, *daigna* remarquer: "Dalhia! dalhia! [sic] que Dalila lia." J'eus tout de même pas mal de succès. (*C. à d.*, pp. 9–10)

[I remember the letter of Albert Thibaudet, then doing his service at the Ministry of War: "It seems that all the dossiers have fallen pell-mell on my desk." Laurent Tailhade, whose attention had been called to this by a friend, was good enough to remark: "Dahlia! dahlia! that Delilah bound together." I had a fair amount of success after all.]

In the years after the war and with the rise of surrealism, young writers began to make collections of *calembours,* usually combining the play on words with the *grosse blague.*

This punning led to extensive experimentation, principally on the part of Desnos, Duchamp, Prévert, and Queneau. They seem to have given themselves over wholeheartedly to playing on words, sometimes in an effort to duplicate punning elements of popular speech in France but often out of what appears to be mere linguistic perversity and a wanton desire to create verbal disorder. And in almost every case, Jacob's efforts antedate theirs; one finds a model for an astonishing number of their puns already present in the *Cornet à dés* and even in the *Saint Matorel.*

These efforts parallel other more serious ones which represent the last quasi-hallucinatory stages of positivistic thinking. Verbally at least, the destructive tendencies of the first cubists and the constructive tendencies of the last positivists are virtually one and the same thing. For example, in the *Matorel,* one finds this tiny whimsical *fait divers* constructed of the most reduced phonetic elements:

VARIATION D'UNE FORMULE

La bourse houle! avis!
La bourse ou la vie!
Là bout sous la vie
(Glas! boue!) sourd, l'ami
Glabre, ours sous l'habit.
Las! bouc saoul, Lévy
Court, à court d'avis
Et vite, les coups évite
A court souffle ce lévite. (*St. Mat.*, p. 229)

[VARIATION ON A FORMULA
Wallet sea-swell! Warning!
Your wallet or your life!
Boils there under life
(Death knell! mud!) deaf, the friend
Clean shaven, a bear under the suit.
Alas! drunken old goat, Levy
Runs, out of ideas
And quick, avoids the blows
Short-winded that Levite.]

Jacob's exercise, probably dating from 1903, bears a striking resemblance to one like it in *La Grande loi ou la clef de la parole* (1900) of Jean-Pierre Brisset:

Les dents, la bouche.
Les dents la bouchent,
L'aidant la bouche.
L'aide en la bouche.
Laides en la bouche
Laid dans la bouche
Lait dans la bouche
L'est dam le à bouche
Les dents-là bouche.[6]

[The teeth, the mouth.
The teeth stop it up,
Helping the mouth.
Help in the mouth.
Ugly in the mouth
It's ugly in the mouth
Milk in the mouth
It is a punishment to the mouth
That closes the teeth in.]

But Brisset had written his in all seriousness, which moved the *Petit Parisien* to publish, under the heading "Chez les fous," "On cite même un aliéné qui, sur un système d'allitération et de coq-à-l'âne, avait prétendu fonder tout un traité de métaphysique."[7] ["Among the madmen:

6 Ibid., pp. 192–93.
7 Ibid., p. 191.

They even cite a madman who claimed to base a treatise of metaphysics on a system of alliteration and senseless punning."]

André Breton, more indulgent than the *Petit Parisien*, because *chef d'école* of the surrealists himself, has underlined the importance and traced the relationship of this phenomenon:

> Envisagée sous l'angle de l'humour, l'oeuvre de Jean-Pierre Brisset tire son importance de sa situation unique commandant la ligne qui relie la *pataphysique* d'Alfred Jarry ou "science des solutions imaginaires, qui accorde symboliquement aux linéaments les propriétés des objets décrits par leur virtualité" à l'activité paranoiaque-critique de Salvador Dali ou "méthode spontanée de connaissance irrationnelle basée sur l'association interprétative-critique des phénomènes délirants." Il est frappant que l'oeuvre de Raymond Roussel, l'oeuvre littéraire de Marcel Duchamp, se soient produites, à leur insu ou non, en connexion étroite avec celle de Brisset, dont l'empire peut être étendu justqu'aux essais les plus récents de dislocation poétique du langage: Léon-Paul Fargue, Robert Desnos, Michel Leiris, Henri Michaux, James Joyce, et la jeune école américaine de Paris.[8]

> [Seen from the viewpoint of humor, the work of Jean-Pierre Brisset takes its importance from its unique situation which is on the line that ties the *pataphysics* of Alfred Jarry (or "the science of imaginary solutions which symbolically grants to features the properties of objects described in terms of their virtuality") to the paranoiac-critical activity of Salvador Dali (or "the spontaneous method of irrational knowledge based on the interpretive-critical association of lunatic phenomena"). It is striking that the work of Raymond Roussel and the literary work of Marcel Duchamp were produced, with or without their authors' knowledge, in close connection with that of Brisset whose influence may be extended to the most recent attempts of poetic dislocation of the language: Léon-Paul Fargue, Robert Desnos, Michel Leiris, Henri Michaux, James Joyce, and the young American school of Paris.]

It is unjust of Breton not to have mentioned Jacob, for Jacob was certainly *at least* as instrumental as Brisset in launching experiments in verbal irrationality. Let us compare Jacob's

> La gloire du poète André Salmon s'étendrait-elle jusqu'au faubourg Saint-Antoine? (*St. Mat.*, p. 232)

[8] Ibid., p. 192.

[Would the glory of the poet André Salmon extend all the way to the Faubourg Saint-Antoine?]

with Desnos'

Aragon recueille *in extremis* l'âme d'Aramis sur un lit d'estragon.[9]

[Aragon gathers up the soul of Aramis *in extremis* on a bed of tarragon.]

Jacob's phrase is more natural and less perfectly equilibrated. But it is nevertheless extremely complicated on the purely verbal plane, transposing the following elements:

	A	B	C	D
1)	gloire	po-	-èt'André	Sal-
2)	-toine	bourg	étendrait	Saint-
3)			aint-An-	-elle
4)			-ait-elle	

Here the phonetic variants pile up as much as four deep (although with diminishing similarity). *Po-* may be marginally paired with *bourg* since they both begin on the same labial (though, respectively, unvoiced and voiced) and continue on [o] and [u], back sounds that are fairly close together. In some instances, the same sounds may combine with several slightly altered elements, thus shifting back and forth in the characteristic cubist manner, and especially does this occur in the four-level series listed under letter C.

Desnos' phrase may be analyzed as follows:

	A	B	C	D	E	F
1)	Ara-	-gon	ex-	-tre-	-mis	l(it)
2)	Ara-	-gon	es-	-tra-	-mis	l(âme)
3)	-(t)ra	-cueille		-tra-	-it	
4)	Re				-me	
5)	â					

and though it is complicated enough, because of its regularity and the introduction into it of the ecclesiastical *in extremis* and the exotic

[9] *Robert Desnos*, ed. Pierre Seghers (Paris, 1949), p. 118.

Aramis, extraneous to the informal tone of this type of poetic production, it is obviously more contrived.

There are many resemblances between Jacob and Desnos. Indeed, a great many things Desnos wrote could be attributed to Jacob. Besides verbal byplay, Desnos assimilated Jacob's freedom of fantasy and form, Jacob's cutting across *genres* and social distinctions, Jacob's exploitation of folksy popular effects. There is also their common interest in *Fantômas*: Jacob, Apollinaire, and company had organized *Les Amis de Fantômas* and Jacob includes two Fantômas *poèmes en prose* in the *Cornet à dés*,[10] while Desnos' "XXᵉ Complainte de Fantômas"[11] is probably one of *his* best-known works.

Desnos even practices some of Jacob's negativism and refusal to deliver up to the reader a previously announced element, in the manner of Jacob's *2ᵐᵉ réflexion:*

Les quatres sans cou vivent encore, c'est certain
J'en connais au moin un
Et peut-être aussi les trois autres

Le premier, c'est Anatole,
Le second, c'est Croquignole.
Le troisième, c'est Barbemolle,
Le quatrième, c'est encore Anatole.[12]

[The four headless men are living still, it's certain
I know at least one of them
And perhaps also the other three

The first is Anatole,
The second is Croquignole.
The third is Barbemolle,
The fourth is still Anatole.]

Here he consents to give us only three of the four *sans cou*. The childish tone of the nonsense-poem is comparable to the coy infantilism of certain

10 Pp. 94–95.
11 Seghers, p. 149.
12 Ibid., p. 163.

Jacob poems. Still other elements from Jacob can be discovered; even the *trous de haillons* (pp. 41–42, 92) reappears in Desnos:

—Ho! petite fille
Ta robe tombe en lambeaux
On voit ta peau.[13]

[—Ho little girl
Your dress is falling apart
We see your skin.]

The poem about Aragon comes from a collection of plays on words that represents Desnos' and all the surrealists' preoccupation with what they called *Rrose Selavy* (*rose, c'est la vie*). Anothing punning phrase, again modeled after Jacobean examples, is:

Perdue sur la mer sans fin Rrose Selavy mangera-t-elle du fer après avoir mangé ses mains?[14]

[Lost on an endless sea, will Rrose Selavy eat iron after having eaten her hands?]

This passage combines the forgoing verbal elements with black humor. Many of the original surrealist group, notably Duchamp, continued to practice this playing on words late into the thirties, as in these examples of Duchamp's real virtuosity in what he calls his *anti-chef d'oeuvre:*

Rrose Selavy et moi esquivons les ecchymoses des Esquimaux aux mots exquis.[15]

[Rrose Selavy and I avoid the bruises of the Eskimos with exquisite words.]

or his witty comment on Stravinsky:

Sacre du printemps, crasse du tympan.[16]

[Rite of Spring, filth of the eardrum.]

[13] Ibid., p. 170.
[14] Ibid., p. 118.
[15] André Breton, *Anthologie*, p. 281.
[16] Ibid., p. 282.

Prévert to Ionesco

The surrealist poet who achieved artistic recognition combined with the greatest popular success is Jacques Prévert. His poetry is filled with processes and attitudes we have encountered in Jacob's poetry: sound-sense equivocation, transposition of elements, slang, popular forms, a constant shifting of images, a caustic tone of social criticism, an overweening hatred of the bourgeois, a refusal to operate within any traditional poetic norms. There are specific as well as general resemblances, however. Jacob plays on sounds shifting the optic in the following manner:

> Mille bouquets de bosquets, mille bosquets de bouquets. . . .
> (*C. à d.*, p. 64)

> [A thousand bouquets of thickets, a thousand thickets of bouquets.]

Prévert, using the same type of sounds, changes the focus in much the same manner but within his characteristically erotic frame of reference:

> Pauvre joueur de bilboquet
> A quoi penses-tu
> Je pense aux filles aux mille bouquets
> Je pense aux filles aux mille beaux culs.[17]

> [Poor player of cup-and-ball
> What are you thinking of
> I'm thinking of girls with a thousand perfumes
> I'm thinking of girls with a thousand pretty behinds.]

Prévert presents not one but three "enfants blonds," in somewhat the same context as Jacob's in "Jouer de bugle":

> Et la Misère
> dans sa voiture
> traînée par trois enfants trop blonds
> traverse les décombres.[18]

[17] *Histoires* (Paris: Gallimard, 1948), p. 56.
[18] *La Pluie et le beau temps* (Paris: Gallimard, 1952), p. 36.

[And Misery
in its chariot
drawn by three children too blond
crosses the ruins.]

Although these similarities are clear, it is undoubtedly assuming much to attribute to Jacob any direct influence on Prévert. One may safely assert, however, that, after Jacob and the cubists, ideas, techniques, and attitudes of this nature were going the rounds, forming the environmental background for most surrealist and post-surrealist poets in France.

In one *poème en prose*, Jacob describes the process of completing a painting:

> Quand on fait un tableau, à chaque touche, il change tout entier, il tourne comme un cylindre et c'est presque interminable. Quand il cesse de tourner, c'est qu'il est fini. . . . (*C. à d.*, p. 52)

> [When one paints a picture, at each touch the picture changes entirely. It turns like a cylinder and it's nearly an interminable process. When it stops turning, it's because it's finished. . . .]

Prévert seems to have expanded this basic concept and invested it with some of the wonderment with which he always surrounds birds as creatures, light, airy, gay, not wholly subject to the laws which oppress purely terrestrial beings.

POUR FAIRE LE PORTRAIT D'UN OISEAU

Peindre d'abord une cage
avec une porte ouverte
peindre ensuite
quelque chose de joli . . .
quelque chose de beau
pour l'oiseau
placer ensuite la toile contre un arbre
dans un jardin
dans un bois . . .
attendre s'il le faut pendant des années . . .
Quand l'oiseau arrive . . .
observer le plus profond silence
attendre que l'oiseau entre dans la cage . . .
fermer doucement la porte avec le pinceau
puis

effacer un à un tous les barreaux
en ayant soin de ne toucher aucune des plumes de l'oiseau . . .
et puis attendre que l'oiseau se décide à chanter
Si l'oiseau ne chante pas
c'est mauvais signe
signe que le tableau est mauvais
mais s'il chante c'est bon signe
signe que vous pouvez signer
alors vous arrachez tout doucement
une des plumes de l'oiseau
et vous écrivez votre nom dans un coin du tableau.[19]

[To Do the Portrait of a Bird

First you paint a cage
with an open door
then paint
something pretty . . .
something nice
for the bird
then place the canvas against a tree
in a garden
in a wood
wait if you must for years and years
When the bird arrives
observe the most profound silence
wait until the bird enters the cage
quietly close the door with the paintbrush
then
paint out the bars, one by one
taking care not to touch even one of the bird's feathers . . .
and then wait until the bird decides to sing
If the bird doesn't sing
it's a bad sign
a sign that the picture is bad
but if it sings it's a good sign
a sign that you can sign
so pull out one of the bird's
feathers very gently
and write your name in a corner of the picture.]

Many of the touches again are pure Jacob or, in any case, had never

[19] *Paroles* (Paris: Gallimard, 1950), p. 185.

appeared in French poetry in so crystallized a form before the *Cornet à dés.*

Many writers like Cocteau and the older Léon-Paul Fargue (b. 1878), who were perhaps only marginally surrealists, show distinct traces of cubist influence. Fargue, in the tradition of Baudelaire and the symbolists, talks about the blind man, a symbol which we have identified as one of the abject incarnations of the misunderstood man of letters:

> . . . comme l'aveugle,
> Qui regarde du rouge sombre
> Et joue ses mains grattées
> Sur le vieux banc de son enfance . . .
> Comme l'aveugle, lorsqu'il songe
> Et bougonne, et que son coeur gronde
> Contre la beauté au corps tiède
> Qui le regarde, toute en larmes . . .[20]

> [. . . as a blind man
> who looks at deep red
> and pats his scratched hands
> on the old bench of his childhood . . .
> As a blind man when he dreams
> and mumbles, and when his heart rails
> Against the beauty with the warm body
> who stands there looking at him in tears . . .]

The bench is here again as in "les veuves sur des bancs solitaires," and so is an ineffable, wordless melancholy like that of the mute child in "Jouer du Bugle," indicated by the verb *bougonner*. Fargue is capable of typical verbal Jacobisms from time to time:

> Un coq de Caldecott crache un coquelicot![21]

> [A cock of Caldecott spits out a poppy.]

So in addition to Fargue's well-known attachment to, and appreciation of, various aspects of the picturesque *quartiers* of Paris, there are as we

[20] *Au pays,* quoted in Wallace Fowlie, *Mid-Century French Poets* (New York: Twayne, 1955), p. 60.
[21] Ibid., p. 60.

see here a great number of other points of similarity between him and Jacob.

The surrealist poet who is most like Jacob on the verbal plane is probably Raymond Queneau. The resemblance is not only verbal: in Queneau one also finds that alternation between rollicking humor and caustic social criticism, that sly attraction to proletarian speech and manners, that same infatuation with rhetoric, and a certain tendency to ghoulishness. For example, Jacob writes:

> Mon camarade est couché dans un pré
> Y a pus qu'des os
> Y n'est pas enterré
> Le trou d'son nez on y mettrait son doigt
> Et ses deux oeils c'est comme du chocolat.
> L'été qui vient ça te f'ra z'un complet. . . . (*St. Mat.*, p. 178)

> [My comrade is lying in a meadow
> He is no longer anything but bones
> He is not buried
> You could stick your finger in the hole of his nose
> And his two eyes are like chocolate.
> In the summer approaching, that will make you a suit. . . .]

In much the same vein, Queneau writes:

MA PETITE VIE

> Porcelaine de mon crâne
> Je m'effrite ô mes aieux
> ah que c'est effroyable
> ces deux trous au lieu d'yeux
> des morts y en a c'est pas croyable
> les vaches ils les ont multipliés . . .
> ça m'intéresse un tant soit peu z-aussi
> ma petite vie ma petite vie.[22]

[MY LITTLE LIFE

> Porcelain of my skull
> I'm crumbling, oh my ancestors
> ah how dreadful it is

[22] Raymond Queneau, *L'Instant fatal* (Paris, 1948), p. 36.

these two holes instead of eyes
the number of dead there is incredible
the bastards, they've multiplied them
that interests me somewhat too
my little life, my little life.]

And when he describes, as in the title poem of *L'Instant fatal,* the effects
of death on the body,

et le cerveau mité un peu genre gruyère
 apanage des morts[23]

[and the brain something like soft cheese
 attribute of the dead]

he, like Jacob, has recourse to similes employing food in a grotesquely un-
appetizing context.

 Queneau is given to phonetic spellings reproducing popular speech
with its mispronunciations, *pataquès,* and persistent elisions, witness:

MAIGRIR

Moi, jmégris du bout des douas
Seskilya dplus distinglé[24]

[TO LOSE WEIGHT

Me I lose weight from the ends of my fingers
Thassthemost distinglished thing there is]

or:

LA PENDULE

Je mballadais sulles boulevards
Lorsque jrencontre lami Bidard
Il avait lair si estomaqué
Que lui ai dmandé dsesspliquer[25]

[23] Ibid., p. 10.
[24] *Les Ziaux* (Paris, 1948), p. 42.
[25] Ibid., p. 27.

[THE CLOCK

I was strolling down the boulevards
When I meet old friend Bidard
He looked so astounded
That I asked him to explain himself]

In this same poem, Queneau transcribes *lorsque* as *lossqu'il* and, in the preceding poem, *boulevards* as *boulvar*. This lack of consistency in transcription shows that he gives no great thought to the question but rather does it all as a joke conceived on the spur of the moment much as Jacob himself was wont to do.

Queneau cultivates a modified version of the ballade form as in "Jouer du Bugle," and indeed one could easily find a dozen similar examples common to both authors. Most striking, though certainly coincidentally, he too uses *velours* as in the *Matorel* to suggest death:

LE GAI RETAMEUR

Je ne pense pas
que le dit trépas
viendra m'étreindre dans ses deux bras de velours rouge. . . .[26]

[THE GAY ITINERANT TINKERER

I don't think
that the above-mentioned death
will come to clasp me in its two arms of red velvet. . . .]

The major, as well as one of the minor, surrealists constantly used most of the unconventional, or rather anti-conventional, devices extensively developed by Jacob around 1905.

Although the beginnings of surrealism are quite well-defined, its practitioners, because of various differences, personal or ideological—that is, esthetic and political—have tended to spread out in different directions to become aligned with other currents. Surrealist poetry reveals now one aspect, now another of a common bond with cubism, most of which it also has in common with Jacob's particular pioneering brand of literary cubism; he thereby stands incontrovertibly as one of the initiators, in spite of the persistent refusal on the part of the surrealists

[26] *L'Instant fatal*, p. 27.

to recognize or credit him. The principal differences between them can be reduced to the fact that Jacob's anguished but ambivalent religiosity is countered by the surrealists' usual atheism; and his resigned and penitential homosexuality, by their outspoken and belligerent heterosexuality.

Considerable surrealist influence may still be discerned in many of the most important contemporary writers in France. And where its influence is discernible, faint and far off echoes of Jacob's daring turn-of-the-century experiments are usually discernible too. Samuel Beckett, now so taken up by the establishment as to be a Nobel Prize winner, is generally considered one of the heirs to the surrealist esthetic tradition. But in the final hopeless helplessness of the derelicts who people his plays, he harks back *in a direct line* to Jacob's abject hero and ultimately back to the whole artist-elderly lady-marionette complex that comes, as we have seen, from romanticism through Baudelaire.

Beckett's long serio-comic tirades, employing pompously academic speech in a vertiginously nonsensical way, also remind us of Jacob and of Jarry before him. Psychologically, *pastiche* is the answer that decadence gives to the bourgeoisie. In other words, if modern art is unintelligible to a M. Cottard and he looks upon it with a coldly disapproving eye, then the decadents are bent on showing how equally unintelligible the expression of a M. Cottard is to them when removed from the middle-class social framework that gives it cogency.[27]

[27] M. Cottard is the bourgeois who is unable to fathom the style of painting of the modern painter in Proust: "Comme le public ne connaît du charme, de la grâce, des formes de la nature que ce qu'il en a puisé dans les poncifs d'un art lentement assimilé, et qu'un artiste original commence par rejeter ces poncifs, M. et Mme Cottard, image en cela du public, ne trouvaient ni dans la sonate de Vinteuil, ni dans les portraits du peintre, ce qui faisait pour eux l'harmonie de la musique et la beauté de la peinture. Il leur semblait . . . que le peintre jetait au hasard des couleurs sur ses toiles. Quand dans celles-ci, ils pouvaient reconnaître une forme, ils la trouvaient alourdie et vulgarisée (c'est-à-dire dépourvue de l'élégance de l'école de peinture à travers laquelle ils voyaient, dans la rue même, les êtres vivants), et sans vérité, comme si M. Biche [the painter] n'eût pas su comment était construite une épaule et que les femmes n'ont pas les cheveux mauves." (*A la recherche du temps perdu*, Du côté de chez Swann, II, p. 289). [Since the public only understands charm, grace, and natural form from what it has retained from the clichés of a slowly-assimilated art style, and since an original artist begins by rejecting those clichés, M. and Mme. Cottard, the image of the public in this respect, found neither in the sonata of Vinteuil what constituted for them harmony in music, nor

Beckett too loves to make crude plays on words:

Mais non, je n'ai jamais été dans la Vaucluse! J'ai coulé toute ma chaudepisse d'existence ici, je te dis! Ici! Dans la Merdecluse![28]

[Absolutely not, I have never been in the Vaucluse! I tell you! Here! I trickled out my whole clapped-up existence right here. In the Shitcluse!]

He also employs a kind of *va-et-vient* technique reminiscent of Jacob's own "tendance à être protéiforme et quasi insaisissable," Jacob's infinite capacity for never taking a stand.

VLADIMIR. —Ca fait un bruit d'ailes.
ESTRAGON. —De feuilles.
VLADIMIR. —De sable.
ESTRAGON. —De feuilles.

Silence

VLADIMIR. —Elles parlent toutes en même temps.
ESTRAGON. —Chacun à part soi.

Silence

VLADIMIR. —Plutôt elles chuchotent.
ESTRAGON. —Elles murmurent.
VLADIMIR. —Elles bruissent.
ESTRAGON. —Elles murmurent . . .
VLADIMIR. —Ca fait comme un bruit de plumes.
ESTRAGON. —De feuilles.
VLADIMIR. —De cendres.
ESTRAGON. —De feuilles.[29]

[VLADIMIR. That makes a noise of wings.
ESTRAGON. Of leaves.
VLADIMIR. Of sand.
ESTRAGON. Of leaves.

Silence

in the portraits of the painter what constituted for them the beauty of painting. It seemed to them . . . that the painter had flung his paints pell-mell on the canvas. When, in these canvases, they could recognize a form, they found it heavy and vulgar (that is, to say, devoid of the elegance of the school of painting through which they saw, even in the street, human beings), and without verisimilitude as if M. Biche [the painter] would not have known how a shoulder was constructed or that women do not have mauve hair.]

[28] *En attendant Godot* (Paris, 1954), p. 104.
[29] Ibid., pp. 104–6.

VLADIMIR. They all speak at the same time.
ESTRAGON. Each one from his heart.

Silence

VLADIMIR. They whisper rather.
ESTRAGON. They murmur.
VLADIMIR. They rustle.
ESTRAGON. They murmur.
VLADIMIR. That makes a noise of feathers.
ESTRAGON. Of leaves.
VLADIMIR. Of ashes.
ESTRAGON. Of leaves.]

This device, repeated throughout *Godot,* has interesting visionary implications. More transparently than Jacob, Beckett posits, or allows his character to posit, a first visionary hypothesis, an initial suggestion contradicted by the second character who advances a "better" explanation. The first character, more hopeless perhaps, corrects but "downward" as it were: from *ailes* to *sable,* from *chuchotent* to *bruissent,* and from *plumes* to *cendres.* His partner, however, rather than progressing to another step in the fantasy, always simply repeats his original notion, usually triter and more reassuring—but not truer—than the other.

From the standpoint of the two characters, the initial vision is countered by what amounts to an illusion, a safe and uninteresting idea. This then is countered by what is nearly a hallucination, but the fourth reply stalls the action, leaving the hopeless derelicts stranded in the morass of conventional thinking, a return to the illusion. Such a device would seem to represent the ultimate defeat and surrender of modern man, so aptly foreshadowed by Jacob's Baudelairean *vieilles,* and also perhaps a hint of the old symbolist immobility.

Another playwright, Eugène Ionesco, is commonly thought of as a neosurrealist. He too exhibits many of the attributes that can be traced back to Jacob: a mincing humor, a savage hatred of the bourgeoisie, of authority, of pompousness, a fascination with words and punning, and a total lack of conventional literary restraints. He too creates a glittering surface where reality and fantasy become confused, an effect he sometimes produces by means of verbal techniques much in the Jacob manner.

Take, for instance, Jacob's poem:

AVENUE DU MAINE

Les manèges déménagent.
Manèges, ménageries, où? . . . et pour quels voyages?
 Moi qui suis en ménage
 Depuis . . . ah! y a bel âge!
De vous goûter, manèges,
 Je n'ai plus . . . que n'ai-je? . . .
 L'âge.
 Les manèges déménagent.
 Ménager manager
 De l'avenue du Maine
 Qui ton manège mène
 Pour mener ton ménage.
 Ménage ton manège
 Manège ton manège
 Manège ton ménage
 Met des ménagements
 Aux déménagements
 Les manèges déménagent
 Ah! vers quel mirages?
 Dites pour quels voyages
 Les manèges déménagent. (*St. Mat.*, pp. 229–30)

[AVENUE DU MAINE

The merry-go-rounds move out.
Merry-go-rounds, menageries, where? . . . and for what voyages?
 I who have been keeping house
 For . . . ah! it's been a long time!
To enjoy you, merry-go-rounds
 I no longer have . . . what don't I have? . . .
 The right age.
 The merry-go-rounds move out.
 To spare the manager
 Of the Avenue du Maine
 Who runs your merry-go-round.
 To run your household.
 Spare your merry-go-round
 Merry-go-round your merry-go-round
 Merry-go-round your household
 Put some caution

Into your moving
The merry-go-rounds move out.
Ah! toward what mirages?
Tell me for what voyages
Do the merry-go-rounds move out.]

Despite the wistful tone of the family-man watching the *romanichels* dismantling their sidewalk carnival, one finds that turning and twisting in every which way of a simple set of phonetic elements. A very similar process is used in his theater by Ionesco to show the virtually limitless scope of the manipulation of consciousness by word-play.

ROBERTE II.	—Qu'est-ce que c'est sur votre tête?
JACQUES.	—Devinez! c'est une espèce de chat. Je le coiffe dès l'aube.
ROBERTE II.	—C'est château?
JACQUES.	—Je le garde toute la journée sur ma tête. A table, dans les salons, je ne l'enlève jamais. Il ne me sert pas à saluer.
ROBERTE II.	—C'est un chameau? Un chaminadour?
JACQUES.	—Il donne des coups de pattes, mais il sait travailler la terre.
ROBERTE II.	—C'est une charrue!
JACQUES.	—Il pleure quelquefois.
ROBERTE II.	—C'est un chagrin?
JACQUES.	—Il peut vivre sous l'eau.
ROBERTE II.	—C'est un chabot?
JACQUES.	—Il peut aussi flotter sur l'onde.
ROBERTE II.	—C'est une chaloupe?
JACQUES.	—Tout doucement.
ROBERTE II.	—C'est un chaland?
JACQUES.	—Il aime parfois vivre caché dans la montagne. Il n'est pas beau.
ROBERTE II.	—C'est un chalet?
JACQUES.	—Il me fait rire.
ROBERTE II.	—C'est une chatouille, ou un chapitre?
JACQUES.	—Il crie, il me casse les oreilles.
ROBERTE II.	—C'est un chahut?
JACQUES.	—Il aime les ornements.
ROBERTE II.	—C'est un chamarré?
JACQUES.	—Non!
ROBERTE II.	—Je donne ma langue au chat.
JACQUES.	—C'est un chapeau.

ROBERTE II. —Oh, enlevez-le. Enlevez-le, Jacques. Mon Jacques. Chez moi, vous serez chez vous. J'en ai, j'en ai tant que vous voudrez, des quantités!

JACQUES. —. . . de chapeaux?

ROBERTE II. —Non . . . des chats . . . sans peau!

JACQUES. —Oh, mon chat. . . .[30]

[ROBERTE II. What do you have on your head?

JACQUES. Guess! It's a kind of cat. I put it on at dawn.

ROBERTE II. It's a chateau?

JACQUES. I keep it on my head all day long. At the table, in the living room; I never take it off. I don't use it to greet people with.

ROBERTE II. It's a camel? A chaminadour?

JACQUES. It kicks with its feet but it knows how to work the earth.

ROBERTE II. It's a plow!

JACQUES. It cries sometimes.

ROBERTE II. It's a chagrin?

JACQUES. It can live under water.

ROBERTE II. It's a chub.

JACQUES. It can also float on the waves.

ROBERTE II. It's a launch?

JACQUES. Easy now.

ROBERTE II. It's a customer?

JACQUES. It sometimes likes to live hidden in the mountain. It's not good looking.

ROBERTE II. It's a chalet?

JACQUES. It makes me laugh.

ROBERTE II. It's a tickle, or a chapter?

JACQUES. It yells, it makes my ears ache.

ROBERTE II. It's an uproar?

JACQUES. It likes ornaments.

ROBERTE II. It's all beribboned?

JACQUES. No!

ROBERTE II. I give up.

JACQUES. It's a hat.

ROBERTE II. Oh, take it off. Take it off, Jacques. My Jacques. When you're in my house, you're in your own house. I have some, I have all you want, huge quantities!

JACQUES. . . . Of hats?

ROBERTE II. No . . . of cats . . . without skins!

JACQUES. Oh, my pussycat. . . .]

[30] *Théâtre I.* (Paris, 1959), pp. 120–21.

With the phonetic element of the first syllable [ša], Ionesco leads the spectator or reader through a maze of sense possibilities, each suggested by that syllable plus a changing second element, a process much like Jacob's draining the last drop of sense out of *manège* and *ménage*.

Ionesco resembles Jacob in other ways as well. For example, Ionesco's *La Cantatrice chauve* contains the following stage directions:

> Un autre moment de silence. La pendule sonne sept fois. Silence. La pendule sonne trois fois. Silence. La pendule ne sonne aucune fois.[31]

This is the same Jacobean device of confusing something with nothing, reality with fantasy, a refusal to make the effort to communicate, the *2ᵐᵉ réflexion* all over again.

In the same play, M. Smith says:

> Elle a les traits réguliers et pourtant on ne peut dire qu'elle est belle. Elle est trop grande et trop forte. Ses traits ne sont pas réguliers et pourtant on peut dire qu'elle est très belle. Elle est un peu trop petite et trop maigre. Elle est professeur de chant.[32]

> [She has regular features and yet you can't say she is beautiful. She is too big and too heavy. Her features are not regular and yet you can say that she is very beautiful. She is a little too small and too thin. She is a singing teacher.]

Ionesco is demonstrating here the final inarticulateness and incoherence of ordinary notions expressed in everyday speech, the impotence of bourgeois vision and language. It is interesting to learn that the dialogue for this comedy was inspired by lessons from the *Méthode Assimil, L'Anglais sans peine*, one of the more wide-spread recent manifestations of positivistic thought.

Max Jacob was a predecessor and harbinger, not only of the major surrealists writing in the Twenties and Thirties and Forties, but also of some of the most important poets, prose writers, and dramatists of the Fifties and Sixties. And what constituted startling innovations or fantastic and revolutionary experiments just after the turn of the century

[31] Ibid., p. 20.
[32] Ibid., p. 22.

now pass as time-tested, tried-and-true devices, largely taken for granted by the vast majority of creative intellectuals today yet bearing, at the same time, the unmistakable stamp of "modernism." Jacob stands among the first of that cohort of writers who can be called genuinely modern.

In order to appreciate fully Jacob's contribution to recent literary productions, one must first sight back down the line of his poetic techniques. The fragmented images with which he habitually works piece together into a cogent whole as one applies knowledge of the source, Baudelairean decadence in this case. But if one looks forward in time, and loses sight temporarily of the identifications afforded by the Baudelaire-decadence-cubism *rapprochement*, the image undergoes increasing fragmentation. It becomes correspondingly difficult for the reader to isolate the rational, real-life referent of any given subject, or even to distinguish with any certainty the ideological implication.

If we glance back to Jacob's intellectual beginnings in Montmartre before 1900, we find a worldly fop, a dandy gotten up in superannuated finery, engaged in writing elegant art criticism. Few authors of his generation were more imbued with the values of late romanticism, few more a slave to what he himself considered its preposterously contradictory premises. At the same time, probably no young writer was more caustically lucid about what he understood as the falsifications fundamental to and inherent in all the works of the romantic *Zeitgeist*, nor did any young writer exert a more corrosive influence on what were, for him, its hackneyed conventions.

In this sense Jacob was a master of both centuries, taking much from the one, giving much to the other. In addition to his annihilation of the sacred cows, he forged an entire new literary vocabulary, as witness the fact (demonstrated in this chapter) that it is difficult to cite a modern French writer whose work (or elements of it) cannot be traced back to similar procedures in Jacob. His was a prophetic voice announcing the dissolution of the esthetic resources of a century, and it is precisely by his uncanny ability to show us in 1903 what the future—our present—was to be like that he imposes himself as a true herald of the new art.

In a first wave of decadence about the middle of the last century, Baudelaire, along with Gautier, Nerval, Borel, and others, had initiated the subversion of anti-social, anti-rational trends. In the last decades of the waning century, the symbolists along with a second group of decadent

writers—Lautréamont, Corbière, Laforgue, Rimbaud, and Jarry—continued the subversion and made it more extreme. The surrealists only confirmed all these tendencies. With Jacob, the disaggregation is so severe that total abstraction is in view. As new art continues its drift in this same direction, it arrives at an ever more drastic, ever more dramatic incoherence. Already contingency to the point of unintelligibility, a decadence bordering on schizophrenia, an extenuated oriental mysticism, plus thematic preoccupations such as anti-Semitism, religious conversion, homosexuality, and hallucination due to drugs and psychosis, are the order of the day if one is to judge by the recent crop of novelists, playwrights, and poets, as well as composers, figurative artists and cineastes, whether in Europe or in the United States. Jacob is certainly historically secure as one of the first to give voice to these trends in our century.

A Selected Bibliography of the Works of Max Jacob

L'Histoire du roi Kaboul ler et du marmiton Gauwain. Bibliothèque d'éducation récréative. Paris, 1904.

Le Géant du soleil, conte pour enfants. Paris, 1904.

Saint Matorel. Paris, 1911. With *eaux-fortes* by Pablo Picasso.

La Côte, recueil de chants celtiques anciens inédits. Paris, 1911.

Les Oeuvres burlesques et mystiques de Frère Matorel, mort au couvent. Paris, 1912. With *eaux-fortes* by André Derain.

Le Siège de Jérusalem, drame céleste. Paris, 1914. With *eaux-fortes* by Pablo Picasso.

Les Alliés sont en Arménie, poème hors commerce. Paris, 1916.

Le Cornet à dés, poèmes en prose. Paris, 1917. With an *eau-forte* portrait of the author by Pablo Picasso.

Le Phanérogame, roman. Paris, 1918.

La Défense de Tartufe, extases, remords, visions, prières, poèmes, et méditations, d'un juif converti. Paris, 1919. Twenty-five copies with an *eau-forte* by Pablo Picasso; twenty-five with drawings by the author; twenty-five on the same paper but without illustrations; 750 copies on ordinary paper without illustrations.

Cinématoma, collection de caractères. Paris, 1920. 1,245 copies printed.

Lulle, Raymond. Le livre de l'ami et de l'aimé. Translated by De Barreau and Max Jacob. Paris, 1920.

Matorel en province, plaquette illustrée. Paris, 1921. Illustrated by J. Depaquit.

Works are arranged in chronological order.

173

Ne coupez pas, mademoiselle, ou les erreurs des P.T.T., plaquette de grand luxe. Paris, 1921. With illustrations by Juan Gris.

Dos d'arlequin. Paris, 1921. With colored woodcut illustrations by the author; ten copies with original drawings in the margins by the author; 272 copies printed.

Le Laboratoire central, poésies. Paris, 1921. 750 copies printed.

Le Roi de Béotie, nouvelles. Paris, 1922.

Le Cabinet noir, lettres avec commentaire. Paris, 1922.

Art poétique. Paris, 1922. 1,100 copies printed.

Filibuth ou la montre en or, roman. Paris, 1923.

Le Terrain Bouchaballe, roman. Paris, 1923. Two volumes.

La Couronne de Vulcain, conte breton. Paris, 1923. With illustrations by Suzanne Roger.

Visions infernales, poèmes en prose. Collection: Une Oeuvre, un portrait. Paris, 1924. With a self-portrait of the author. 550 copies printed.

L'Homme de chair et l'homme reflet, roman. Collection bleue. Paris, 1924.

Les Pénitents en maillots roses, poèmes. Les Cahiers nouveaux. Paris, 1925. 1,800 copies printed.

Le Nom, nouvelle. Liège, 1926.

La Côte, recueil: chants celtiques anciens inédits. Reprinted, Paris, 1926. With seventeen watercolors by the author. 235 copies printed.

Fond de l'eau, poèmes. Collection de l'Horloge. Toulouse, 1927.

Le Cabinet noir, lettres avec commentaires. In a considerably augmented edition, Paris, 1928.

Visions des souffrances et de la mort de Jésus, fils de Dieu. Paris, 1928. With forty drawings and a self-portrait by the author. 300 copies printed.

Sacrifice impérial, poèmes. Collection: Les Introuvables. Paris, 1929.

Cinématoma, collection de caractères. Reprinted, Paris, 1929.

Tableau de la bourgeoisie. Paris, 1929. With original lithographs and numerous drawings by the author. 348 copies printed.

Fable sans moralité. No place, 1931. With music by H. Bordes.

Le Bal masqué. No place, 1932. With music by Francis Poulenc.

Cinq poèmes. No place, 1932. With music by Francis Poulenc.

Bourgeois de France et ailleurs. Paris, 1932. Reissue of only the text of Tableau de la bourgeoisie without lithographs and drawings.

Rivages, poèmes. Toulouse, 1934.

Saint Matorel, Oeuvres burlesques et mystiques de Frère Matorel, mort au couvent, le Siège de Jérusalem. Paris, 1936. Reissue of three earlier works.

Le Chemin de croix infernal. Paris, 1936. With a drawing by J. M. Prassinos.

Morceaux choisis. Paris, 1937. With a preface by Paul Petit.

Ballades, poèmes. Paris, 1938.

Posthumous Editions

Conseils à un jeune poète, Conseils à un jeune étudiant. Paris, 1945.

Derniers poèmes en vers et en prose. Paris, 1945.

Le Cornet à dés, poèmes en prose. Paris, 1945. New edition with the addition of a "Petit historique du Cornet à dés," composed in 1943.

Méditations religieuses. Paris, 1945. With illustrations by the author. 325
copies printed.
Lettres à Edmond Jabes. Alexandria, 1945.
Méditations religieuses, choix. Paris, 1947. With a preface by Abbé Maurice
Morel.
L'Homme de cristal, poèmes. Paris, 1948. With illustrations by the author.
349 copies printed.
Lettres de Max Jacob à Jean Cocteau, 1919–1944. Paris, 1949. With an intro-
duction by André Fraigneau and Jean Denoël and a preface by Jean
Cocteau. With a self-portrait of the author.
Miroir de l'astrologie. Paris, 1949. In collaboration with Claude Valence.
L'Histoire du roi Kaboul ler et du marmiton Gauwain. Reissue by Les Cahiers
Max Jacob, I. Paris, 1951.
Lettres imaginaires. Les Cahiers Max Jacob, II. Paris, 1952. With a note by
Jean Cocteau and drawings by the author.
Théâtre I, Un amour du Titien, la Police napolitaine. Les Cahiers Max Jacob,
III. Paris, 1953. With a note by Henri Sauguet.
Poèmes de Morven le Gaelique. Paris, 1953. With a preface by Julien Lanoë.
Correspondance, Tome I, Quimper-Paris, 1916–1921. Paris, 1953. Tome II,
Saint-Benoît-sur-Loire, 1921–1924. Paris, 1955. These letters were col-
lected and conserved by François Garnier. With a preface by André
Brissard.

Unpublished Works

La Femme fatale, comédie. 1917. The text of this comedy has never been
found.
Trois nouveaux figurants au théâtre de Nantes, comédie en un acte. 1919.
Presented at the Galerie Barbazange.
L'Enfant de la maison, comédie en trois actes. 1920. Presented at the Galerie
Barbazange.
Ruffian toujours, truand jamais. 1920. Presented at the Galerie Barbazange.
Le Terrain Bouchaballe, pièce en trois actes. 1920. Adapted from the novel of
the same name; the text has never been found.
Une Leçon de diction, en un acte. 1922. There exists a second version which
had been expanded to three acts.
Les Impôts, comédie musicale. 1929–1932.
La Turquoise, farce en un acte. 1934. In collaboration with Pierre Lagarde.
Special issues of "little magazines" dedicated to Max Jacob and containing,
in addition to critical articles and appreciations, many previously un-
published texts or texts of works that had been long out of print.
Le Disque vert, November, 1923, Brussels-Paris.
Le Mail, April, 1928, Orléans-Paris.
L'Année poétique, January, 1934, Paris. Poems with a portrait by Picasso.
Aguedal, II (May, 1939), Rabat. Reissued in 1944.
Les Documents du Val d'Or, XXXI (March, 1945), Loiret. Published through
the efforts of M. le Curé at the Abbey of Saint-Benoît-sur-Loire.
La Boîte à clous, X (February, 1951), Bordeaux.

Simoun (n.d.), Oran.

In addition to the foregoing, there exists an immense number of collective works upon which Jacob collaborated, as well as numerous introductions, prefaces to books of poetry, to catalogues of art expositions, etc. For the majority of these, only the sketchiest bibliographical information is available.

Index

Note: Works for which no author is given in parentheses are by Max Jacob.

THE JOHNS HOPKINS PRESS

Designed by Arlene J. Sheer
Composed in Bodoni Book text with Bodoni Bold Condensed display
by Typoservice Corporation

Printed on 55 lb. Lockhaven
by Universal Lithographers, Inc.
Bound in Holliston Roxite C-57662
by Moore and Company, Inc.